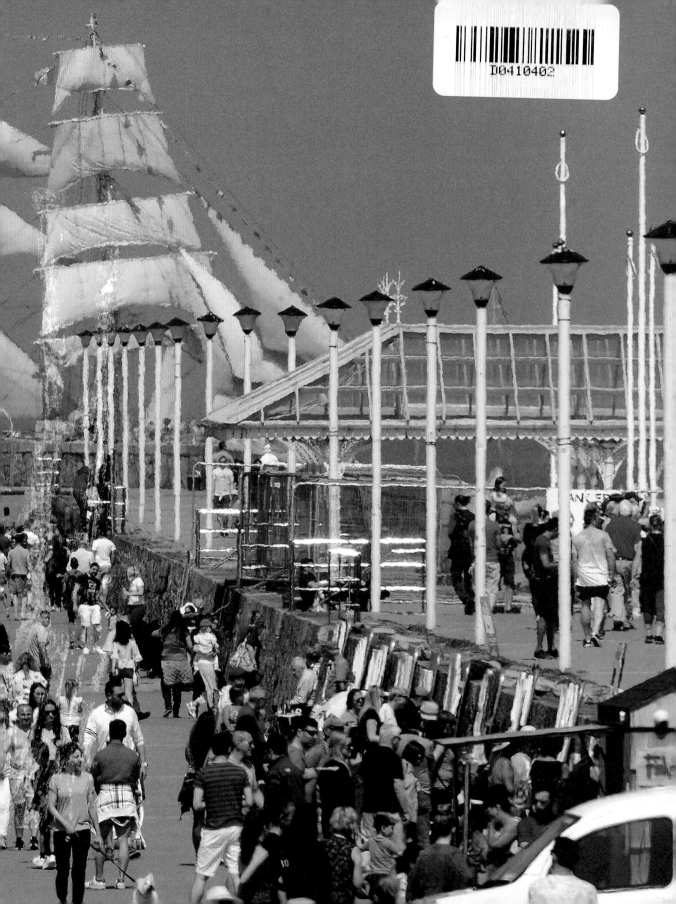

PEOPLE
ON
THE
PIER

PEOPLE ON THE PIER

MARIAN THÉRÈSE KEYES
BETTY STENSON

NEW ISLAND

PEOPLE ON THE PIER
First published in 2018 by
New Island Books
16 Priory Hall Office Park
Stillorgan
County Dublin
Republic of Ireland

www.newisland.ie

ISBN: 978-1-84840-709-1

Internal and cover design by Karen Vaughan
Printed by Introkar Poland

PUBLISHING IRELAND
FOILSIÚ ÉIREANN

New Island Books is a member of Publishing Ireland.

Comhairle Contae County Council

In partnership with Dún Laoghaire-Rathdown County Council.

CONTENTS

TIMELINE OF DÚN LAOGHAIRE HARBOUR

1800 Captain Bligh of *Bounty* fame, completes a survey of Dublin Bay. Dunleary was just a small village of fishermen's cottages centred around a creek where the present day *Purty Kitchen* is situated.

1804 What had been a wild and rock coastline was opened up by the building of a line of Martello Towers along the coast, with connecting military roads.

1807 Two ships, the *Prince of Wales* and the *Rochdale* sail from Dublin with volunteers for Wellington's army. In a terrible storm, both ships are driven onto the rocks between Dunleary and Blackrock. Nearly 400 lives are lost.

1808 Petition signed in Monkstown Church calling for an asylum harbour to be built.

1811 An anonymous seaman, believed to be Richard Toutcher, a Norwegian ship broker living in Dublin, agitates for a harbour.

1813 Howth Harbour completed.

1814 Campaign begins for a harbour in Dunleary. Toutcher secures a lease on Dalkey Hill to excavate granite for the construction of the harbour. The granite will be supplied free of charge.

1815 Act of Parliament passed to allow appointment of five Harbour Commissioners. War with France ends with the Battle of Waterloo. Hundreds of Irish sailors and soldiers flood back home. August: First Board Meeting of the Harbour Commissioners.

1816 Act of Parliament to build harbour passed on 20 June 1816. Toutcher appointed Second Assistant Engineer on the harbour construction. Lord Lieutenant approves extension of East Pier. Martello Tower at Glasthule (now the People's Park) to be used for storing gunpowder.

1817 In May, Lord Lieutenant Whitworth lays the first stone. In June, contract for quarrying stone is awarded to George Smith. Ex-army men, now labourers, sworn in as special constables to do guard duties. In December, resident poor chosen as labourers in preference to strangers. Any man found guilty of joining a combination (the forerunner of unions) to be dismissed and not re-employed. Men to be paid in cash every Friday. No payment 'by tickets or order on publicans or hucksters' (small shop keepers).

1818 In April, parts of the pier washed away in bad storm.

1820 700 men employed in harbour construction. Work starts on West Pier after Parliament agrees. Harbour Commissioner's house built by George Smith, Dunleary's first public building.

1821 May. Unrest among labourers and a strike over long hours and low pay. 'It is entirely owing to the appearance of the military that the men continue peacefully at their work'. Sept. Departure of King George IV; town renamed Kingstown until 1920. John Rennie Senior dies and is replaced by his son, also John Rennie.

1822 William Hutchison appointed Harbour Master. He retired in 1874 and died in 1881. Lighthouse on East Pier is lit.

1823 Obelisk erected on Queen's Road to commemorate departure of George IV. 1,000 quarry workers and their families living on Dalkey Commons. Snow and frost hold up the work, men laid off for fortnight with no pay.

1824 Convict hulk, the *Essex*, a former American ship is placed in the Harbour.

1825 Stonemason George Smith dies. Sam Smith, his son continues contract after re-negotiating price of stone.

1826 Dalkey Hill workers on strike. Police protection given to those who wanted to return to work. Mail service transferred from Howth to Kingstown.

1827 Wharf built on East Pier for mail packets.

1828 Thomas Gresham seeks to bring salt water pipe to his proposed salt water baths in the Royal Marine Hotel. Dublin Regatta held, first major yachting event in harbour.

1829 A bad storm damages machinery on the outside of the East Pier, five men drowned. More unrest with a proposal by the Harbour Commissioner for a reduction in men's wages. Report of stones being removed from site for building houses. Harbour Commissioners seek new contract for supplying stone. Contractor refuses to negotiate. Original contract remains. Stone-weighing machines to be erected. Harbour Master Hutchison becomes the first Irish man to be awarded the RNLI Gold Medal.

1830 Lifeboat installed in the harbour. It was previously based in Sandycove.

1831 Contract for building sewer at back of the West Pier given to John McMahon.

1834 Kingstown Commissioners formed. Opening of the first railway line in Ireland between Dublin and Kingstown.

1837 Convict hulk the *Essex* is sold off.

1840 Harbour Master's House completed. In area now known as Moran Park.

1841 Construction of pier heads begins.

1842 East Pier lighthouse built.

1845 Lieutenant William Hutchison settles in new Harbour Master's house.

1847 East Pier lighthouse opened.

1853 Carlisle Pier commenced.

1856 Carlisle Pier completed. Railway extended from Kingstown to Bray.

1859 Railway extension to Carlisle Pier, now passengers could transfer from train to Mail Boat in comfort.

1861 Captain Boyd and five of his crew from the guard ship HMS *Ajax* drowned off back of East Pier attempting to rescue drowning sailors. Lifeboat house at end of East Pier completed.

1863 Lighthouse Keeper's house constructed at the end of the West Pier.

1918 On 10th October the RMS *Leinster* sunk, shortly after leaving Kingstown harbour, after being torpedoed by a German U-boat, only weeks before the end of World War I.

1920 Kingstown reverts to its original name – Dún Laoghaire.

1924 Becomes Dún Laoghaire Harbour under the State Harbours Act.

1924 Passengers for the Tailteann Games disembark at the Carlisle Pier. The Games were held in Croke Park and venues around the city.

1930s Dick Farrell rented out rowing boats from the steps of the Carlisle Pier. Rowing was confined to the harbour.

1932 The Papal Legate, Cardinal Lauri, disembarked at the Carlisle Pier for the start of the Eucharist Congress. He arrived on the *Cambria* and was met by the Archbishop of Dublin, Edward J. Byrne and Éamon De Valera.

1937 Visit of German training ship SMS *Schleswig-Holstein*. It later fired the first shots of WWII in Danzig (Gdansk).

1938 A Flying boat landed in the harbour, a Supermarine Southampton and was moored just to the side of the East pier.

1959 In the middle of July 1959, cars were being lifted into the for'ds of the mail boat by fixed cranes. The capacity on board was 25 cars.

1965 Car ferries with roll-on-roll-off facilities were introduced on a seasonal basis.

1968 On 10 April, a Rolls Royce was hoisted aboard the mail boat for the evening sailing to Holyhead.

1975 The mail boat continued to operate from the Carlisle Pier until 1975.

1985 The paddle steamer *Waverley* docked at the Carlisle Pier for a few weeks in the summer of 1985. She ran trips from Dún Laoghaire to Arklow.

2009 The *South Rock* lightship was moored at the Carlisle Pier for some years. When she was withdrawn from service on the 25 February 2009, she was the last of the lightships in the service of Irish Lights.

2011 On 11 February 2011, the foghorn situated in the battery at the end of the East Pier was considered obsolete and no longer needed as an aid to navigation. It ceased to be heard from that day on.

2012 On 24 April the MV *Quest* was the first cruise ship to come into Dún Laoghaire harbour: it is the smallest cruise ship in the world.

2013 Although not coming in to berth in the harbour, the *Queen Mary* was just outside Dún Laoghaire on 16 May, 2013. Her passengers were brought ashore in tenders. Also calling in to Dún Laoghaire was the cruise ship *Wind Surf* which docked at the Carlisle Pier.

2014 In Autumn 2014, the last ferry left Dún Laoghaire harbour. For the first time in over 200 years there was no passenger service to Britain from Dún Laoghaire.

2017 On 31 May, 2017 President Michael D. Higgins celebrated the 200th anniversary of the laying down of the foundation stone by the Lord Lieutenant, Lord Whitworth.

Timeline, Chapter 1 and other historical sections are courtesy of Colin Scudds of the Dún Laoghaire Borough Historical Society who prepared the exhibition entitled Bicentenary of Dún Laoghaire Harbour, in partnership with dlr LexIcon, displayed in the library from May 2017-May 2018.

Dedicated to the memory of all those who have worked on and walked the piers in Dún Laoghaire over the last 200 years, to those who continue to enjoy the unique pleasure of a jaunt by the harbour and to all those who have yet to join the ranks of the people on the pier.

FOREWORD
by An Cathaoirleach
Councillor Ossian Smyth

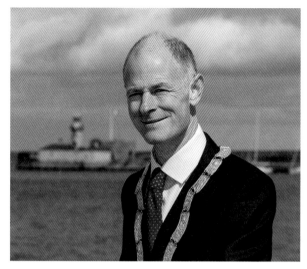

Photo by Peter Cavanagh

It gives me great pleasure to write a foreword for this beautiful book. The pier has such a distinctive and iconic presence in Dún Laoghaire, beloved of countless people at home and abroad and I am so pleased to see such a community-based project come to fruition.

The pier is the opposite of a shortcut, it leads to the end where you turn around and walk home again. There is a sense that everyone you pass and acknowledge on the pier has no goal other than walking for its own sake. Nobody is rushing to an urgent appointment. There is nothing to do but talk to your companions or meditate and appreciate the ephemeral beauty of the changing skies over the bobbing yachts.

dlr LexIcon hosts the Local Studies Collection of the Dún Laoghaire-Rathdown Library Service. Last year, working in partnership with Dún Laoghaire Borough Historical Society, they produced an exhibition to coincide with the bicentenary of the pier in May 2017. One curious fact that emerged during the course of their research was that there were very few photos in the Local Studies Collection of people on the pier, other than some well-known images taken from the Lawrence Collection in the National Library. The aim of the People on the Pier project was to remedy that, building a major resource of photos for future generations, capturing the 200th anniversary in a meaningful manner.

Through Facebook, Twitter and Instagram, the photos poured in and the dlr People on the Pier community was born! At the end of the year, many of these photos were projected, in spectacular fashion, on the side of the LexIcon – a fitting finale to a very special year. Such was the success of the project, New Island publishers were keen to produce the book you now hold in your hand.

A warm thanks to the hundreds of people who participated in this publication, with their cherished photos from the past and the present and to those who shared their stories, poems and special moments. We hope this publication will rekindle memories and encourage many to rediscover this wonderful amenity, one of the most enduring landmarks along our coastal landscape. Well done to Betty and to Marian and all at dlr Libraries for their work on a publication which will be an excellent addition to the Local Studies Collection at dlr LexIcon.

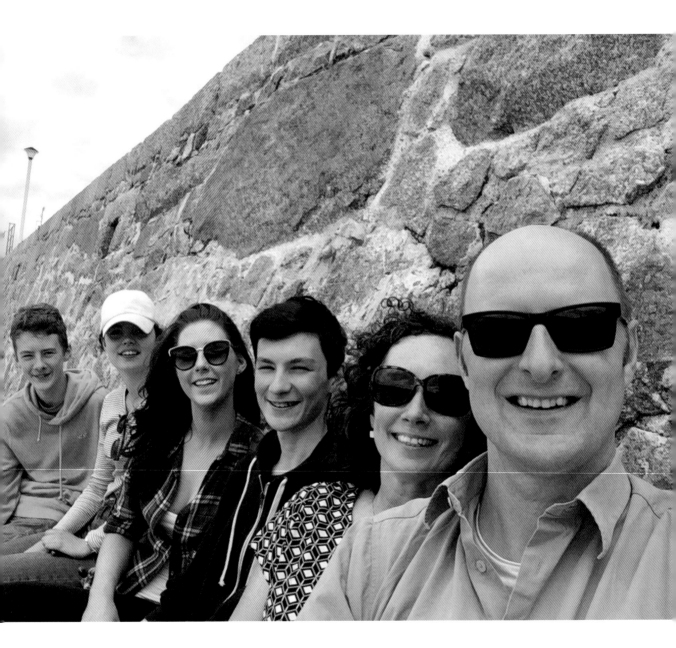

The Nolan Family, taking a break from a post-breakfast walk on the pier on the morning of Padhraig's fiftieth birthday, July 2016. From left to right: Conor, Hazel, Eve, Seán, Helen, Padhraig.

INTRODUCTION

'Vera's favourite thing to do was to cross the railway and the main road for a stroll along the seafront, or down the pier and back. Coming home, the looming bronze statue put her in mind of men walking in the sky. Summer evenings were luminous and rich, the sea full of boats and white sails; the halyards ticked in the harbour, boules clicked on the green. The place filled up with people then, walking their dogs or their children, teenagers sunbathing on the rocky side of the pier.'

'Blood is Thicker' by Lia Mills (from *Taking the Plunge*)

People on the Pier was created as a platform for people to share photos of their visits to Dún Laoghaire Pier, which celebrated its bicentenary in 2017. It was an initiative of the Local Studies Department of dlr Libraries, who were intent on growing their collection of pier imagery, bringing it right up to date during this landmark year.

'Meet me on the pier' is a familiar phrase and over the last 200 years, the East and West Piers have been popular destinations for days out, such as holy communions, birthdays, first dates, walking the dog, a Sunday stroll, hanging out with friends, taking the air, engagements, weddings, and even reconciliations!

More than a million people walk the pier annually and for many it is a daily pleasure. On weekend afternoons, the throngs of strollers pace themselves along both piers, enjoy fish and chips or an ice cream cone whilst watching the many maritime activities in the bay.

People from all over the world, including famous politicians, royals and celebrities, have embarked and disembarked at the ferry terminals and many thousands of Irish people have joined the diaspora from these shores, seeking employment and brighter opportunities abroad. Some have happily returned over the years.

The response to the People on the Pier project has been overwhelming. Once the social media channels for the project were set up in early June 2017, people began sharing their poignant, personal, comical, nostalgic and downright crazy photographs, resulting in the formation of a strong virtual visual community of those who love Dún Laoghaire, its harbour and its piers. From the very beginning, on all of the platforms, there was an immediate sense of a community of people who were eager to share their snapshots and memories of Dún Laoghaire, who had almost been waiting in the wings to make this happen. It was the immediacy and accessibility of sharing a photo and its context with ease and spontaneity that seemed to encourage participation. People on

the Pier made it as easy as pinning a notice on a community centre noticeboard or having your family photo included in the local newspaper's 'Out and About' section. Since the tone was light, casual and inclusive, people responded. The ensuing interactions culminated in a digital exhibition and the projection of over 200 of the photos onto the exterior of dlr LexIcon on 6 December 2017, with 300 more on screens indoors, followed by a celebration afterwards which included many of the contributors to the project.

That might have been the end of the project, but photos kept coming in, the community continued going strong and people were unwilling to let it go. It was becoming clear that a more physical, enduring record of this year on the pier was required and the idea of a book took hold. New Island Books, with their vision and experience, came on board immediately and together with dlr Libraries, it is our pleasure to present this fine volume which will appeal to all who have enjoyed the many wonderful benefits of a stroll down the piers over the years and who will, it is hoped, continue to do so in the future.

As you journey through these pages from the building of the piers 200 years ago through to the bicentenary in 2017, you'll discover fascinating historical facts and compelling contemporary tales all interspersed with poetry, prose and quotations from some of the county's finest writers.

Chapter 1 shows how the building of the East and West Piers was filled with unexpected drama, poignancy and even a palpable sense of adventure. The stories of the main protagonists are brought to life here, from the pioneering Captain Richard Toutcher to the labourers who often toiled for up to seven days a week. Chapter 2 deftly brings us back to the twenty-first century, to a world that that was unimaginable to our forebears and featuring events from formal ceremonial

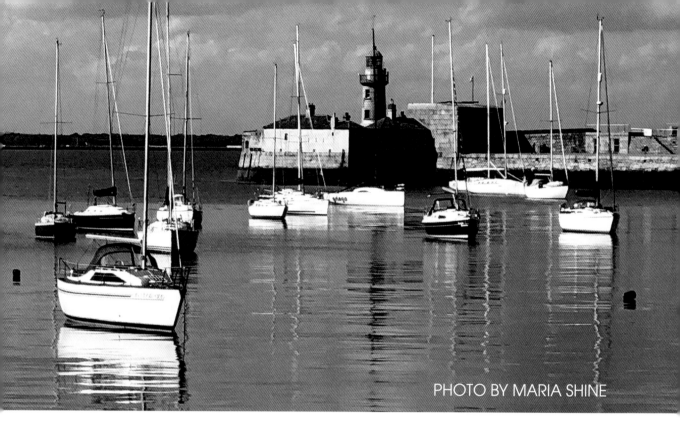

celebrations of the bicentenary to glittering social occasions. Chapter 3 was written by and about the People on the Pier, the extraordinary everyday lives and stories of those who populate this place or those whose hearts have been touched by a brief sojourn here. The story would of course be incomplete without the inclusion of Dún Laoghaire's doggy denizens and Chapter 4 introduces some of the finest! In Chapter 5 the long history of emigration from the pier is examined along with the fascinating history of the iconic Harbour House. The evolution of Dún Laoghaire from meagre settlement to bustling, prosperous port is delineated clearly in Chapter 6, showing as it does the calendar of cultural and social events throughout any given year and the prominent people, past and present, who have alighted here. Chapter 7 highlights the natural phenomena of storms, scenery and sunscapes on the pier, with the many beautiful photos proving that the pier is an awesome backdrop; a blank canvas waiting to be filled with ever-changing colours and activities.

In an era where so much of what is captured is ephemeral, merely data on a disk, or easily erased pictures, videos or clips, the physical preservation of the present for future generations seems more urgent than ever before and it is hoped that this book has gone some way towards achieving this.

'The town embraces the sea in its tidy harbour. Sailboats clack in the marina and the ferry port creates a sort of unofficial centre. I look out beyond the harbour to the bay and let my eyes de-focus so that the scene shifts into a kind of abstract version of itself: blocks of colour and a sense of undulating movement.'

'Immersion' by Michelle Read (from *Taking the Plunge*)

SEA BATTERIES
by Daniel Wade

This harbour wall is truer than any god,
 chequered rust glazing fuse-blasted stone.

The sea thunders over and over, between
north-easterly choirs and abrasive granite.

For now, though, there's a lull in the fighting
between wave and wall, the light of June

smearing itself over horned rocks. I ask
myself, how many navvies poured their lives

into stone, just to build these pincer-piers,
carving the slowest of inroads on the tide,

iron cabals sagging to the water's edge?
A thousand men, maybe more, who sweated

for asylum, hauling tallow-greased drays
from the Dalkey pits, laden with the import

of granite and the friction of their hands.
If there is anything to love about the place,

it's the closeness of the sea, the tide's
ebbing murmur, the waves' crumbling chant,

miniature forests of algae swaying underwater.
The bandstand, with rust-tattooed masonry,

letting the rain enter as lazily as the sun.
A catamaran throbs whitely on the horizon,

towing behind her a chain of swollen miles,
the mould of her prow acute as a whetstone.

Even now, under a crash of spray, I ask:
does the harbour hold any provision for exiles?

From A Sound Map of Dún Laoghaire, an ongoing project by Anthony Kelly & David Stalling
(www.dunlaoghairesoundmap.com)

'Sea Batteries' was written in tribute to the men who built the two piers in Dún Laoghaire. The piers were built with the express purpose of providing a safe harbour for shipping in Dublin Bay. Over 1,000 local men were employed in this enterprise. Daniel Wade, a graduate of IADT, describes how he has always felt that Dún Laoghaire operates primarily as a beacon of refuge against the rage and restlessness of the world. The recording was made at Haigh Terrace in Autumn 2016.

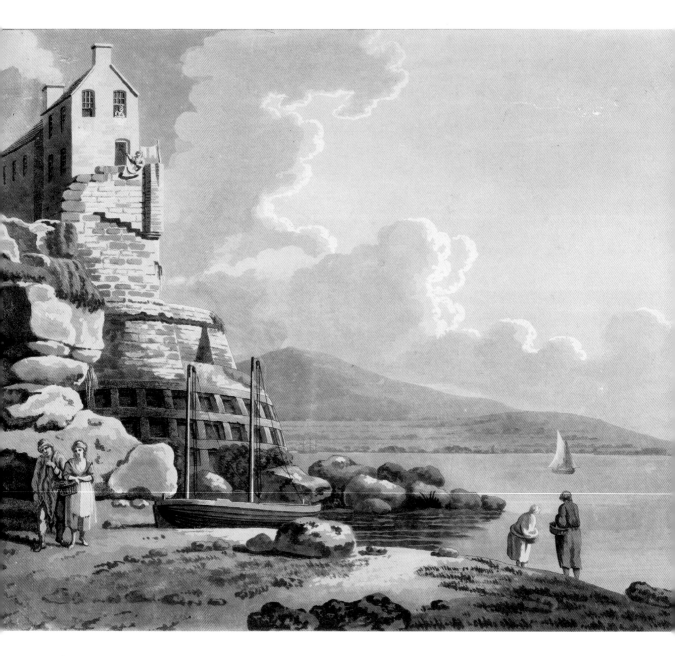

A view in the Bay of Dublin. View of Coffee House Dunleary, 30 December 1785. Francis Wheatley, printed by James Malton. NGI 11,645. Photo © National Gallery of Ireland.

CHAPTER 1
HISTORY OF THE EAST AND WEST PIERS

'Dunleary, or rather a little to the east of it was a good site for the construction of a harbour of asylum, for ships which, under unfavourable circumstances get embayed in Dublin Bay and cannot with safety enter the present harbour.'

George Rennie, 1802

Dublin Bay has always been a danger to shipping – Captain Charles Malcolm, one of the most eminent navigators in the Royal Navy in the early 1820s, wrote that 'The Bay of Dublin has perhaps been more fatal to seamen and ships than any other in the world.'

In the Middle Ages, ships would often unload their cargo in Dalkey in the Coliemore or Bullock area. Goods were then sent to Dublin by cart or packhorse. Dunleary was a small village of fishermen's cottages centred around a creek where the present day Purty Kitchen and Coal Harbour is situated. It had a dramatic coffee house overlooking the bay but the Dunleary coast was too wild and rocky to be of assistance to ships at this time. Sandbars in the bay made it difficult for ships to enter the Liffey to offload cargo along the quays and there might be as little as six feet of water clearance over the bars at low tide. Sailing packets in the 1700s could take up to twenty-four hours, even with a favourable wind, to reach Holyhead from Dublin and the trip often took two to three days. Bad weather could delay the mail packets' departure for up to three weeks.

Captain Bligh, of *Bounty* fame, made a thorough survey of Dublin Bay in 1800 and made suggestions as to how it could be made safer for shipping, blaming the inexperience of masters and crews and penny-pinching of many ship owners. Following the wreckage of two troopships in November 1807, the *Prince of Wales* and the *Rochdale*, nearly 400 men, women and children perished – the *Prince of Wales* running ashore at Blackrock where it was battered to pieces on the rocks and the *Rochdale* running aground on the rocks at the back of the Martello Tower at Seapoint. The resulting petition from parishioners and prominent members of the community, headed by Captain Richard Toutcher, ensured that the way would be paved for the building of an asylum harbour to prevent such tragedies in the years to come.

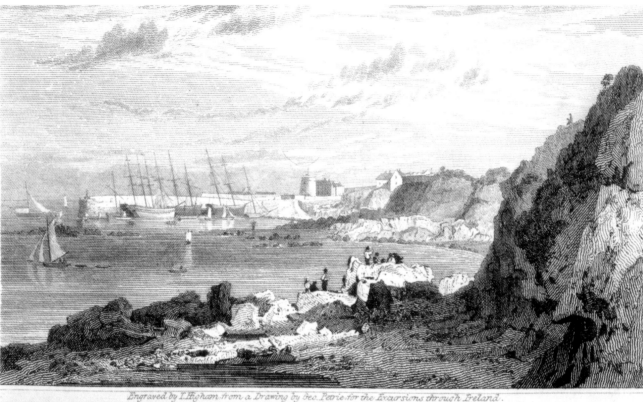

Engraved by T. Higham, from a Drawing by Geo. Petrie, for the Excursions through Ireland.

The Old Pier

DUNLEARY,

Co of DUBLIN.

The old pier Dunleary, engraved by T. Higham; from a drawing by Geo (George) Petrie, for the Excursions through Ireland. 1820. Image courtesy of the National Library of Ireland, NLI ET A 365.

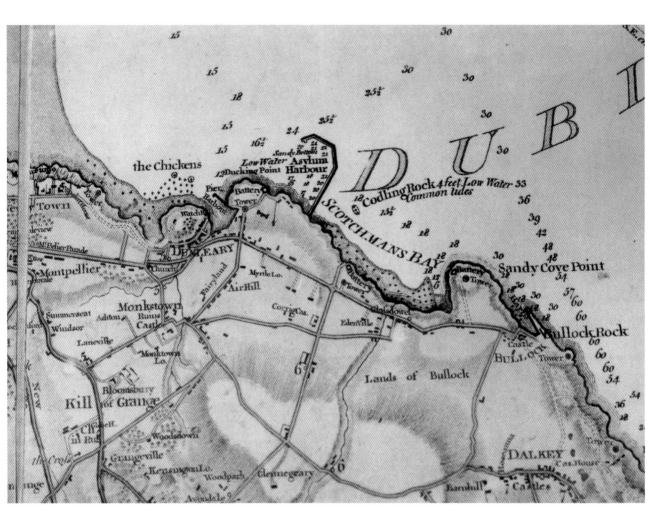

Taylor's Map of Coast, 1815. Image courtesy of Colin Scudds.

In 1816, an Act of Government granted permission for the building of an asylum harbour (not for a port for landing or loading goods or passengers) under the jurisdiction of Dublin Port.

The magnitude of this great engineering feat in the early 1800s cannot be underestimated as it became the largest manmade harbour in the world at that time, encompassing an area totalling 251 acres. The West Pier is 1 mile long (1,548m), the East Pier a third of a mile (1,300m), both sitting on a 300-foot-wide foundation (90m). The pier ends ensure that sand and silt are forced across the harbour mouth and not deposited in the harbour.

The building of the East Pier began in 1817 and was completed circa 1841. The West Pier was completed circa 1848 and the Carlisle Pier in 1856. Over the last 200 years, old Dunleary, a small creek that was home to a few fishing vessels, was to change beyond recognition by the building of the asylum harbour.

Th

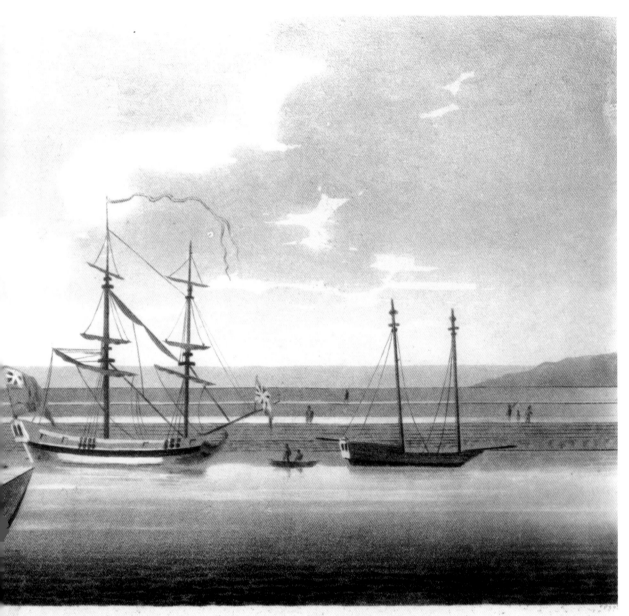

at DUNLEARY _ 5 Miles from Dublin .

Plate 19.

London Pub.d Jan. 1.st 1799. by F. Jukes Howland St.

View of old Dunleary pier of 1767, County Dublin, with images of ships in port. Francis Jukes (Artist).
Printed Jan 1st 1799. Image courtesy of the National Library of Ireland, NLI ET B97.

PEOPLE BEHIND THE PIER

RICHARD TOUTCHER

Horrified by the loss of life in Dublin Bay, a campaign to build a harbour at Dunleary was headed by the pioneering Captain Richard Toutcher (1758–1841), a seaman and shipbroker of Norwegian birth. For his dedication in fundraising and securing a lease on Dalkey Hill for the granite, he was employed as Second Assistant Engineer with a salary of £227 per annum. Toutcher worked for the harbour until the early 1830s and he was awarded a pension of £100 on the Civil List in May 1834. However, with all the demands from his work on the harbour, he had neglected his own business. Debts mounted up and he died bankrupt.

His legacy was not only to change the lives of ordinary seamen forever, reducing the deadly risk from the ever-changing sand banks in Dublin Bay, but it also gave rise to the growth of this dynamic and important town, now a safe haven for sea vessels. With the arrival of the new railway in 1834, Kingstown experienced further significant growth and prosperity.

"... but the idea of an Asylum Port at Dunleary is ever first in my thoughts..."

Signature of Richard Toutcher.

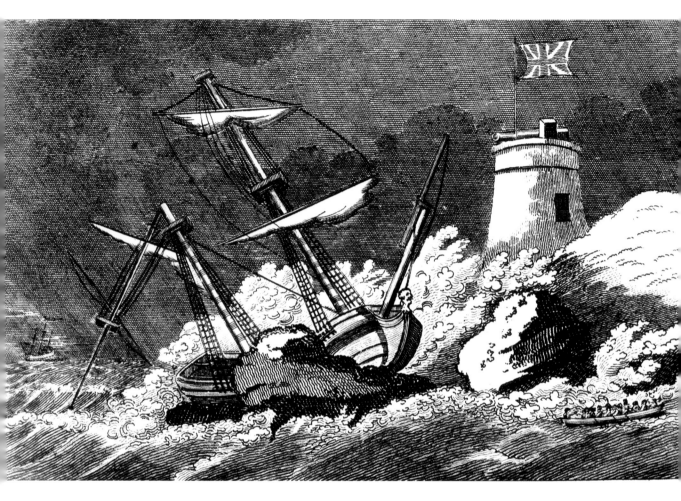

Loss of the *Prince of Wales* (photograph of print) illustrated in *Walkers Hibernian Magazine*.
Image courtesy of the National Library of Ireland.

A view of the Black Rocks and of the mountains on the south side of the harbour of Dublin ... ca. 1730-60. Engraved by Giles King, publ. Will Jones. Image courtesy of the National Library of Ireland, ET C169. The seascape with the abundance of treacherous rocks shows just how difficult it was to negotiate these waters in rough weather.

Aerial Photo 29 May 1968 at 5,400 ft. Irish Air Corps. Rennie's dramatic legacy.
Image courtesy of Colin Scudds.

Portrait of John Rennie 1761-1821 by Sir Henry Raeburn (1810).

JOHN RENNIE

John Rennie (1761–1821) was appointed Chief Engineer for the construction of the harbour in 1815. He was one of the leading civil engineers of the day, designing many well-known bridges, such as Waterloo Bridge, and canals and docks at Hull, Liverpool and London. Keeping an effective link between Ireland and England was vital in the early nineteenth century and Rennie was responsible for the construction of Howth Harbour a decade earlier than Dunleary.

Originally the plan was that only one pier, the East Pier, would be built but Rennie was adamant that one pier would result in sand drift so he insisted on the West Pier also. The foundations of the pier are 300 feet wide and 24 feet below low water level. Rennie maintained that the space between the two pier heads should be 430 feet with the pier heads turned into the harbour to prevent swells. However, initially he was ignored with the opening at 1,066 feet but this was reduced to 760 feet at a later date.

George Smith, a private stone contractor, was awarded the contract for supplying stone for the harbour. He lived at Granite Lodge and operated several quarries in the Dunleary area. Stone was quarried at Glasthule, the site of today's People's Park and what was to become the pond area in Moran Park, today the grounds of dlr LexIcon. It had also been decided to use the Martello Tower in Glasthule (the People's Park) for storing the powder used in blasting. When George died in 1825, his son Samuel continued the contract and he lived in Stone View House at Clarinda Park which had been built for him by his father. George Smith also built the former Harbour Commissioners' house beside County Hall in 1820 for £330, where the current Harbour Master resides.

The pier contains some of the finest examples of the stonemason's craft seen anywhere in the country and many of its features are regarded as unique. Among these are the West Pier lighthouse, set into the centre of radial paving and the lighthouse keeper's house (1863), beautifully constructed in granite ashlar blocks with a cornice and parapet. Both piers still have interesting features like the original mooring posts, mooring hoops and granite steps descending into the harbour.

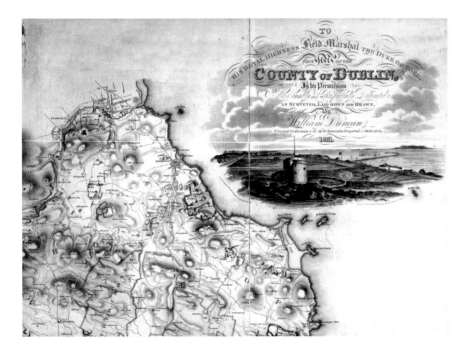

Map of County Dublin by William Duncan. 1821.
Image courtesy of the National Library of Ireland, reproduced in 6B 532.

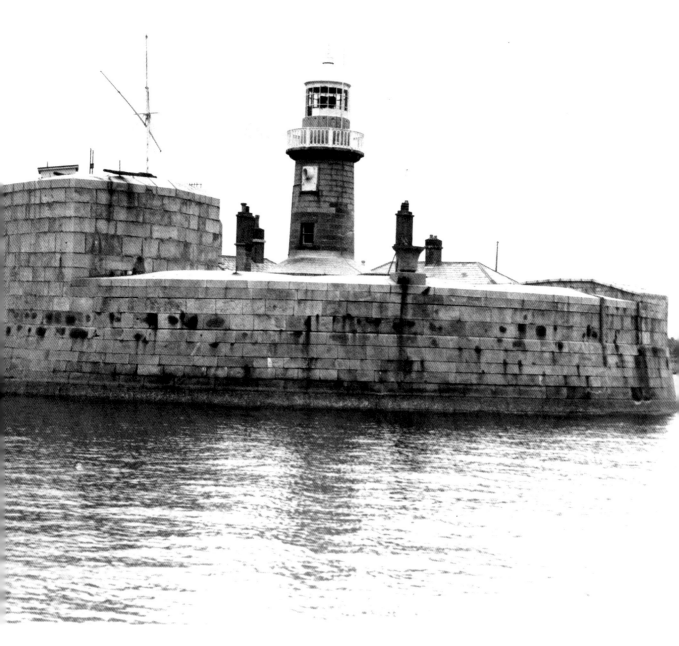

East Pier Lighthouse and Battery. 1987. Image courtesy of Colin Scudds.

'The sun hung just to the east of the Kish Bank. It was due to rise at six minutes past six. The Fraser Bank and the Muglins would feel its warmth first. Then it would spread, slowly and steadily, over Sandycove, across Scotsman's Bay, setting the mica in the granite of the East Pier a-sparkle, as it began its measured track across the country.'

Mary, Mary by Julie Parsons, 1998

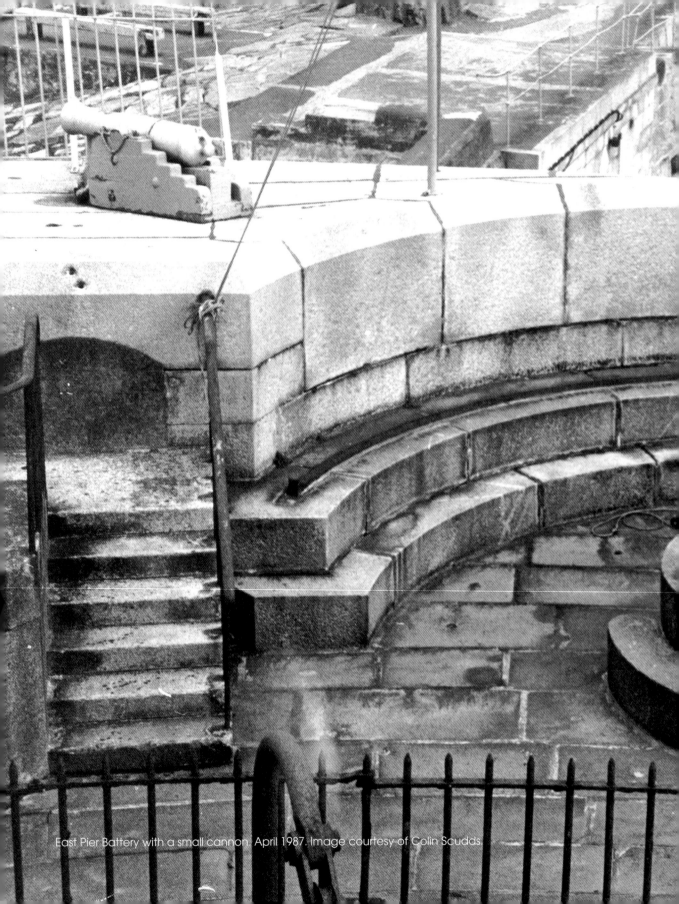

East Pier Battery with a small cannon. April 1987. Image courtesy of Colin Scudds.

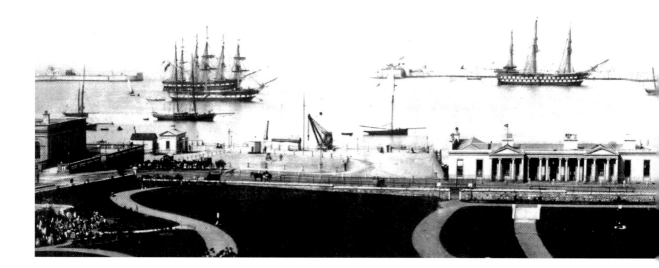

LIEUTENANT WILLIAM HUTCHISON, FIRST HARBOUR MASTER

The Harbour Commissioners were fortunate in their choice of their first Harbour Master, Lieutenant William Hutchison of the Royal Navy, who was aged twenty-four. He was appointed in 1822, and, as work had only just started on the harbour, his position also carried the title of Harbour Master of Bullock and Old Dunleary Harbour and Inspector of Quarries at Bullock. A house overlooking Bullock Harbour went with the job along with a salary of £100 per annum. He had many responsibilities including supervision of the lifeboat stationed at Sandycove, and, after 1826, he acted as

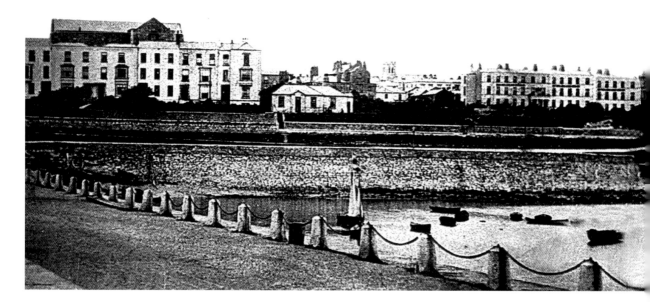

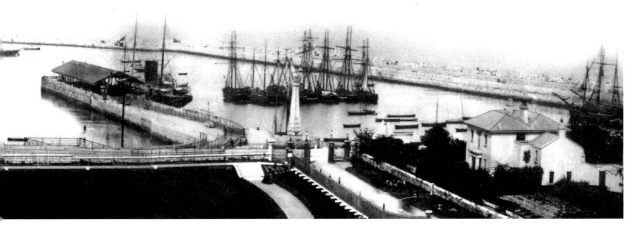

Kingstown Harbour c. 1860. Image courtesy of Colin Scudds.

the agent to the mail packets. Hutchison was popular, efficient and dedicated to the growth of the harbour. His management of the lifeboat service was outstanding and he carried out many rescues. In 1829 he received the RNLI Gold Medal for his courageous rescue of the eleven crew members of the *Duke* which had come to grief at Sandycove. In 1840, Hutchison moved to the Harbour Master's House, now the Design Gallery at Moran Park. After a long and extraordinary career, he died in 1881 aged eighty-seven.

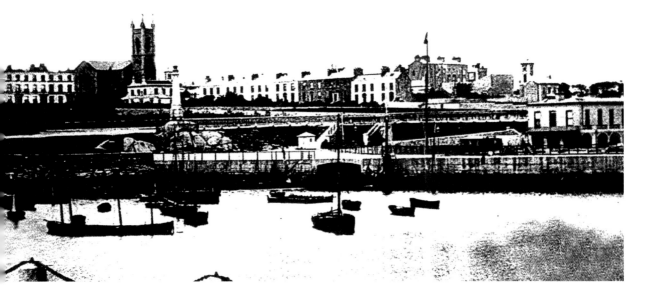

DALKEY COMMONS AND THE METALS

The superior Dalkey granite used on the main structure of the harbour, cut from Dalkey Commons by skilled stonemasons, was delivered to the harbour by a railway, connected by a continuous chain. At the height of the construction, 250 wagons of stone a day were being delivered to the harbour via this route, now known as The Metals. Other quarries used were sited at the People's Park and also the Three Churls, three substantial domes of granite found at the present-day Moran Park and Pavilion Theatre area.

The distance between Dalkey quarry to the beginning of the East Pier is around 3.25km. In 1819, the government sanctioned the building of the West Pier and the Metals railway was extended to deliver stone to the new site, a further 1.5km.

The area covered by the Metals has evolved substantially over the last 200 years, from open farmland to its current use as a popular cycle and pedestrian route in a fully developed suburban landscape. It is still possible to see remnants of the Metals on the West Pier and at the quarries at Dalkey Hill.

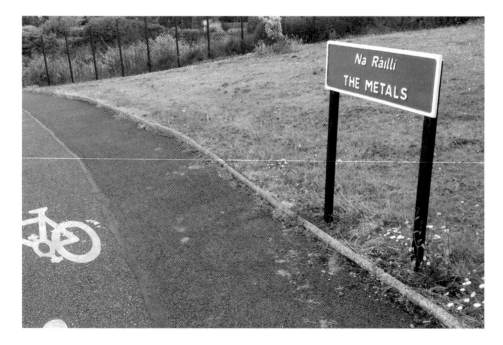

The Metals, 2017. Photo © dlr Local Studies Collection.

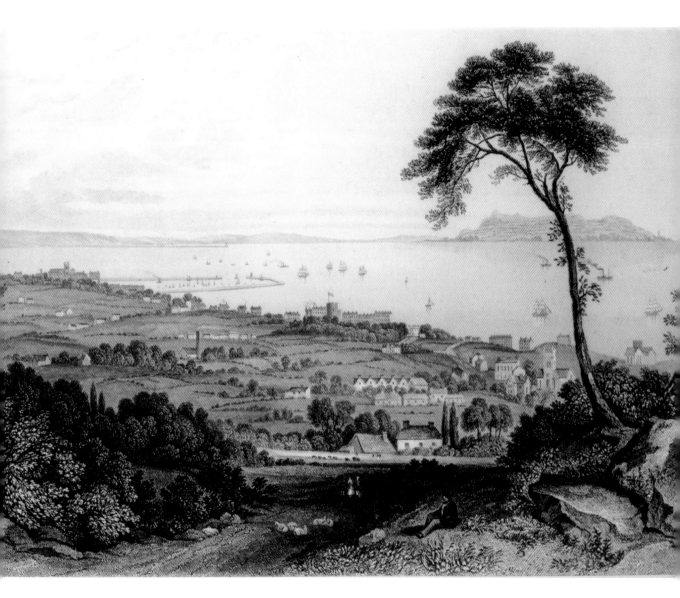

View of Kingstown and Bay of Dublin from Killiney. J. Brown /Adlard. Image courtesy of National Library of Ireland 847 TB.

Dublin Bay (from Kingstown Quarries) W.H. Bartlett/
J.C. Bentley. Photo © dlr Local Studies Collection.

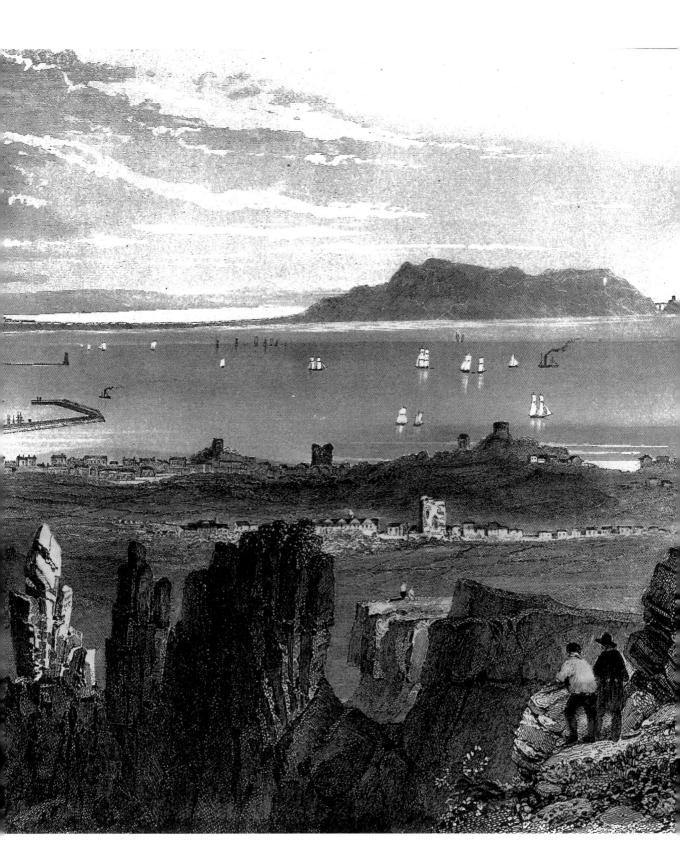

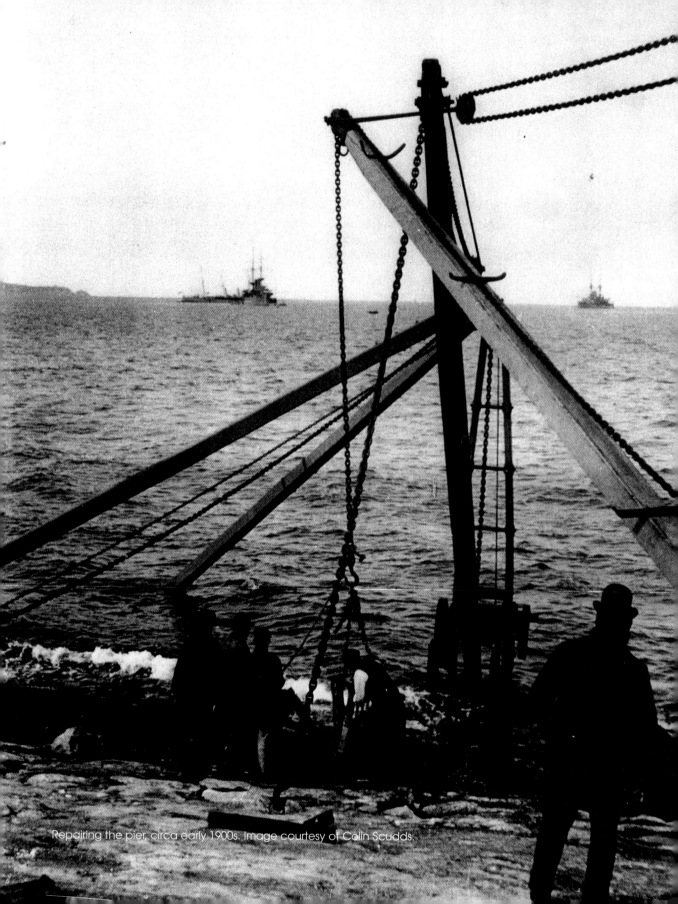

Repairing the pier, circa early 1900s. Image courtesy of Colin Scudds.

	DAYS	PER DAY	WEEK'S WAGES
CARPENTERS			
Luke Kelly (Foreman)	6¼	4/4	£1-7-1
Michael Burne	4¼	¾	14/2
William Riggs	6¼	2/8½	16/11
Pat Markey	6¼	2/8½	16/11
William Grogan	6½	2/2	13/6½
BLACKSMITHS			
John Harper (Foreman)	6	6/	£1-16-0
James Callaghan	6	4/	1-4-0
Peter Callaghan	6½	4/	1-6-0
John Hughes	6	4/	1-4-0
Robert Mooney (helper)	6	2/8½	16/3
LABOURERS			
Charles Mathews	6¾	2/0	13/6
Pat McDermott	6¼	2/0	12/6
James Maguire	6¼	2/0	12/6
Pat Donly	6	2/0	12/0
Peter Smith	6	2/0	12/0
LABOURERS AND QUARRYMEN AT BOAT HARBOUR			
John Scully	6½	2/0	13/0
Patrick Gorey	6½	2/0	13/0
Nicholas Earle	6½	2/0	13/0
Nicholas Costello	6½	1/8	10/10
Patrick Hickey	6½	1/8	10/10

LABOURERS AND PAY

In 1815, the Duke of Wellington had a decisive victory at the Battle of Waterloo, which led to a drastic reduction in the numbers of men in the army, a large percentage of which were Irishmen and they gradually drifted back home. Work on the harbour started in earnest in 1817, providing work for a number of skilled and unskilled workers. All workmen had to sign a contract which forbade them joining a combination – the forerunner of today's unions. Their work was hard and the hours long. Even a skilled man could work six days a week, while labourers often toiled six and a half to seven days a week. Many of the names and the wages they earned have survived although little else is known about their lives.

Labourers were paid 1s 8d (about 10 cents) a day and overseers 2s (13 cents) a day, for a six-day week. The chart gives a breakdown of their wages. For example, 9/2 = 9 shillings and 2 pennies. One of the earliest recorded harbour workers, Luke Kelly, employed as a Foreman Carpenter, appears in records in 1823. In that year, he worked six and a quarter days a week at 4s 4d per day, giving him £1-7s-1d per week. It is recorded in 1832, when work on the East Pier was slowing down for a time, that he was one of the few foremen kept on to oversee tools and implements but his wages were reduced to 4s per day.

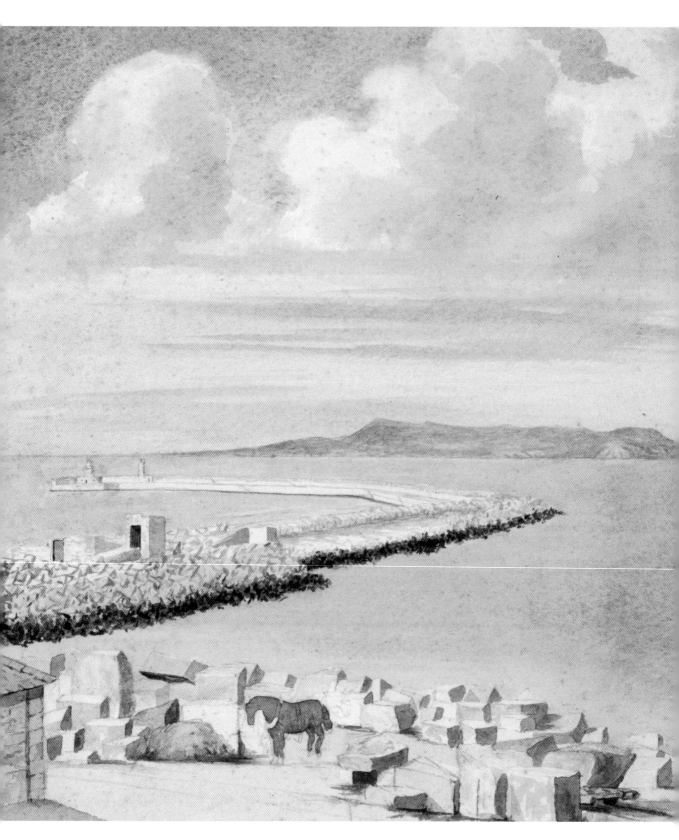

Howth Head from Kingstown. East Pier reinforcement works with horse and stone slabs in foreground. Circa early 1850s. Image courtesy of National Library of Ireland PD 3059 TX 32.

LIVING AND WORKING CONDITIONS

Many of the quarrymen lived in huts and stone cabins they had built themselves on Dalkey Commons, identified as the area from Sorrento Road, Coliemore Road, Convent Road and Leslie Avenue. Most of the homes had no sanitary facilities or running water, with drinking water drawn from local springs and wells. Outbreaks of typhus and cholera were commonplace, as were injuries, at a time when even a minor injury could prove fatal. Michael Bryon of Monkstown had lost both legs in 1828 when a large loaded truck went over his legs and they had to be amputated. In 1842, he petitioned for a new pair of artificial limbs to replace his existing pair which had worn out.

The numbers employed varied over the years but in 1823 for example there were 129 men employed by the Harbour Commissioners and 690 by the Contractor. From time to time the military had to be called in due to strikes over low pay and poor conditions. In 1823, when snow and frost held up work for two weeks, the men were laid off – no work of course meant no pay. When the Parish of Monkstown intervened and asked the Commissioners to pay something to the unemployed men, their reply was that 'the workers were well paid and had been in steady employment, so should be able to survive without pay for two weeks'. Theft from the harbour workings was such a persistent problem that every Tuesday, a court sat to try harbour-related offences.

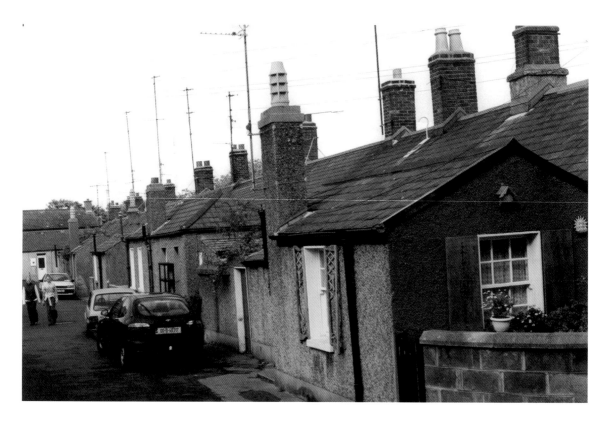

Rear of Harbour Cottages built for Harbour workers 1820-40. Photo 2002. Demolished 2005.
Image courtesy of Colin Scudds.

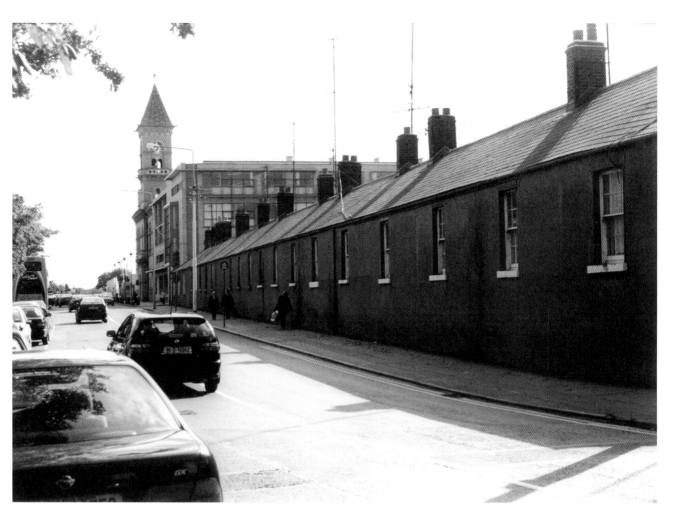

Harbour Commissioner's Cottages, Crofton Road, built 1820-40. Photo 2002. Demolished 2005.
Image courtesy of Colin Scudds.

This chapter has given an overview of the building of the pier and some of the key figures involved and of course a snapshot of the hard-working labourers involved in the gruelling business of creating what was to become one of the finest man-made harbours in the world. Throughout the rest of the book, further historical information will be included, whether it is a focus on Carlisle Pier or Harbour House in Chapter 5, the royal visits during the nineteenth century in Chapter 6 or the ferocious storm of 1861 in Chapter 7.

When the new dlr LexIcon opened in late 2014, the architects Carr, Cotter & Naessens inscribed a map of Dún Laoghaire into the concrete, high up on the wall overlooking the study spaces on Level 4. They have described just how the pair of crooked, angular piers dominate the town and have drawn parallels with how the experience of walking the piers has something in common with the experience of navigating the library.

In this book, we hope to take you on a similar journey, glancing over our shoulder every so often at the rich history of the last 200 years while we enjoy the stories of today.

'The piers lead you out, away from the town, not in a straight line (like a jetty would) but indirectly. Pavilions and viewpoints are dotted along the way, allowing for a change in pace, a look around. On reaching the end, following the winding form of the pier, you are just as likely to be facing back towards the townscape as out towards the sea.'

'Perspective and parallax in the LexIcon' by Luke Naessens (from Carr Cotter & Naessens Architects *dlr LexIcon, Dún Laoghaire*)

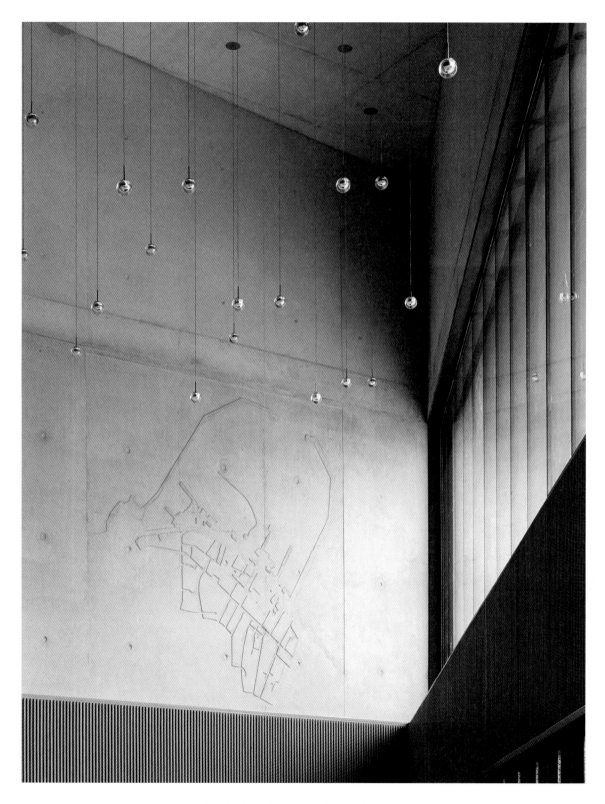

Photo © dlr Local Studies Collection

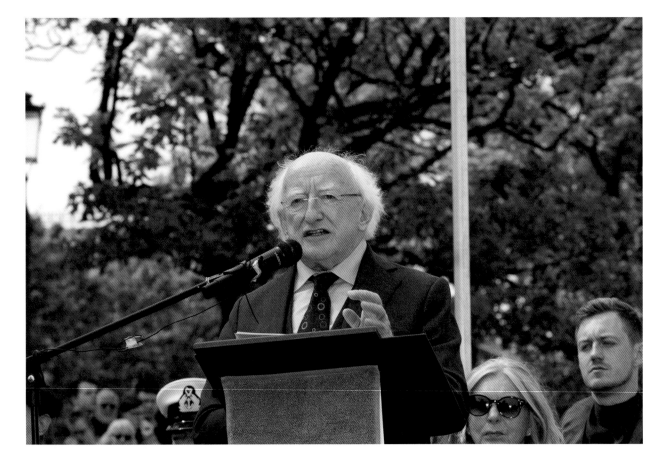

President Michael D. Higgins in Dún Laoghaire on 31 May 2017. Courtesy of Peter Cavanagh.

CHAPTER 2
A BICENTENARY YEAR ON THE PIER

A VISIT FROM PRESIDENT MICHAEL D. HIGGINS

A defining event of 2017 was the visit of President Michael D. Higgins to Dún Laoghaire Harbour on 31 May to celebrate the laying of the first foundation stone 200 years earlier for what would become the iconic East and West Piers. It was during the President's stirring speech on that day, amidst the roar of cannons and the boom of marching bands, when he urged those gathered to preserve the past and present for future generations, that the concept for the People on the Pier project was conceived.

> *'Just as we are all custodians of history, recipients of stories, anecdotes and accounts of the past, handed on to us by previous generations, so also we are recorders of the present moment which will craft what is yet to come.'*
>
> President Michael D. Higgins, 31 May 2017

On the anniversary of the laying of the foundation stone, the President was accompanied by a guard of honour from the RNLI and Coast Guard and a time capsule was placed at the King George IV monument overlooking the Carlisle Pier. The capsule holds letters from local schoolchildren, photos of the harbour in 2017, notes from people who use the harbour and a copy of the day's print edition of *The Irish Times*. Apparently another time capsule was placed in this area back in 1817! *The Freeman's Journal* of 31 May 1817 reported several 'coins of the realm' and newspapers were placed into a glass time capsule, and inserted into 'a specially prepared hole in the foundation stone' by the then Lord Lieutenant of Ireland, Charles Whitworth. However, to date the original time capsule has not been found but is assumed to be near the present-day George IV monument.

During the bicentenary celebration, an overhead fly past was performed by the Defence Forces and the event was completed by a twenty-one-gun salute, fired from the gun battery at the end of the East Pier.

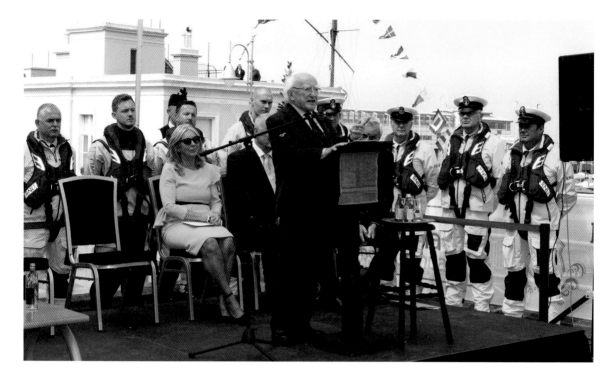

Photo courtesy of Peter Cavanagh

Photo courtesy of Peter Cavanagh

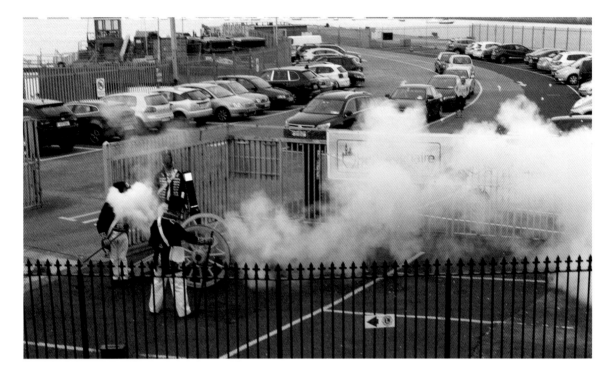

Photo courtesy of Peter Cavanagh

Library staff Seán Downes, Brenda Carey, Vita Coleman and Robert Murphy on the pier on
31 May 2017. Photo ©Local Studies Collection

A YEAR OF CELEBRATIONS

The President's visit heralded the beginning of a major calendar of events to mark the 200 year anniversary for posterity. These included dlr LexIcon's Bicentenary of Dún Laoghaire Harbour exhibition and numerous Dún Laoghaire Harbour Bicentenary events, many partnered with Dún Laoghaire-Rathdown County Council including: the International Harbour Food Festival featuring over twenty-five unique venders, the Vintage Carousel Company, an exhibition of paintings by Peter Pearson in the former ferry terminal, the WillFredd Theatre Harbour 200th Birthday Party

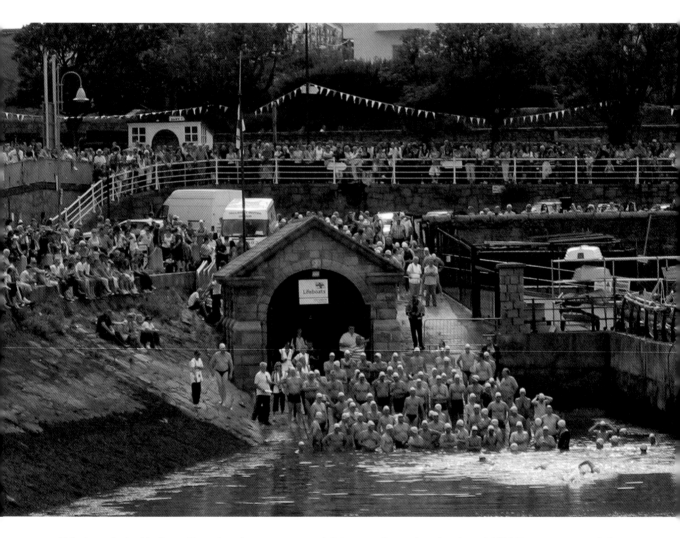

Dún Laoghaire Harbour Race has been an annual fixture on the calendar since 1931! Photo courtesy Dún Laoghaire-Rathdown County Council Communications Office.

at dlr LexIcon and, on the pier, the Viking Invasion (a re-enactment with longboats), the Dún Laoghaire Harbour Rally and Harbour Lights, a literary evening with local authors Bernard Farrell, Declan Hughes and Julie Parsons. A variety of walking heritage tours took place throughout the year, expanding and promoting local and tourist knowledge of the events. The photos on these pages give a flavour of the incredibly exciting programme of events for the many national and international visitors to Dún Laoghaire. Towards the end of the year, dlr Writer in Residence Sarah Webb produced the exhibition I am Dún Laoghaire, created by her LexIcon Young Writers' Club. The grand finale was the projection of photos from the People on the Pier project onto the side of the LexIcon on 6 December 2017.

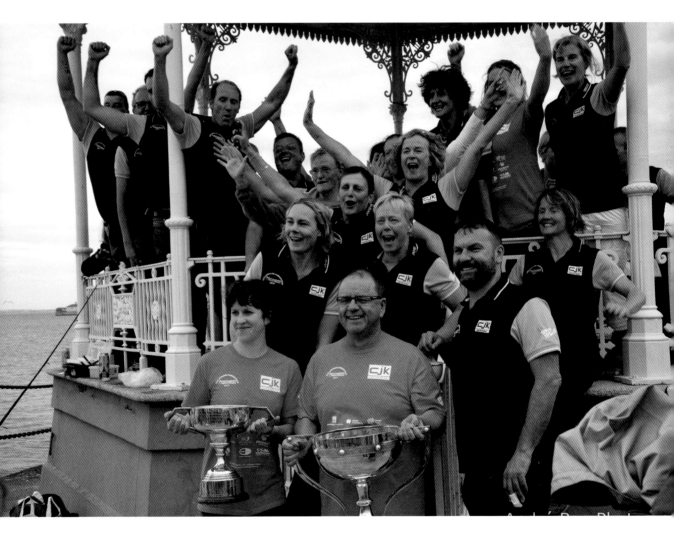

Photograph of many past winners of Dún Laoghaire Harbour Swim taken at the bandstand in 2017.
Courtesy André Ray and Sandra Trappe, librarian and former champion (1990 and 1991).
Sandra is in the top right hand corner!

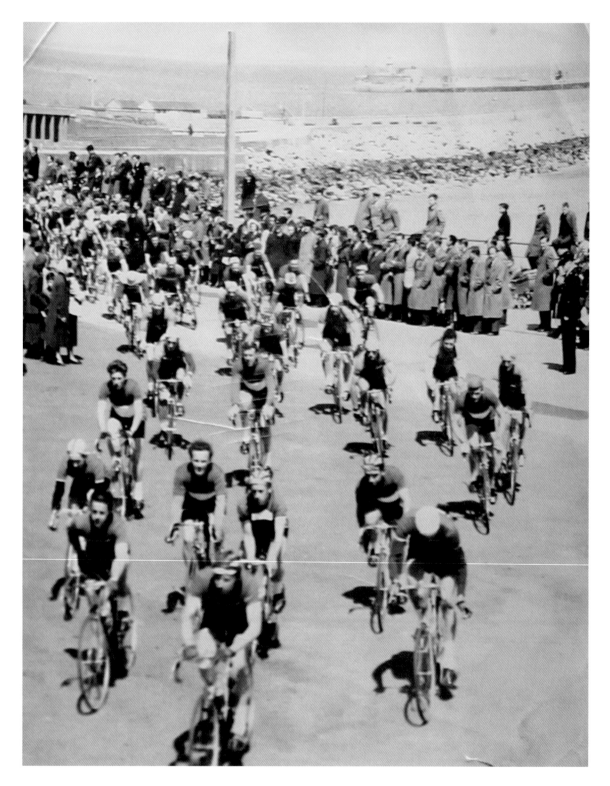

Dún Laoghaire Cycling Week 1950s. East Pier in background. Photographer was 'McKeown of 10 Idrone Terrace, Blackrock'. Courtesy Con Enright.

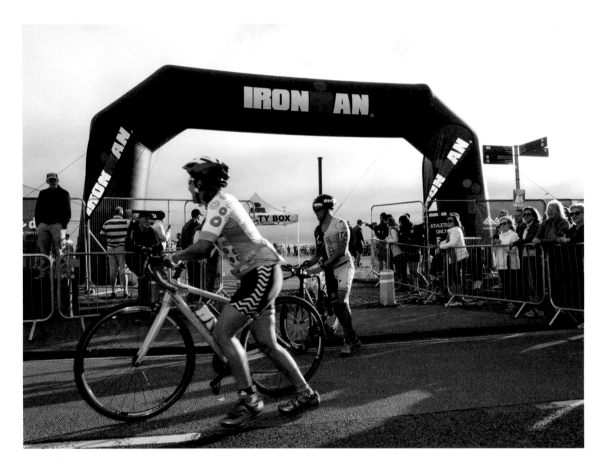

IRONMAN. A cycling competition with a difference. Second leg of the competition at Newtownsmith. Courtesy Peter Cavanagh.

Vintage Carousel at old Ferry Terminal, 2017. Photo ©Local Studies Collection

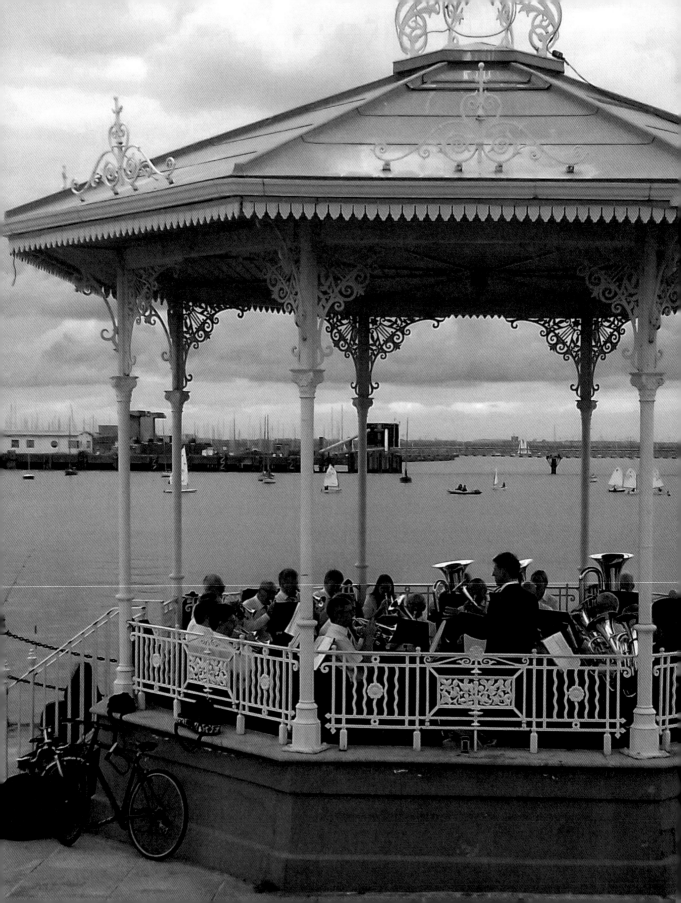

On 27 August 2017 the Stedfast Brass Band returned to the bandstand on the East Pier for a concert of maritime music and sea shanties. Photo ©Local Studies Collection

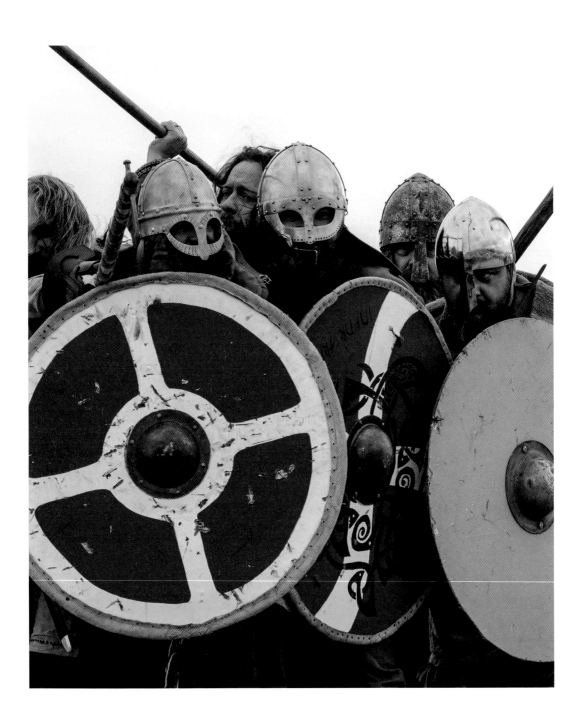

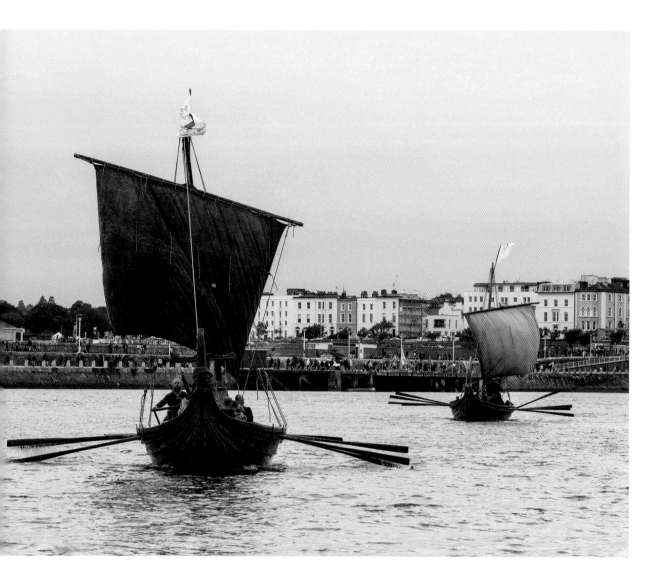

Viking Invasion August 2017– The Irish National Sailing & Powerboat School has been the marine services provider to the hit TV series "Vikings" and was delighted to bring replica longboats, a Viking village and the Vikings themselves to Dún Laoghaire Harbour's East Pier. One of the many Dún Laoghaire Harbour Bicentenary events. Photos courtesy Peter Cavanagh.

BICENTENARY EXHIBITION AT DLR LEXICON

On a gloriously sunny May evening, the Dún Laoghaire Borough Historical Society, in association with dlr Local Studies at dlr LexIcon, launched an impressive exhibition to mark the bicentenary. Scheduled to run until the end of July 2017, it was so popular that it was on display for the entire year until the end of May 2018 and is also available permanently on the dlr Libraries website. Many of the images used in the exhibition have been reproduced in this book.

Cathaoirleach Councillor Cormac Devlin launched the exhibition, which was curated by Colin and Anna Scudds, on the 4th floor of dlr LexIcon, overlooking the pier which provided a splendidly apt backdrop. The Society's first meeting was held in April 1978 and their aim has always been

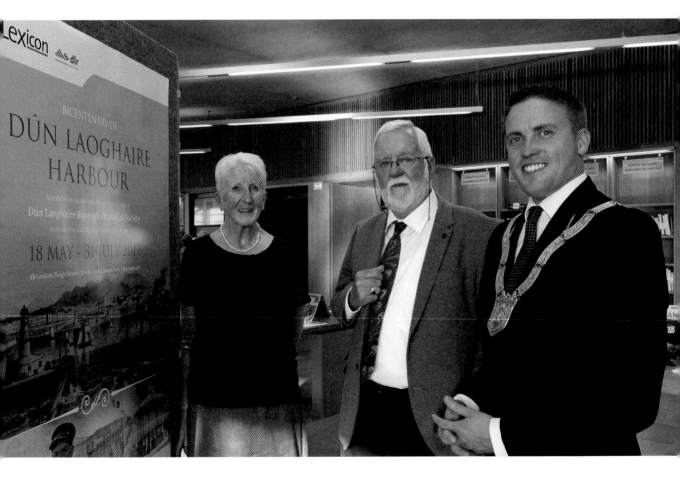

Left to right: Anna and Colin Scudds with An Cathaoirleach Councillor Cormac Devlin.

to promote and sustain an interest in the culture, heritage and history of Dún Laoghaire. They host monthly meetings and have produced more than twenty-one journals to date including the bicentenary special entitled *A Safe Anchorage: Dún Laoghaire/Kingstown Harbour 1817-2017*.

The exhibition tells a marvellous tale – full of high drama, colourful personalities, shipwrecks, gruelling working conditions, royal visits, hulk ships and of course the diaspora – in which thousands of Irish people sought employment and brighter opportunities as they boarded the ferry from Dún Laoghaire, and for many it was to be their last glimpse of Ireland. It takes a leap of the imagination to recall what old Dunleary looked like 200 years ago, but the exhibition provided many rarely seen photos and maps of the area and it included a clear timeline covering the 200 years.

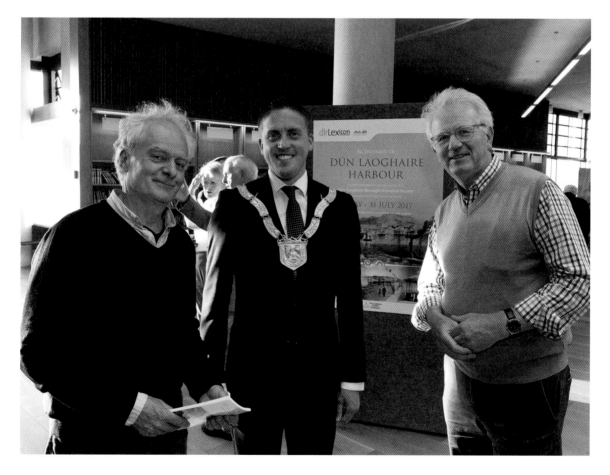

Left to right: Peter Pearson, An Cathaoirleach Councillor Cormac Devlin and Séamus Cannon.
Photos courtesy Peter Cavanagh.

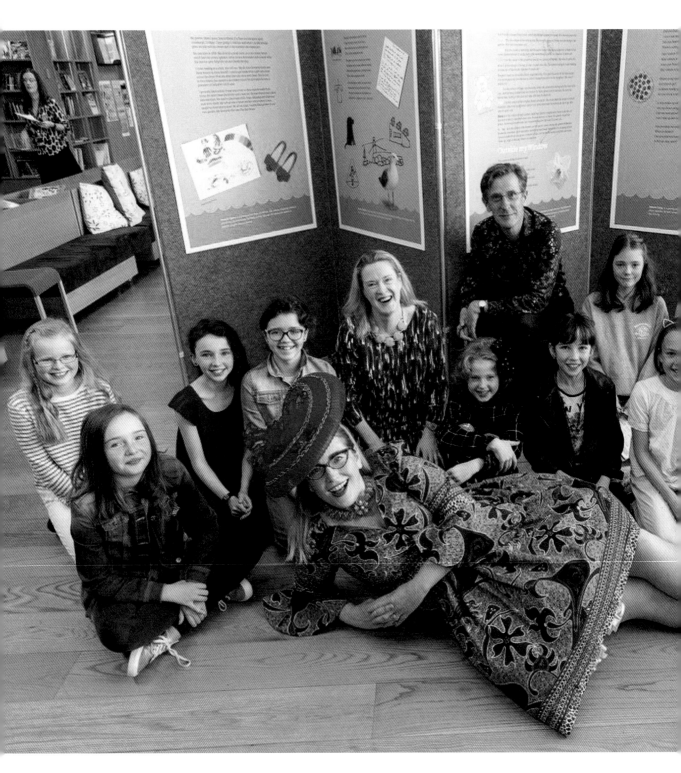

Sarah Webb in back row with members of the LexIcon Young Writers' Club and visiting authors Sarah McIntyre and Philip Reeve who launched the exhibition during the Family Day in October 2017.

Author Sarah Webb was dlr Writer in Residence 2016–2017 at dlr LexIcon. One of her many projects during her residency included the setting up of a Children's Writing Club. For several months, the children worked on the theme 'I am Dún Laoghaire' as part of a celebration of the 200th anniversary of Dún Laoghaire Harbour. The children wrote a variety of poems, prose and intergenerational memoir. Following a visit by poet Lucinda Jacob, the children, with the guidance of Lucinda and Sarah, produced their wonderful poem 'I am Dún Laoghaire'. This provided a centrepiece for the exhibition of their work which was on display in dlr LexIcon from October to December 2017.

I am Dún Laoghaire

by the LexIcon Young Writers' Club

Who am I?
I am tall red buildings that fit like a jigsaw,
I am the lime-green 46A driving along the road,
I am car lights flashing with no-one inside,
I am the children screaming for sweets,
I am mothers with buggies struggling through doors,
I am toddlers running around People's Park,
I am grey-blue sky with a tree like a hill,
I am birds flying in a cheerful manner,
I am rain falling from the dull cloudy sky,
I am the seagull waiting up high for the unlucky person below,
I am noodles with duck, oh how yummy I am!
I am a seagull snatching a sandwich from a child,
I am the willowing trees gliding from side to side,
I am busy shops and restaurants full of people,
I am the hungry pigeon looking at the waffles, yum!
I am the ship-shaped library that touches the sky,
I am books in the LexIcon waiting to be read,
I am dogs pulling their owners by,
I am the waves that crash against the East Pier,
I am red and blue trawlers full of fish,
I am the jelly that sits on top of the ice-cream,
I am the rocks and the waves and the sea,
I am swirly ice-cream, I look great.
I am Dún Laoghaire.

dlr
Comhairle Contae Dún Laoghaire County Council

Created with the help of Sarah Webb, dlr Writer in Residence 2016-2017 and poet, Lucinda Jacob during Sarah's residency.

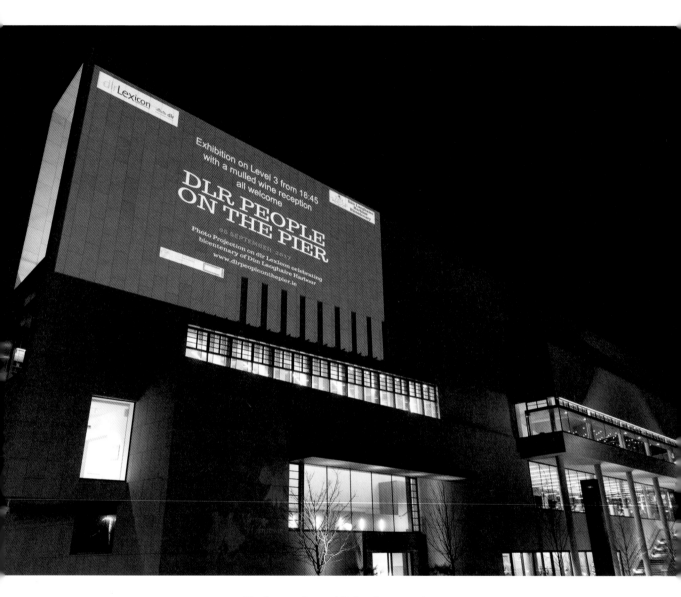

Photo courtesy of Peter Cavanagh.

PEOPLE ON THE PIER DECEMBER CELEBRATIONS – PROJECTION IMAGES.

On 6 December 2017, dlr LexIcon hosted an exciting digital exhibition featuring images taken from the People on the Pier photo files gathered since June. Over 200 images were beamed onto the side of the building outside, a glittering finale coming into the Christmas season and in the LexIcon Lab 300 more collaged images were on display until the New Year.

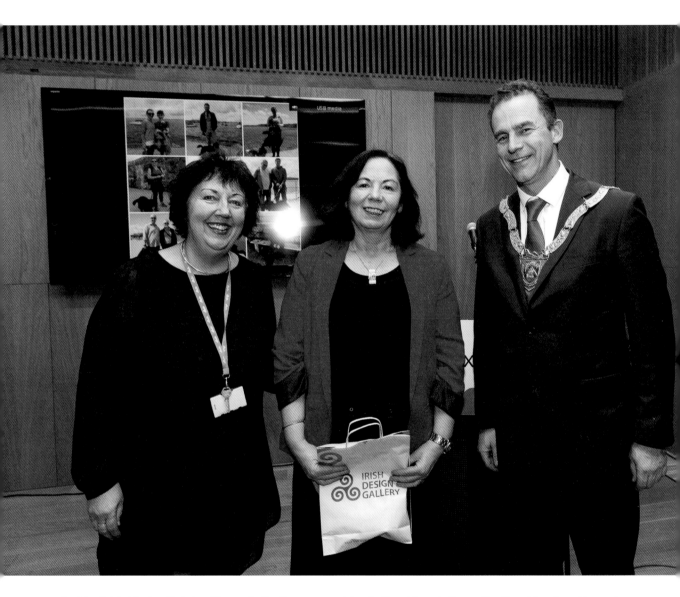

Left to right: Marian Thérèse Keyes, Betty Stenson and An Cathaoirleach Councillor Tom Murphy at launch of People on the Pier Projection evening. Photo courtesy Peter Cavanagh.

Three hundred People on the Pier images were on display in dlr LexIcon as a digital exhibition until end of January 2018. Photo arrangement ©Local Studies Collection

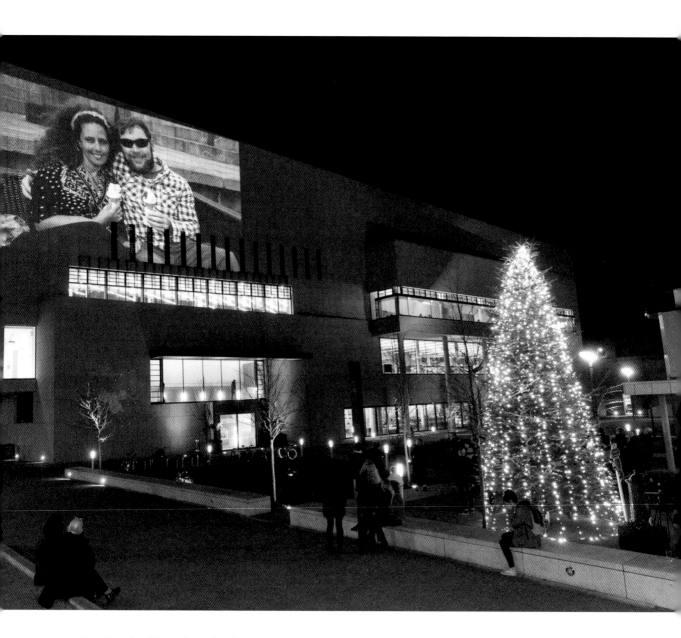

Two hundred People on the Pier images were projected onto the exterior of dlr LexIcon. It was a spectacular sight illuminating the night on 6 December 2017. Photos courtesy Peter Cavanagh.

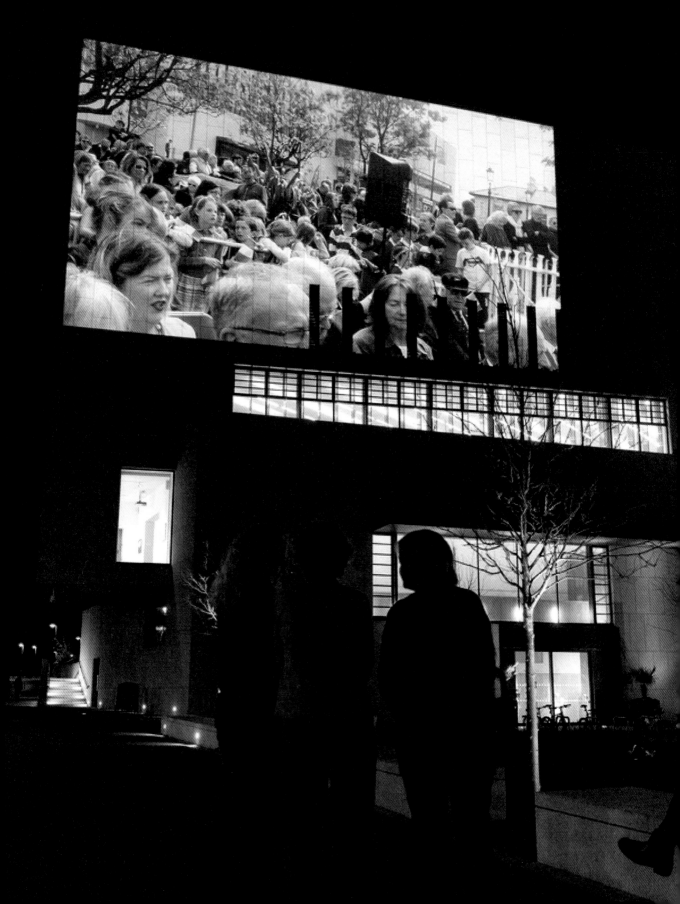

The Keegan Family

CHAPTER 3
FAMILIES AND FRIENDS ON THE PIER

Many will recall the thrill of handing in their film to the pharmacy to be developed and waiting in anticipation to see what sort of photos had been produced, in the pre-digital days when taking a good shot was mainly down to luck and a smattering of skill. Still, the majority of prints made it to the family album and are treasured precisely for their quirkiness as well as for the happy memories conjured up by them. But red eyes and blurry shapes are now a thing of the past as can be seen in the wonderful selection of photos on the pier being celebrated here.

Accompanying these images are stories from people with deep-rooted connections to the pier: seafaring families who go back generations and whose lives and family histories are inextricably linked to the sea and to Dún Laoghaire. There are accounts from families who have crossed distant seas and taken long voyages to make Dún Laoghaire their home and from some who have returned home from abroad for family reasons. Others have navigated deeply personal and emotional journeys and return annually to commemorate loved ones and happier times on the pier. Some, like Megan Crose, have told of their heartbreak at having to move on but who are grateful to have taken with them treasured memories made in this unique corner of the world.

Photos in this family album span the generations, from one-week-old Ruairí Conroy on his first outing to the pier in summer 2017 to ninety-two-year-old Teresa Keyes, a local resident who has been visiting the pier since she was a slip of a girl. The oldest family photos are of Fidelma Furney and family visiting the pier in 1942 and taken with her father's Brownie camera. Little proof is needed that all human life is here, from Tao Li of Xiamen in Southeast China, who on a one-year student exchange fell in love with Dún Laoghaire the first time she visited, to Lauren and Blake Newman, with their two girls Harper and Lily, who are originally from Texas and already professing that Dún Laoghaire has a special place in their hearts.

For many, walking the pier is something of a family tradition, with parents bringing their own youngsters out at an early age, retracing past footsteps and making new memories. It's an intergenerational pleasure too for those like the Bentley and Guinane families, with mum Mary, daughter Megan and Grandmother Ellen enjoying a nostalgic trip to the pier before Megan headed to university in Australia last year. Indeed, for those enjoying retirement, the grandchildren may be excited at the prospect of an outing to Dún Laoghaire, perhaps rightly assuming that the mile-long walk to the end of the pier and back (you have to go right to the edge and wave to the passing boats) will be

rewarded at journey's end with some fish and chips and maybe a Teddy's ice cream. For Mary White's birthday, that's exactly what happened when she and family took the number 63 bus from Kilternan for a novelty trip. Of course, food never tastes as delicious as when consumed here on the pier, flavoured with the salty sea air, with the accompanying music of the haunting cries of gulls!

Enjoy your 'scroll' through the People on the Pier Family Album. Before you know it, you'll be tempted to take a stroll on the pier too!

FRIENDS ON THE PIER

A walk down the pier with a friend might sometimes include two journeys: an emotional journey as well as a physical one. The curative properties of exchanging confidences whilst out walking side by side, eyes to the fore, without having to meet the other's gaze is well-known; it's almost like being in a confessional! The brilliant expanse of sky and sea surrounding you may make your troubles seem more insignificant or may make you more open to sharing them. Striding out together in solidarity with a brisk breeze coming in from the Irish Sea is almost a guarantee to clear the head whilst bringing some clarity to conflicting thoughts.

Of course, chances are that you're sharing happy news and your feet will be literally dancing down the expanse of pier and back as you announce the prospect of the patter of tiny feet, the first class honours exam results, the coveted new job, the bank saying 'yes' to your mortgage application, the successful visa application. These walks are frequently followed up by a celebration, and why not – whether it be a coffee in one of the many fine cafés and restaurants in the town, a long lunch or a glass of champagne in the Royal Marine or in one of the many local yacht clubs.

So who are the friends who walk on the pier? Among others are Deirdre Dargan and Ann Cavey, who have been friends since early childhood with happy memories of Saturday trips to the pictures in 'The Pavilion'. They have been sharing their stories and strolls here for almost forty years, while Blas Molina and Maria Rodriguez, over from Spain and working in Dublin, are good friends who enjoy spending time together sharing their passion for running. These and many more friends share quality time here on the pier.

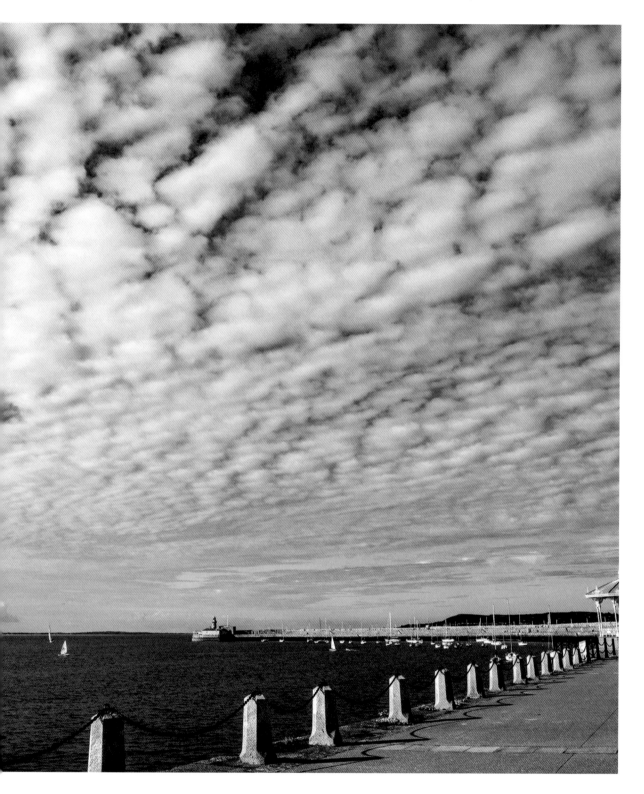

Photo courtesy of Dave Keegan.

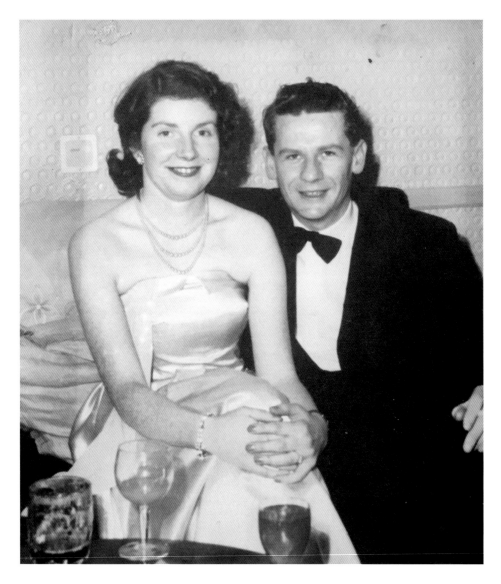

Above: Florence & Dan Engagement Party 1954 in Royal Marine Hotel

FLOR MACCARTHY: PIER PRESSURE

She's radiant in a strapless satin gown; he's all James Bond tuxedo – I've always loved this photo – 'Florence & Dan, 1954'. What I hadn't realised until recently is that my parents too had been drawn, like I am, to Dún Laoghaire's East Pier. After all, they chose the Royal Marine Hotel as the venue for their engagement party. (And that, as they say, is pure coincidence).

I'd no idea of this link when I migrated from West Cork as a student. Nor when we finally moved to Dún Laoghaire in 2005. My husband, Paul Cunningham, was born here (in what was formerly a nursing home, now the car park of St Michael's Hospital!). But I'm a blow-in. An imposter. Not qualified to call this place home.

Then again, if 500 (return) trips down the pier counts for anything, I refuse to feel that particular peer/pier pressure.

The East Pier lures us at sunset, at sunrise (less often), at last light on New Year's Eve, for hijinks at high tide. Down here we've kissed and made up, planned faraway trips, held small hands, leant a shoulder. We've skated, scooted, sailed, and skipped; we've kayaked, jogged, cycled, and danced our way up and down the East Pier, in all weathers.

Here, 'down the pier', we've met new friends and old flames, West Cork nuns and Eastern European fishermen; Edna O'Brien, Pierce Brosnan (a real-life James Bond); we've witnessed the big days (Hurricane Ophelia), the celebrations (Annalise Murphy's Olympic homecoming) and the little moments (watching as the wind whipped our blue baby blanket from the buggy and sailed it up into the sky).

Below: Rock-hopping Isabelle & James

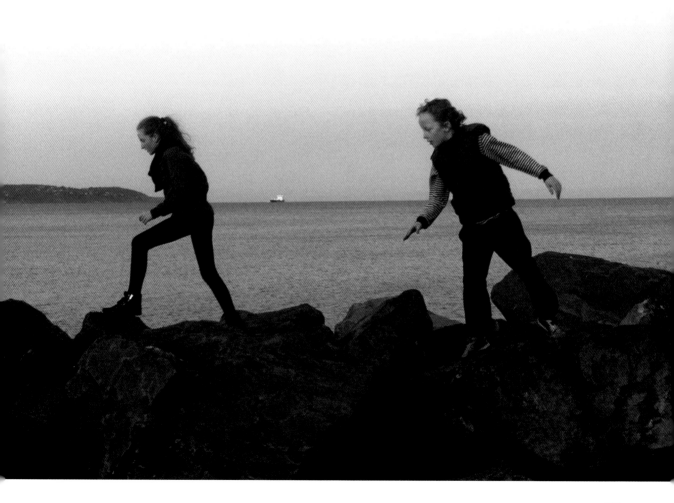

We know the shipwreck stories, we remember the ro-ros at Carlisle Pier, and we're regulars on the Dublin Bay Cruise home from Howth, disembarking at the East Pier just in time for Ouzo's fish & chips. We've watched as dlr LexIcon rose like the bow of a ship to join the Pavilion and National Maritime Museum on our skyline. Now we watch the old/new Dún Laoghaire Baths take shape.

We did abandon ship once, to live in landlocked Brussels – we'll never again live far from the sea. Life around this granite East Pier world ebbs and flows; it can't be captured in a single photo. And that's what brings us back, day after day, time and time again.

Rollerblading with Dad

Barry MacCarthy (Flor's brother) and son Charles

ADRIENNE DONNELLY WITH LORRAINE JAMES AND FAMILY

I met Lorraine James in Dance Theatre of Ireland in 2007, as we both attended dance classes there and we later also attended CoisCéim Dance classes in the city and we became good friends. 2008 was the year that I moved in to my first very own home, my mother had the first of her three strokes and that Lorraine came in to my life. She made me laugh – which is exactly what I needed in between dealing with my mother's ill health, getting used to a new job and a new home. Her children's names are Louis Jr, Conor, Anna and Jonathan. All four children are very talented at acting, singing and playing guitar, keyboard and drums. I am delighted to be their honorary aunt and am made to feel very much part of and involved in their family activities. Christmas morning is always wonderful in their home every year! Lorraine is originally from the UK but has been living in Dún Laoghaire since 1996 – two minutes from the top of the East Pier.

We have all had numerous walks up and down the pier in the last 11 years and the 'children' have grown quite a bit since this East Pier photo was taken in 2010.

MANDY SMITH

Sometimes when we walk the pier the sky is bright. Our moods may be heavy but somehow the blue light lifts us. Sometimes we walk the pier whilst the sea appears bruised and grey. We might set out laughing and come back glad but pensive. When the sky is aqua and the sea the same, and our weeks have been good for us, the whole experience is serene. I am grateful for all these walks.

I live and work in Blackrock, with Dún Laoghaire drifting into my consciousness at the weekend. I relax in its expanse of seascape, which reflects human life and puts perspective on mortality. It becomes my second home. Inhabited by my partner Tom and many favourite haunts, it also holds memories. My dog Rudy once walked with me, and one day another dog might.

I knew Dún Laoghaire before I knew Tom, but since walking it with a native, my perception of it has changed. Tom has his own passion for the place. A great explainer with a sharp mind and an artist's eye, he tells me its intimacies, animating the characters and their stories. We talk as we walk.

Dún Laoghaire, you are being found out!

We met Mandy Smith and Tom Morgan twice on the East Pier taking their usual Saturday morning stroll. Both were excellent examples of the invigorating and health-giving properties of a regular ramble on our favourite thoroughfare!

'In 2002, after personal tragedy, I was inspired to leave my thirty-year career as a barrister and go paint. Something I always wanted to do. Travels to exotic places, including Tahiti on the trail of Gauguin and a sojourn in a studio on the River Nore, were followed by my return to Dún Laoghaire where I settled close to the People's Park in 2005.

I have lived most of my adult life within the petticoats of Dún Laoghaire-Rathdown. I maintained a studio in the Old Fire Station on George's Place until 2015 and walked the Pier on my way to work each morning. I then moved my studio home to behind my house.

I met Mandy in 2012. We walk the pier together on the weekend. Romantic events. Midweek I walk the pier alone or with fellow curmudgeons to solve the Nation's problems.

As an upper deck walker, I remain hopeful that the Storm Emma damage will be fixed up soon.

The East Pier is an identifying feature in my life. Rain or shine it is central to where I belong. My home place.

A high point for me as an artist was to have my work *Refuge* chosen for the biennial open exhibition "Arrival" at dlrLexIcon in 2017/2018 and then to have that work bought into the County Art Collection at Dún Laoghaire-Rathdown County Council.

I find a fruitful symbiosis to it all. The continuing cycle between Dún Laoghaire and the pier, my work and me. Instagram @tommorganart'

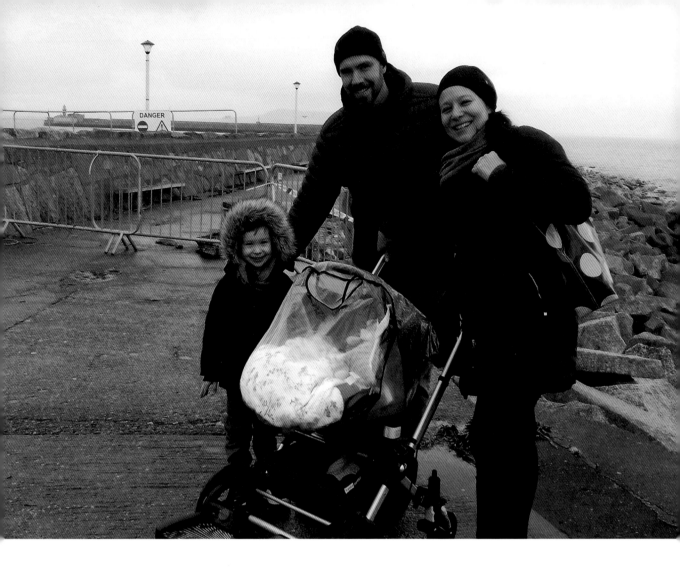

ALICE NGUYEN HOANG

Alice Nguyen Hoang and Feargal Keyes are frequent visitors to Dún Laoghaire as Feargal's father and grandparents were from the area but they are both natives of Belgium where they live now. On their regular visits to Ireland, they always spend time walking the pier, come rain or shine, bringing their son Owen and most recently their baby daughter Orla! On this occasion, not long after Storm Emma, they were shocked to see how the storm had affected the coastline along this much-loved walk.

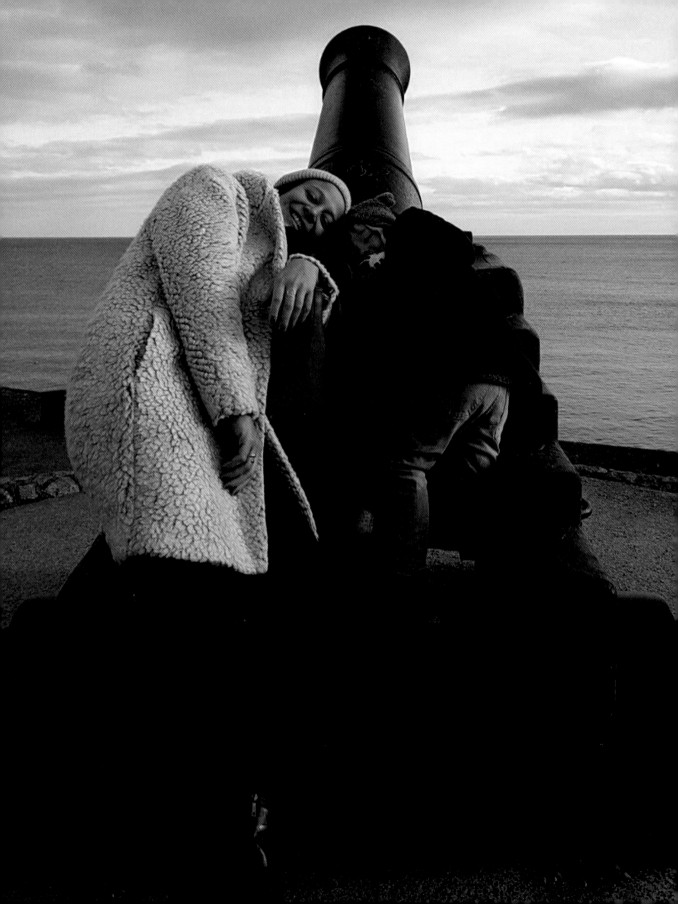

PHOTO BY ALICE NGUYEN HOANG

FIONA DORIS AND HER SISTER JACKIE REDDING

'Is it possible to have a love affair with a place? I think so. Because I really, really love the Pier. It is part of my DNA. Growing up in nearby Mount Merrion meant rarely having a day without a glimpse of the sea. Since as far back as I can remember my family and friends have walked the pier in all seasons and all weathers. As a child, I thought that everyone's family took their visitors to walk on the pier, swim in the Forty Foot and get a 99 in Teddy's. As a teen I learned to walk my moods and "problems" off the East pier. The walk would start gloomy and heavy, lightening as I walked past the bandstand then brightening completely by the turn at the lighthouse. Sometimes the weight would descend again as I passed by the cannons at the start of the pier but more often than not, the walk helped with the blues, the "blahs" and the panics.

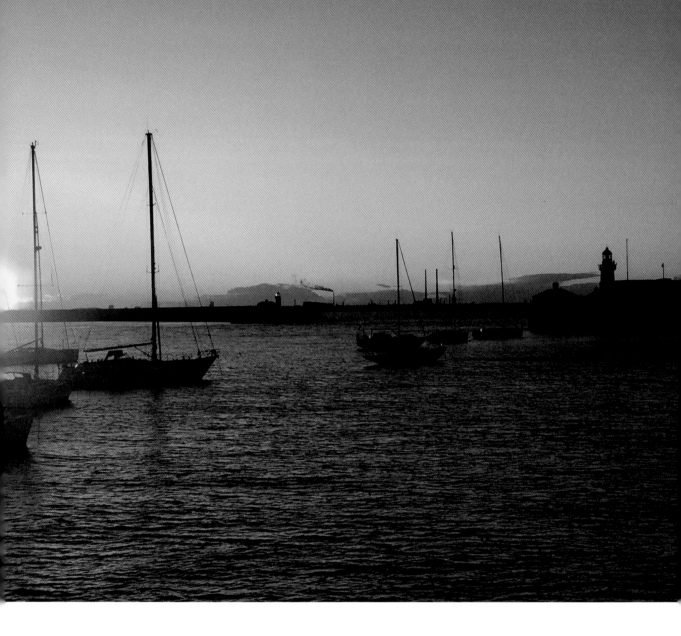

'Every close friendship I have enjoyed (including some romantic attachments) was exercised extensively on the piers. Whenever I left Ireland for work or study there was always a teeny-tiny ball of unease inside. Not so much homesickness as a sense of something missing. On returning home I would visit the pier as soon as I could. The smell of the sea, the ever-changing skies and light, the cries of the seagulls, the sounds in the harbour of gently lapping water, the cow-bell-like tinkling of the masts on the small yachts and boats in contrast to the crashing waves on the other side of the pier ... all those together were the missing piece. I was whole again!!! I needed the sea, I needed Dún Laoghaire Pier.'

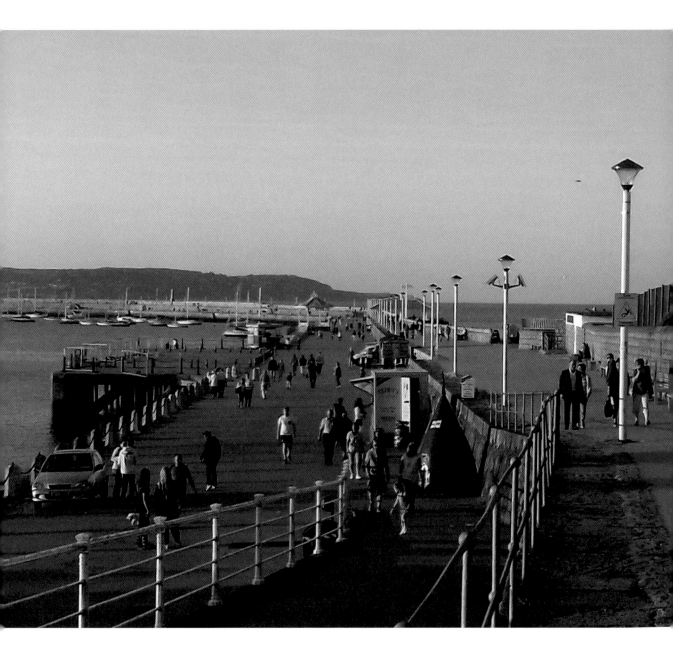

ANN MARIE AND DAVID LAWLOR WITH GRANDSON MATT

'I am from Glasthule and always loved walking the pier. Now that I am in my sixties I walk there with my grandchildren! I can remember going to the pier to wait for the mail boat; it was so exciting to see everyone getting off the boat coming from England for summer holidays and other reasons. I've always loved the scenery here, you can see Sandycove and Howth. I now live in Loughlinstown and I still love to walk the famous pier!'

PEERING FROM THE PIER (PHOTO BY JON KELLY)

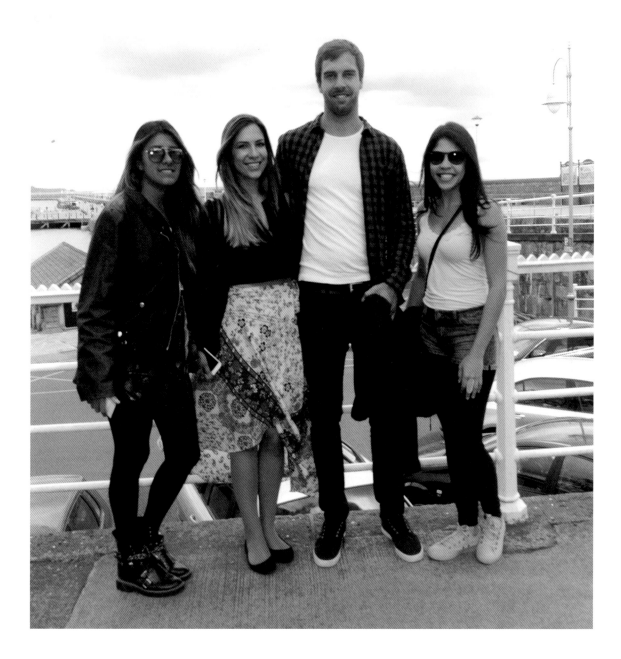

MAYARA AND FRIENDS

SPANISH STUDENTS (PHOTO BY JON KELLY)

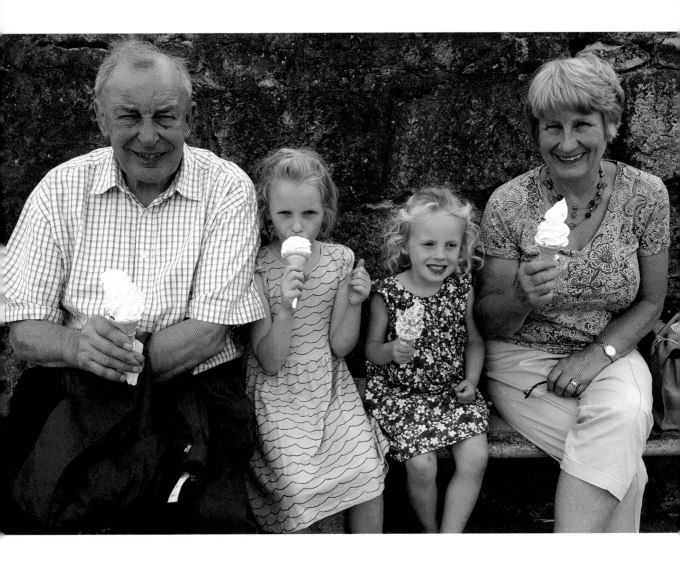

MARY WHITE

'Asked what I'd like to do for my birthday last July, I opted for an outing with an ice cream included! Dún Laoghaire was the chosen destination – we'd taken our children there for many walks on the pier and also to swim at the old baths. So, after our two granddaughters, Isla and Niamh, had finished their summer camp we got the number 63 bus from Kilternan which took the scenic route to Dún Laoghaire. This was a novelty in itself! There was plenty to watch around the harbour, including yachts out racing, and time to sit and enjoy our ice creams on the pier before heading home.'

RENEE & TOM O'ROURKE

'I'm a country girl living in Dublin over forty years and I have been walking the pier since then. I look on it like a "mini holiday" as it's so nice and coastal and therapeutic. Tom also gravitates towards the coast and of course Teddy's ice cream!'

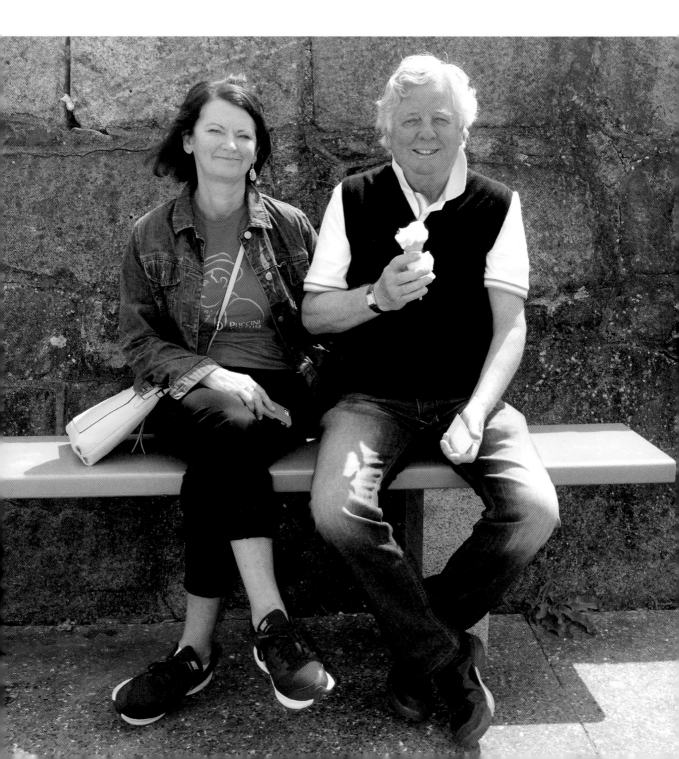

Teddy's iconic ice cream has been a great attraction for generations of visitors to Dún Laoghaire since 1950. Photo ©Local Studies Collection

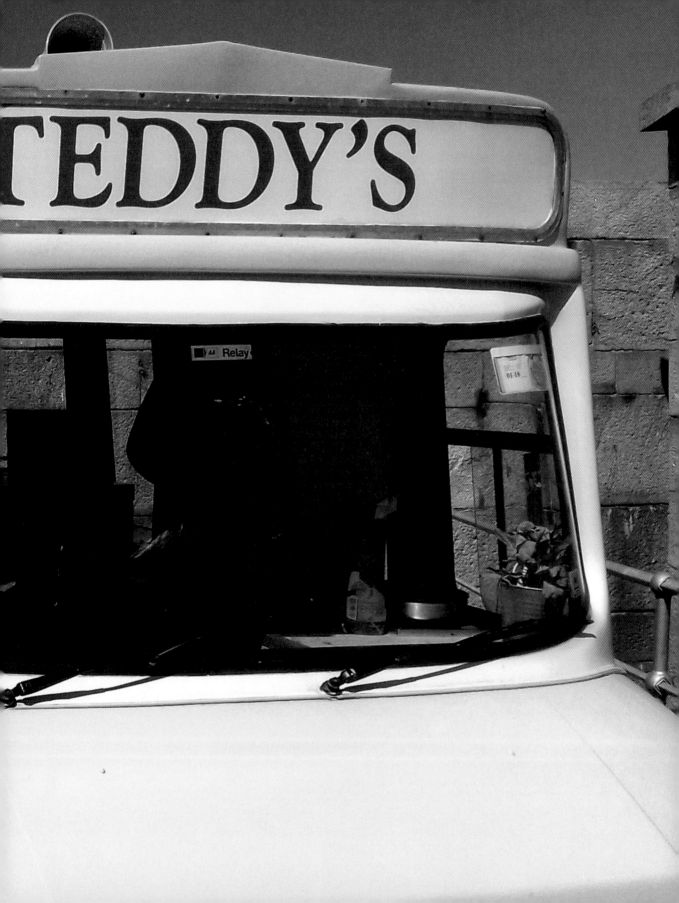

'My mother's side of the family were all seafaring people from Dún Laoghaire so the pier has always been a big draw for us, whether it was seeing relations off on the boat or a swim in Scotsman's Bay. It seems to be a family tradition to walk the pier, I think we find a kind of peace there, I know my husband Ger liked nothing better than a quiet walk to get the old mind free from the usual stresses of work. And now it's time to bring the new generation of our grandchildren down and show them what a beautiful and peaceful place the pier is.'

Left to right: Ann McCoy, Anne Keegan and Jackie Mooney.

Above: Philip McCoy & son Charlie

Below: Ger Mc Coy

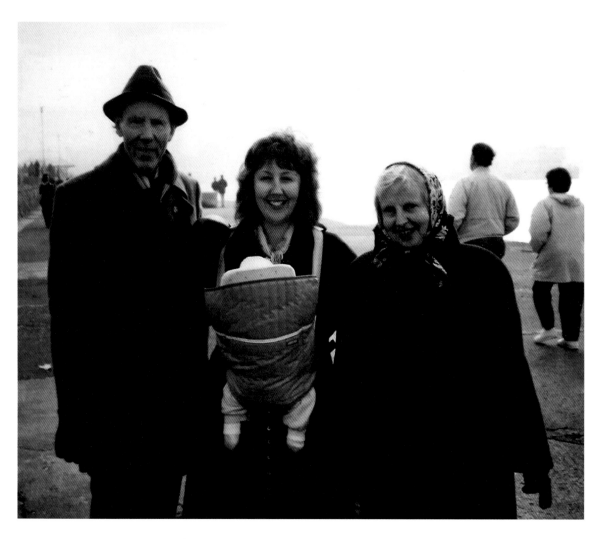

Left to right: Tom, Marian, Nora and Teresa Keyes.

TERESA KEYES

Teresa Keyes has always enjoyed her walks down the pier. Born in 1926 and now aged ninety-two, she grew up in Marino but she loved to come out on the bus with her friends to walk along the East Pier at weekends. There was always a buzz around Dún Laoghaire back in the 1940s and '50s, what with music in the bandstand, the Pavilion Cinema, sailing boats and visits to the People's Park. A few years after she married Tom Keyes in 1959, they moved to Dún Laoghaire where Tom worked as a post office sorter in today's County Hall. During the late 1980s and '90s, rarely a Sunday passed without a ramble to the end of the East Pier where they were guaranteed lots of chats with many friends and neighbours taking a constitutional also! In this photo, taken in 1996, they are accompanying their daughter Marian and her five-month-old daughter Nora who were home for a visit from London. The most recent photo, taken earlier this year shows Teresa enjoying a Teddy's ice cream.

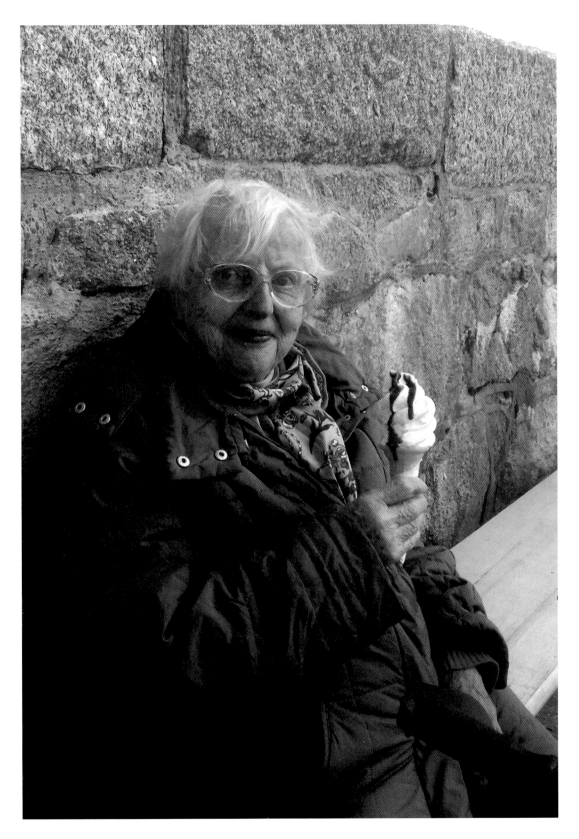

FIDELMA FURNEY – THE O'CARROLL FAMILY

These photos, taken some time in 1942 or 1943, are amongst some of our earliest twentieth-century family photos on the pier. Fidelma, or 'Delma' as she is known to her friends, brought in several photos of her family who took a walk down the East Pier during the war years. Her father, Seán O'Carroll, a veteran of 1916, had a Brownie camera and took the photos on what appears to be a lovely sunny day judging by the dresses, T-shirts and ankle socks! The group photo shows three generations of the family: grandmother Mrs Fitzsimons and from left to right, Eithne, Eveleen (Mrs O'Carroll), Aileen, Delma and Colm O'Carroll. Eithne is shown with a stick in the photo where she sits on one of the pier bollards. She had in fact just come home from eighteen months in Arklow in a TB sanatorium and was making a good recovery. The four children are also shown in the photo on the steps with Colm on the top step, then Delma, Eithne and Aileen. Delma, who is eighty-five this year, described how there were six children in the family altogether – Aileen, Brendan, Colm, Desmond, Eithne and Fidelma – easy to remember as ABCDEF!

Left to right: Mrs Fitzsimons, Eithne, Eveleen (Mrs O'Carroll), Aileen, Delma and Colm O'Carroll

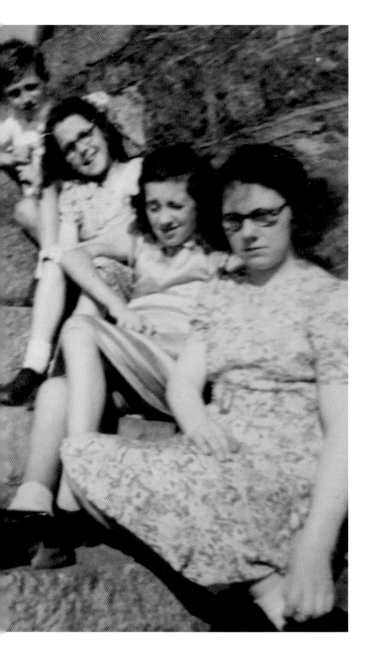

Colm, Delma, Eithne and Aileen

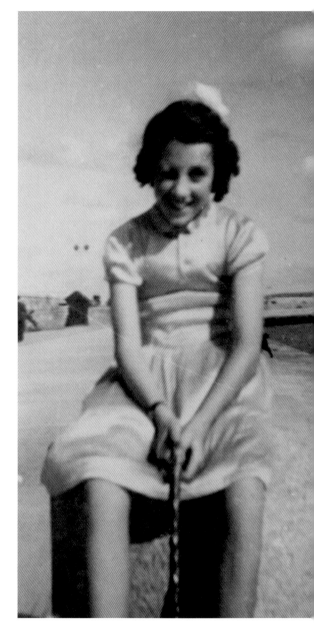

Eithne O'Carroll

KENNEDY FAMILY

Two generations of the Kennedy family having a walk on the East Pier before Sunday lunch. The group are from left to right: Maria Kennedy, Stephanie Kennedy, Sadhbh McLoughlin, Callum McLoughlin, Doreen Kennedy and Cormac O'Dowd.

SÉAMUS CANNON AND GRANDDAUGHTER PEGGY

'There are three cannons on the pier.'

TAO LI

'My name is Tao Li and I am pleased to share the story of my time in Dún Laoghaire with you!

I fell in love with Dún Laoghaire the first time I came across it when I forgot to get off the 46A bus and headed to the last stop by mistake. During my one-year experience as an exchange student in Dublin, I would say it's Dún Laoghaire that made me feel most at home. My favourite thing to do was walking on the pier while watching people going here and there.

I was there on my birthday on 7 May 2017 when I took this picture. My original plan for my birthday was hanging out on the pier with some sunbathing plus ice cream. Then ... in truth, it turned out that everything just went so perfectly that I couldn't have asked for more! It was a birthday celebration alone but felt like I owned the whole world. 1000% sure it was my best birthday ever.

Without a doubt, Dún Laoghaire is my favourite place in Ireland even though it's one year since I left, I still miss it so much.

I am currently doing a masters in Hong Kong, which is also an island! And my hometown, Xiamen, is a gorgeous little island in Southeast China. So literally I do have a special connection with islands.'

Sketch by Tao Li of Dún Laoghaire East Pier.

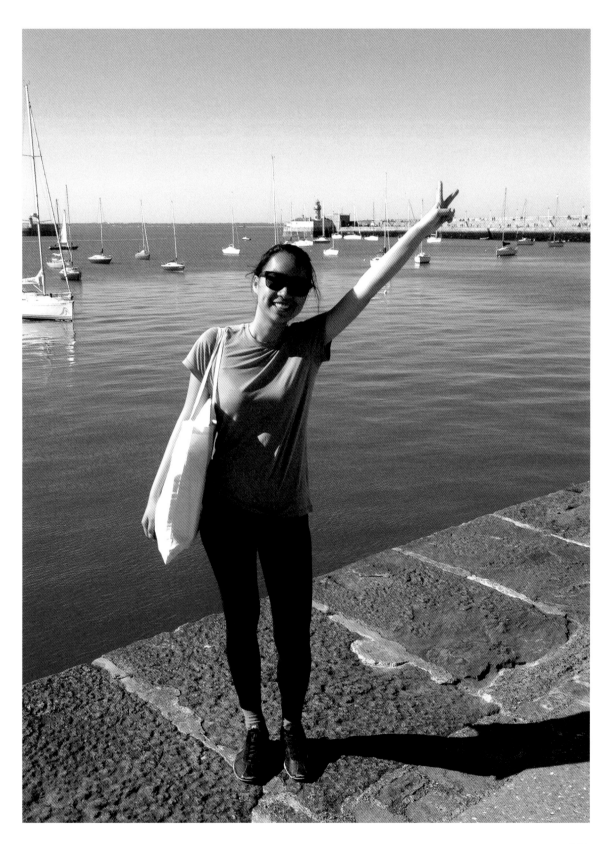

PEARSE O'KANE WITH GRANDCHILDREN JESSICA O'KANE, MOLLY O'KANE
& JACKSON BALL. PHOTO BY ANNE O'KANE

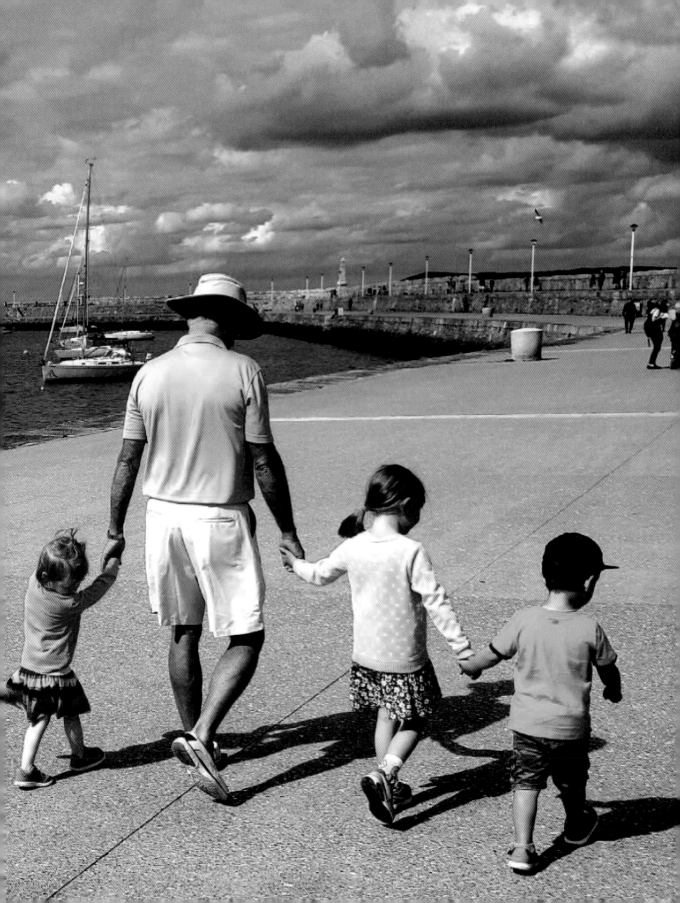

BRIAN DORAN

Text by Christine Doran, Brian's daughter.

Brian Doran was a founding member of the DMYC (Dún Laoghaire Motor Yacht Club) and spent many happy years "messing about in boats", as he always put it, in the harbour – mostly those he designed and built himself – with friends and family. In his later years one of his favourite things to do has been to walk down the pier with his wife Frances and enjoy a Teddy's ice cream cone. He doesn't get to the pier much anymore as my parents are both now nursing-home bound and he's mostly stuck in a wheelchair with a bad leg. He turns eighty-nine this summer. The harbour has been one of the great pleasures of his life, and he said to me a few years ago, as we sat by the pier, that he couldn't imagine a better place in the world to live.

He's actually mentioned on the history page of the DMYC website, here: http://www.dmyc.ie/the-club. It says 'A building committee was formed. We were fortunate to have among our growing numbers experts from every field. These experts took over the project. Brian Doran designed the building and supervised its construction as his 'donation". (He's an architect by profession and a boat builder by hobby.)

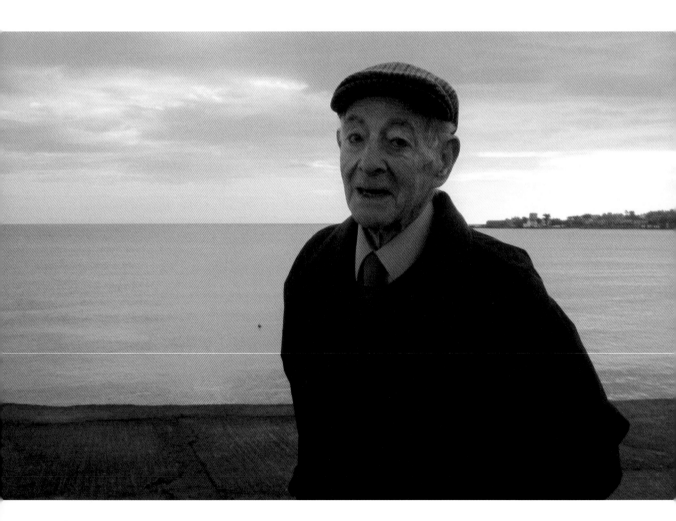

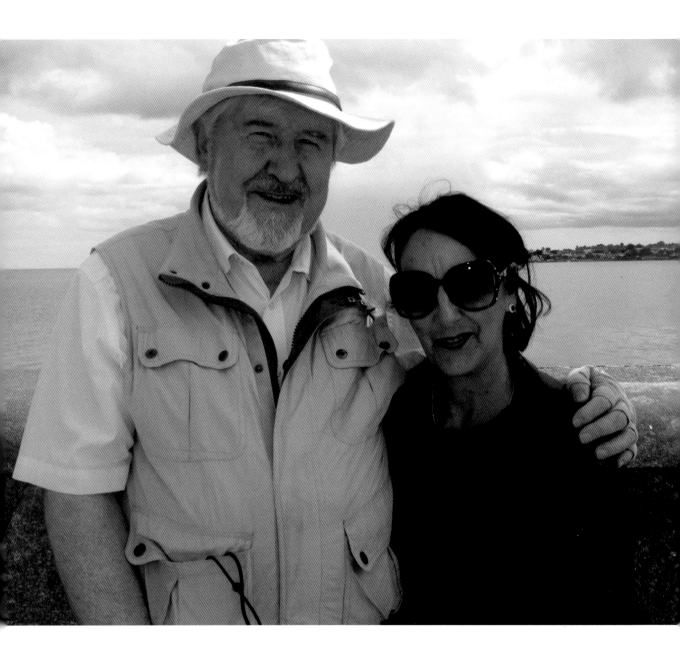

MARY & PAT GIBSON

'Yes the pier holds many memories from early days with Pat before we married, then when our children came along – three girls and two boys. It was always the walk they chose – they used to pick out their favourite boat, they loved to run around the bandstand and of course the girls would dance! Now I love to bring our grandchildren and they enjoy the same things – Patrick loves to climb the rocks and stand on the wall to see the other side, Ella picks out her favourite boat – and one for me too! They all enjoy Teddy's ice cream at the light house at the half way stop.

 The pier gives me a feeling of peace and at times when the seals jump up, it is just magical.'

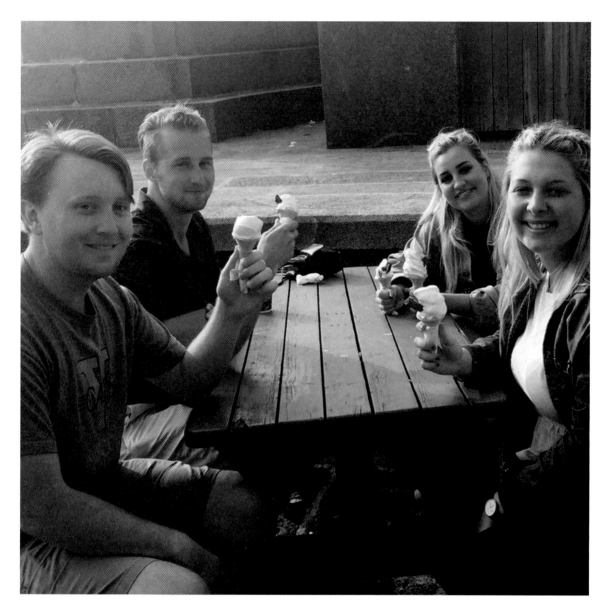

Enjoying a Teddy's ice cream are John Schwartz (Mass, USA) and Aidan Flattery (Mass, USA) with Amy and Susan Flattery (Dublin).

IMELDA FLATTERY

'My mother, who passed away in 2015 at eighty-nine, had lived in Dún Laoghaire when first married and passed on a love of Dún Laoghaire Pier and Teddy's to her children & grandchildren.'

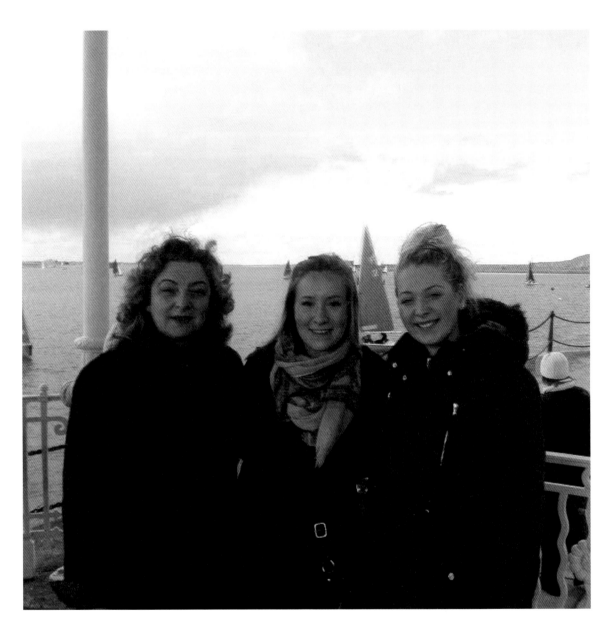

Imelda Flattery with her two nieces Hannah Flattery (Mass, USA) and Amy Flattery (Dublin) in 2013.

George Kelly (who has lived on George's Street, Dún Laoghaire all of his life) describes his favourite places to go fishing around the West Pier and the Coal Quay. He tells of a good day's fishing with his *Irish Press* co-worker Jimmy Deardon when they caught almost 120 fish the day they were both out on strike during the early 1950s.

Transcribed from an original recording made on 10 October 2014 by Anthony Kelly.
From A Sound Map of Dún Laoghaire, an ongoing project by Anthony Kelly & David Stalling (www.dunlaoghairesoundmap.com)

'I remember too, I was young at the time and we were still going to school and you'd go down in the summer time mostly when you'd be off on holidays and that was important too, to be away from school. So you could think you might get paid if you were lucky, if you got a tide and you could go to where you wanted to fish to catch a certain kind of fish.

Down the head was a great place to go if you wanted to get the mackerel with the turn of the tide but if you wanted to get flat fish there were two places. One was the back of the West Pier. Now, there again, the back of the West Pier was a very good place but you had to get your tides because if the water was out, there'd be nothing left and you could walk around it nearly to the end of the West Pier. It was a great place for flounders. Now you don't hear much about the flounder now but they were a bit like plaice only he has no red spots on his back – that was the big difference, how you would know one from the other. You'd get both of them more or less in the same place, as far as I can remember anyway. And for the plaice, a very good bait was the lug, that's what I told you, it was a big oul fat thing that I didn't like but the plaice and the flounders loved them.

Another place where you'd get flat fish was opposite a little pier, still there, the Coal Quay they called it. The coal boats used to come here donkey's years ago and used to offload coal for Kingstown and Dunleary, whichever it was at the time. Now, at the end of that pier, there was a little gap – it was a little pier within the main harbour and off the end of that little Coal Quay pier, it was great place for flounders. People didn't know that and I don't think we said a whole lot about it as we didn't want them all coming down there. Then at certain tides if you went down to the start of the Coal Quay, there was an oul shed – so if it was raining it was good for shelter and you could get lots of flat fish off of that area.

Then I remember years later after that as I was serving my time in printing and we were on strike one day, and an oul pal of mine had a boat. I was in my twenties at the time and we rowed around the back of the West Pier. We spent about three hours there just about 100 yards off and we got 120 flatfish – we were giving them away to the neighbours for the rest of the week. Plenty of places you could get different fish at the West Pier.'

In other recordings on the same website, hear how, in the early 1940s, George and his brother Christy caught a large conger eel near the Ramparts at the back of the West Pier. He also recounts his experiences digging different types of bait for catching flat fish and mackerel off the West Pier during the 1940s.

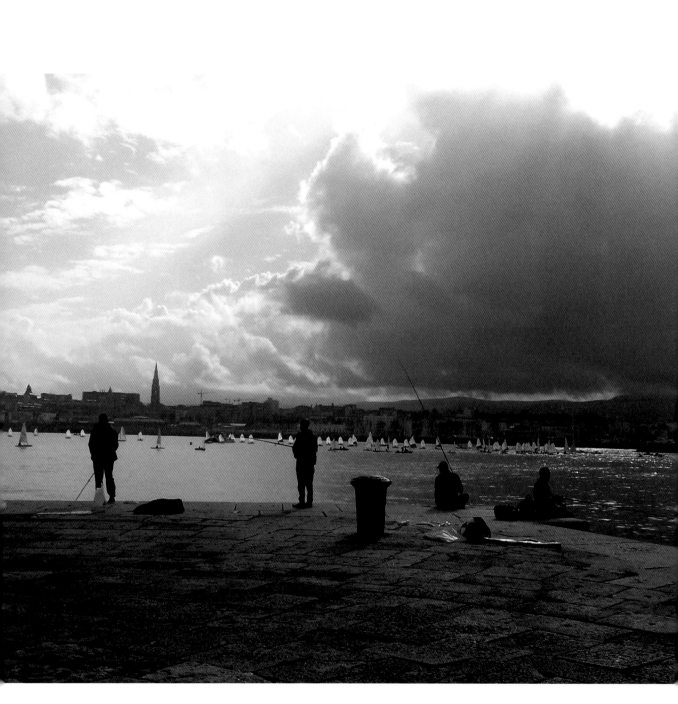

Photo ©Local Studies Collection

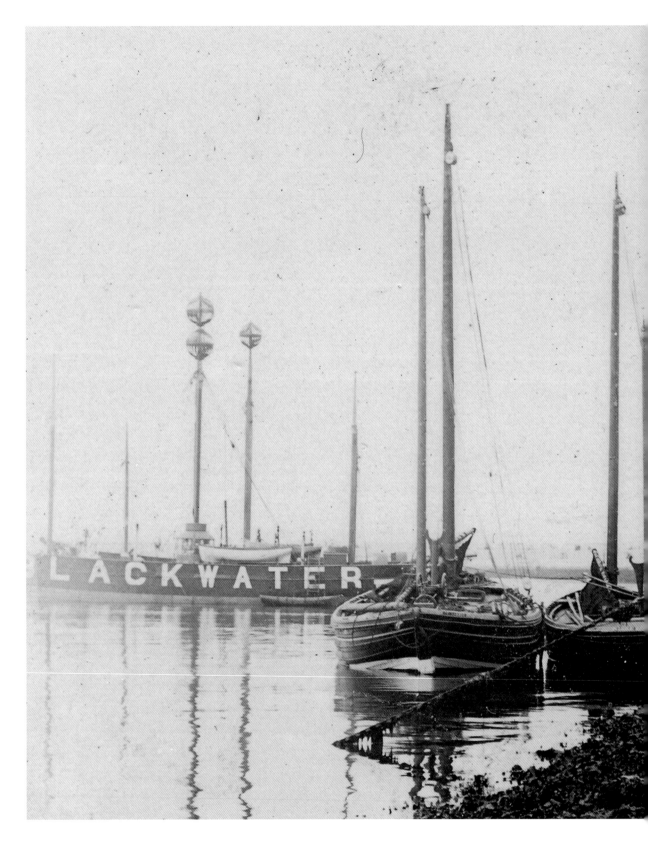

Banff Nobbies were fishing boats from Aberdeenshire port and probably came to Kingstown in pursuit of herrings. The two boats were moored along the East Pier, pre 1890. Note the lightship Blackwater in the background. Lightships served as lighthouses on land and were placed further out to sea to warn ships of danger. Seymour Cresswell Collection. Courtesy of Vincent Delany and dlr Local Studies Collection.

Baby Aisling's first tooth appeared while she was on a trip to the pier with her mum. Here is an adult Aisling, with a full set of pearlies on the pier with her mum today!

Susan also had the photo of the bandstand printed onto canvas as a wedding present as she loved the piers so much. Susan is the Director of Blackrock Education Centre.

BLAS MOLINA & MARIA RODRIGUEZ (PHOTO BY JON KELLY)

'Maria and I are good friends who enjoy spending time together. We both share the same passion for running and Dún Laoghaire is such an important venue for outdoor events that we could not resist to go for one of them. After running 10km we took a stroll along to take in the lovely views of the pier and enjoy the fresh marine breeze. Maria is from Madrid and has lived in Ireland more than four years. I am originally from Bocairent, a small village in Valencia region, Spain. Although I live in Dublin now, my initial five years were in Cork so that I consider myself a Munster person!'

ANTHEA MCTIERNAN WITH HUSBAND KEVIN WEBSTER (PHOTO BY JON KELLY)

LAUREN & BLAKE NEWMAN (PHOTOS BY JON KELLY AND LAUREN NEWMAN)

'We have been residents in Dún Laoghaire since 2017. It has been a fun and relaxing home away from home for us. We are originally from Texas and are here for Blake's job. The pier in Dún Laoghaire is the main focal point of the town. It is a place to come to unwind and enjoy a breath of fresh air. Our two daughters, Harper and Lily, especially like eating the famous Teddy's ice cream, which has a location right on the pier! We also love to take in the view of the pier from the Haddington House garden topped off with a pint. Dún Laoghaire will always have a special place in our hearts.'

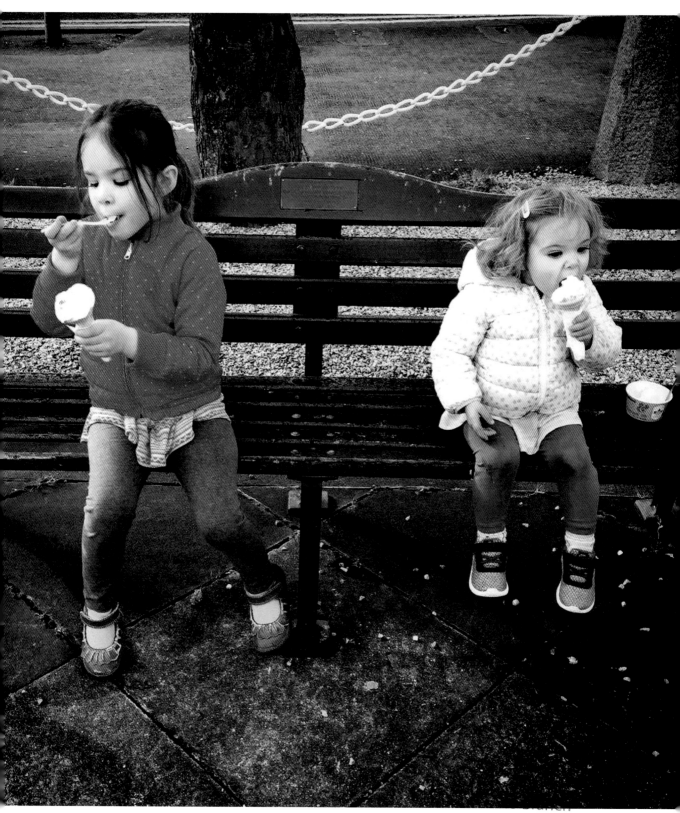

MICHAEL DOORLEY

This photo of Michael Doorley (originally from Offaly) and Marian Keyes (originally from Dublin) was taken at the end of the East Pier in April 1996 when they came back for a visit to Ireland for Nora's Christening. Both had emigrated in the early '90s and had met in London where they lived until 1998. Regular recessions throughout the 1980s and '90s had meant emigration for work and both had also lived and worked in the US and elsewhere, following wherever jobs were available! They were delighted to come back to live in Dún Laoghaire for good in 1999 with their two daughters Nora and Joanna. Marian joined dlr Libraries and is now the Librarian at dlr LexIcon. During the Bicentenary of the Pier, Joanna took a photo in the same spot, recreating that taken twenty-one years earlier.

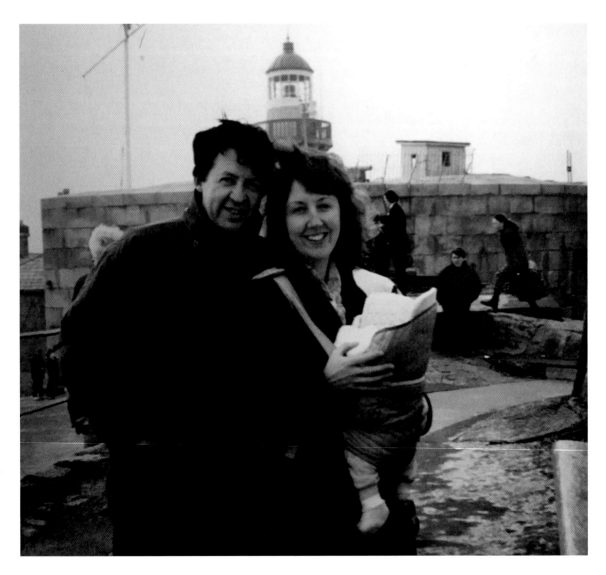

Left to right: Michael, Marian and their daughter Nora in 1996 and in 2017. Photo by Joanna Doorley

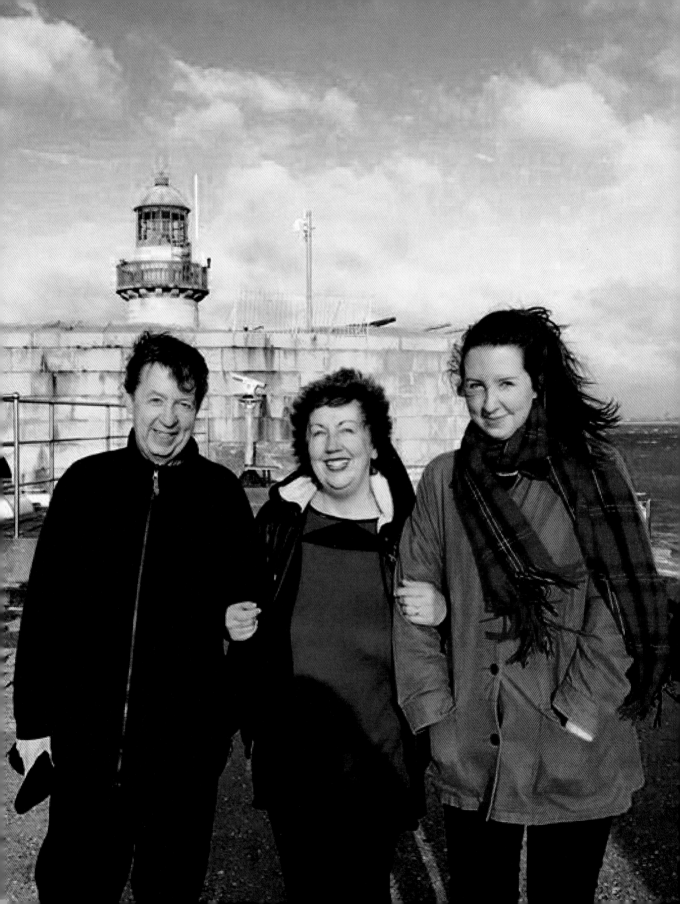

Three generations of Guinanes and Bentleys on the Pier.

From Mary Bentley:

'My mum and my daughter and I went to Dún Laoghaire for a walk down the pier – a trip down memory lane for all of us. My mum and dad had their wedding reception in Dún Laoghaire in 1958 so it holds special memories for her, although the hotel in which it took place is now a block of apartments. My daughter Megan and I were visiting from the UK. Megan came to see her grandma before she went to university in Australia for a year! As a child growing up in Dublin I spent many hours visiting Dún Laoghaire, walking the pier and eating ice cream with my family! A very happy memorable day for all of us.'

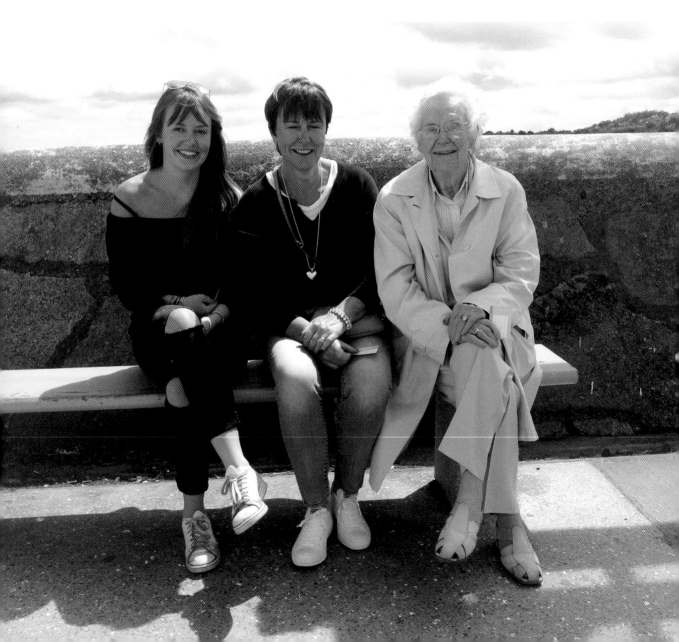

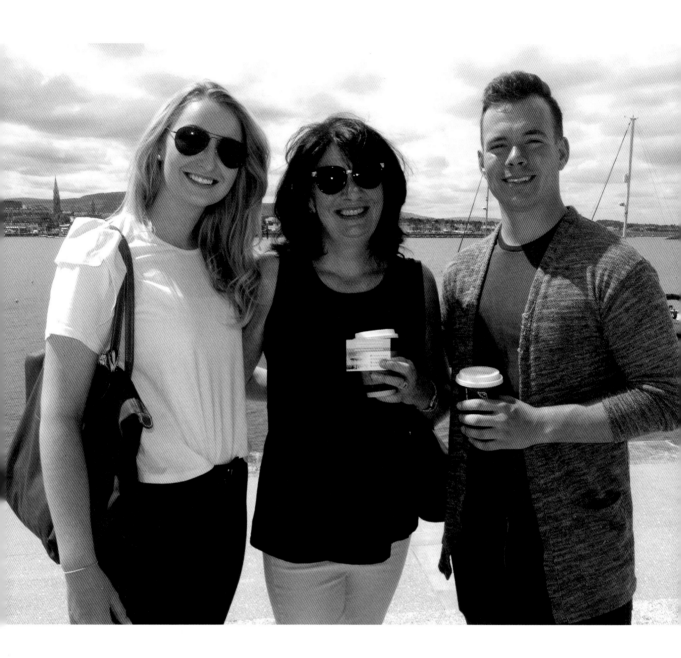

ANNAGH BEVAN (PHOTO BY JON KELLY)

'My name is Annagh Bevan and I'm pictured with my mom Geraldine Bevan and boyfriend Fionn Henderson. Having grown up by the sea in West Cork makes it very hard to let go of it. We chose to move to Dún Laoghaire two years ago for this reason and haven't looked back since. We already have so many memories of walks, fish and chips and a cheeky Teddy's on the pier.

'In this photo mom was up visiting for the weekend. I'm studying Psychology in TCD and Fionn is studying Law in UCD. We love Dublin now, could never move back to Cork but it's always nice to visit!'

This photo features Ann McClurg who became Jim's wife with Jimmy Stuart on the left of photo and Nick Heffernan on the right. Photo taken in 1959.

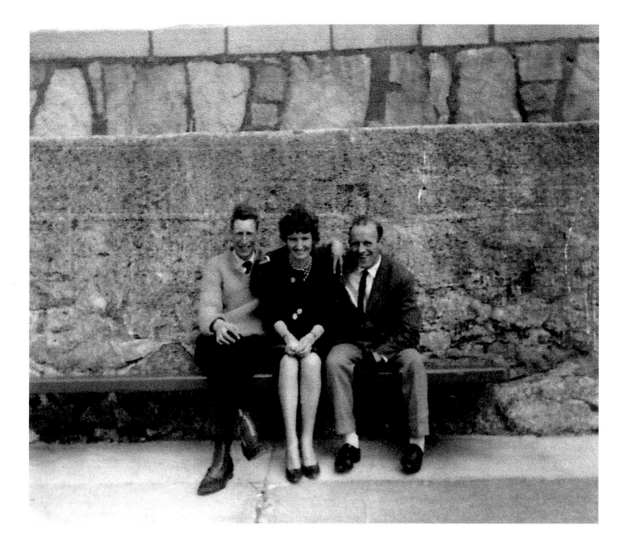

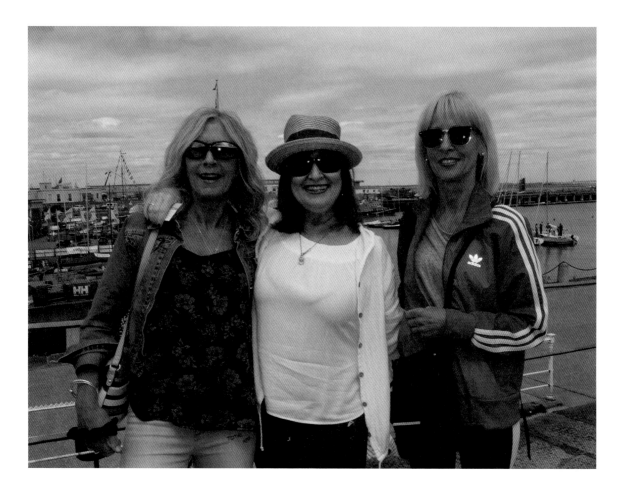

JACKIE CONNOLLY, FIDELMA MURPHY & BETTY ROBINSON (PHOTO BY JON KELLY)

'There is a story about the day! My friend Fidelma, she is on the right of the picture and it was a day out for her birthday which falls on the 4th of July. Fidelma has lived in Waterford for the last thirty-two years but is a Dublin girl but I felt she had lost touch with Dublin so for the last few years I have arranged different excursions around Dublin for her on her birthday to reconnect her with our beautiful city.

That day the girls had no idea where they were going. I even slipped the taxi man a note where to drop us as I did not want them knowing anything till we got to the quays. I had told them what to pack for the day and to bring something nice to wear for the evening. So I had arranged the Dublin Bay tours and we headed to Dún Laoghaire. It was a really sunny morning, couldn't have asked for better, we got to know the history of the docks and the port and I have to say it was a great tour, then we ended up on the pier where the photo was taken. We then got the train to Bray and walked from there to Greystones which was a great walk. When we arrived, we then went for dinner and a few drinks in Greystones and got the train back to Dublin that night. We have been pals ever since we were teenagers. It was a great day for all of us!'

'My husband and I are Americans and we were in Dublin on my husband's PhD visa and when that was winding to a close, unfortunately we were unable to remain in Ireland. We were gutted, but the children even more so. We are now in South Africa but very homesick for Dublin and Dún Laoghaire. My children Skype their old friends daily. We hope one day to find a means of moving back. We've lived in so many places and while we weren't born there, Ireland was definitely "home". Many of these photos were taken on what I then knew to be our family's last walk on the pier. The pier and Sandycove had become our favourite weekend destinations, my children were free and happiest there. It was a very emotional day.'

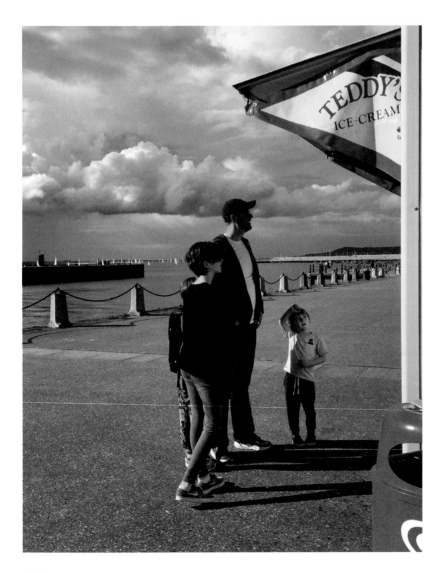

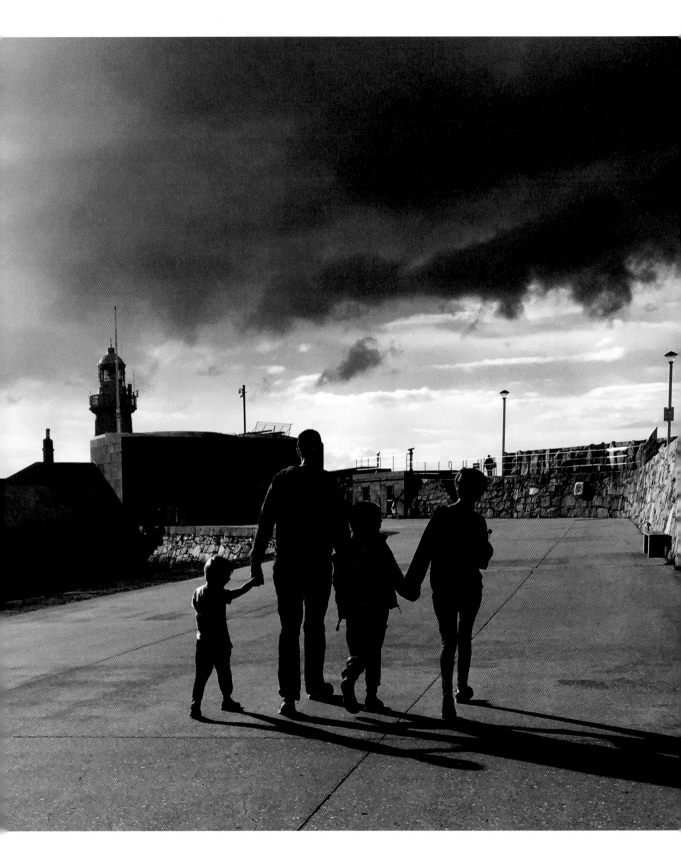

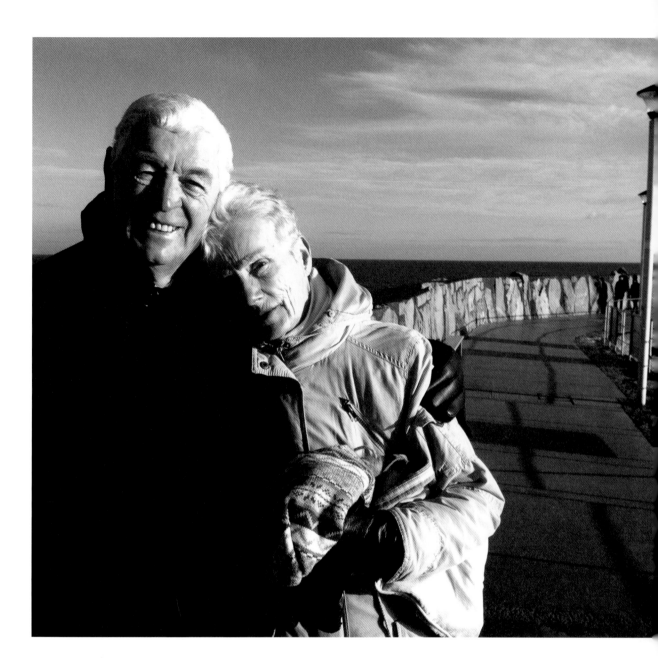

EMMA PRUNTY

'I have a few much-loved photos of my family on Dún Laoghaire Pier. I grew up in Foxrock and until last year, I lived abroad for over twenty years. The pier was always one of the first places I was keen to get to when we'd come home, especially at Christmas when we would walk it on Christmas Day. Maybe it was the sense of being out in the sea, the roughness of the Dublin Bay water, the chance of finding a seal, just the memories of many other walks. I've never come across a pier like it in the world, with the same sense of weight, those heavy granite blocks that I really love. And my kids love that cannon.

The one of my parents was taken on Christmas Day 2012. My Mum passed away in 2014. My Dad is still with us but he's getting on now and he is a big reason we came home from abroad last summer. When I posted this photo on Facebook one of my friends said a lovely thing – that they both look so happy because they're looking at me and showing me love. So the photo of my Dad and my two daughters on the pier is close to my heart too. He can't walk on the pier anymore, staying closer to home these days. Now that we live here, we don't get down to the pier all the time – as I imagined from abroad that we would do every single weekend! It takes some effort to get the girls out there. Having said that, my husband and I have both found how lovely it is it cycle along it late at night when it's much quieter and the lights are on, making it feel really quite safe and full of atmosphere.'

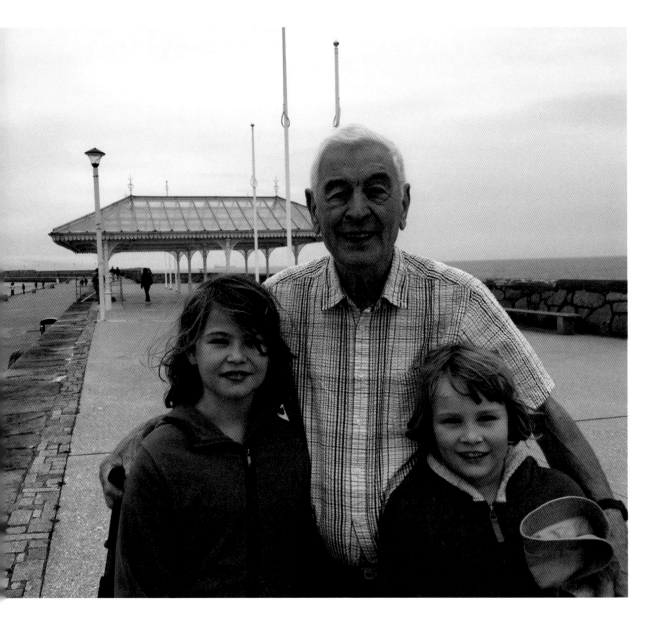

SUSANNA MOLLEN (PHOTO BY JON KELLY)

Pauline and Pat Hennessy with Susanna Mollen and Máire Mollen-Conway.

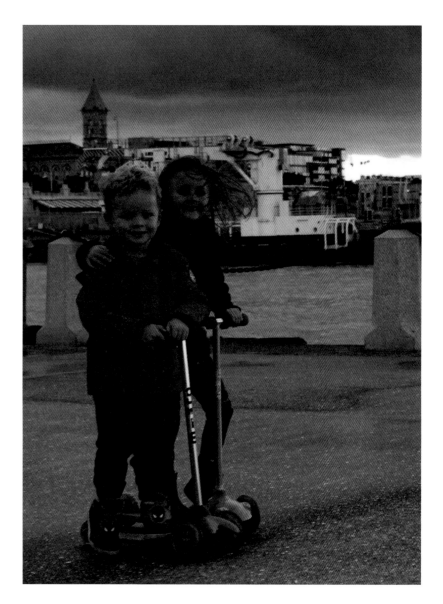

Isobel and Elijah

RACHEL DUFFY HOWE: PHOTOS OF ISOBEL & ELIJAH

'The pier is a very special place to my family. Duffy is my maiden name. My Dad's family are originally from Eden Villas in Glasthule and were a great seafaring family. A lot of my uncles worked for Irish Lights and Dad loved to bring us down to the pier particularly when the *Granuaile* was docked. I love to do the same with my two children Isobel and Elijah now. Otherwise we love to just walk and take it all in.'

LYNN KEEGAN

'Paul Derek Keegan (1945–2015) was a regular walker of the pier. He believed you hadn't fully completed it until you kicked the blue door at the end. Every year around his anniversary in May we walk the pier in his memory, taking some time at the end to remember him. He is very sadly missed.'

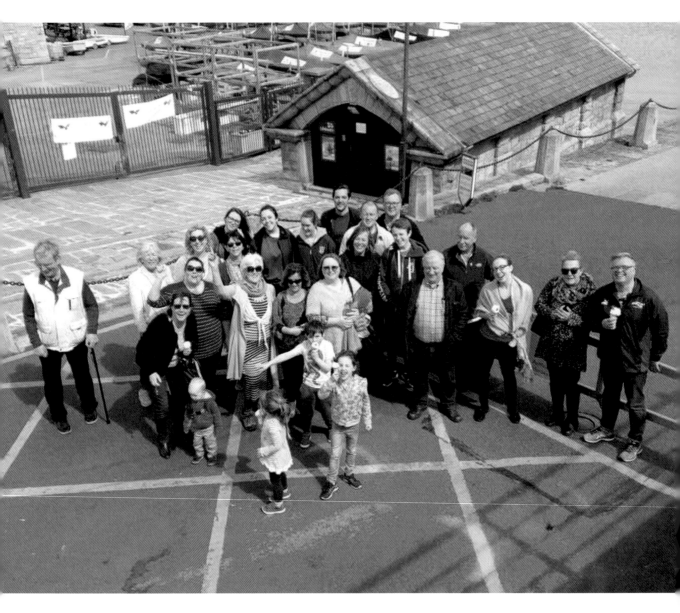

The Keegan family

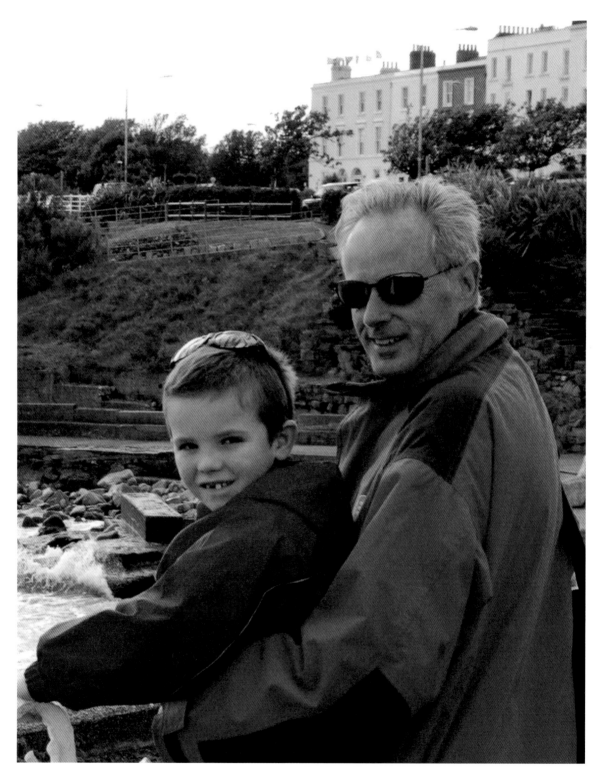

Paul Derek Keegan

BART GRZEBALSKI

Bart is the Night Security Offer at dlr LexIcon from when it first opened in December 2014. His panoramic photo taken from the LexIcon of the East Pier and Carlisle Pier, looking over towards Howth on a sunny, yacht-filled bay was selected for the Home Page image of www.dlrpeopleonthepier.ie. Off duty, he enjoys exploring the pier at close hand with his wife Malgorziata and his two sons Jan and Marcel.

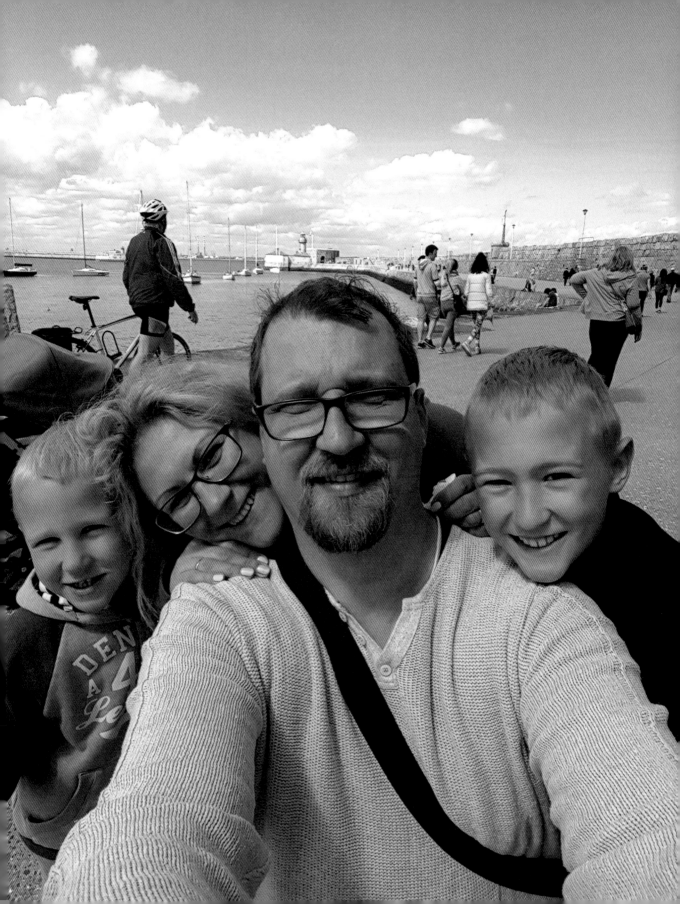

'Myself and my sister Juli were born and raised in Dún Laoghaire. Our dad Joseph owned the Kiosk in Dún Laoghaire Shopping Centre and I spent my youth working there! We both now live in Meath but love coming home to Dún Laoghaire as often as we can to walk the pier which is my favourite place in the world. I always think as I'm walking it and I turn to look back at the harbour that I could be anywhere in the world . . . but I'm home, which makes it extra special!

'The photo with my nieces are my sister's daughters. They were born and raised in Meath but Dún Laoghaire already holds a special place in their hearts and they love to visit their grandparents and walk the pier!'

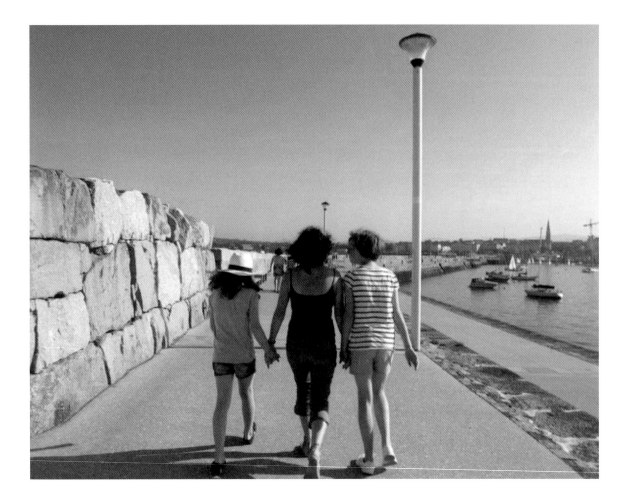

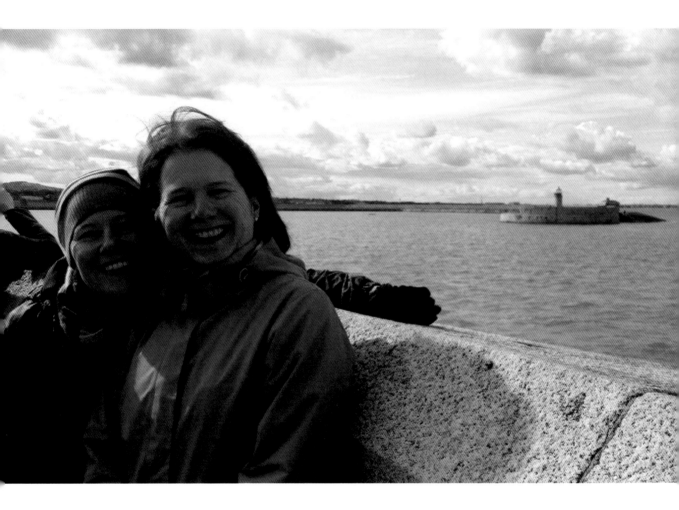

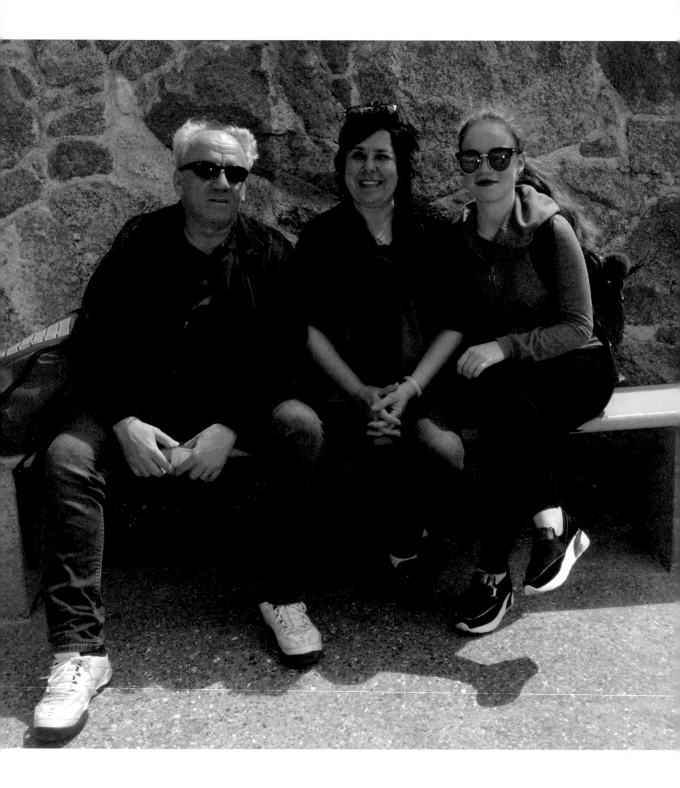

MARIUSZ GRESER AND FAMILY (PHOTO BY JON KELLY)

APLEONA TEAM – FACILITIES MANAGEMENT AT DLR LEXICON

Left to right: Darren Connolly (Facilities Manager), Iulia Dumitru (Site Co-ordinator), Sharon Hyland (Security Officer), Patricia Lynch (Marketing Executive), Jason Forsyth (General Operative)

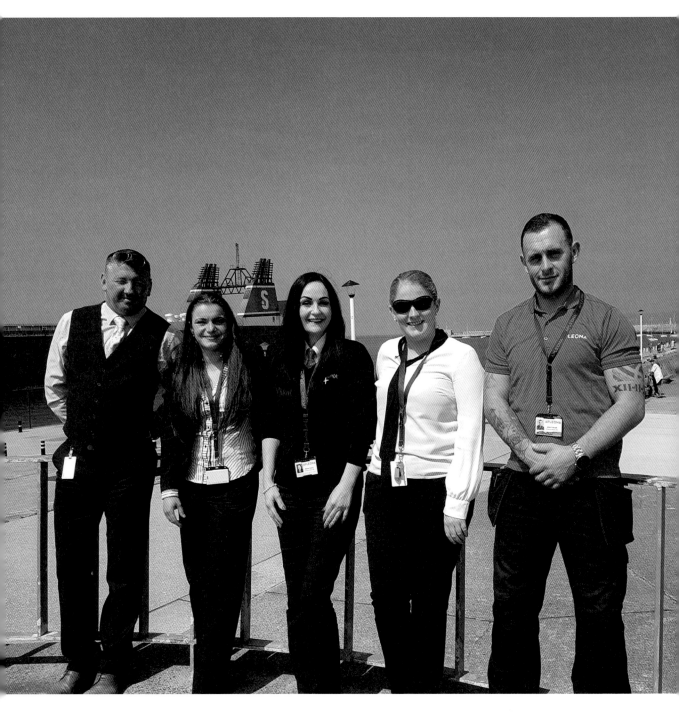

Áine Caffrey with son Dermot

Oliver Keane with grandson Jack Caffrey

Evelyn & Co on the Pier

SINÉAD CAFFREY

'My husband Niall Caffrey was originally from Dún Laoghaire. We regularly frequent the pier. We are now living in Glenageary. This is a picture of my mother in law taken in 1963 which includes Áine and her very first baby Dermot. She since had six kids including Dermot.

Also there's this very special photo of my own Mum who always loved to walk the pier when she came to visit me in Glenageary from Ennis in Co. Clare. She sadly passed on 6 March 2017 aged sixty-nine. I have this photo of Evelyn & Co. on the pier proudly framed in my house. My dad Oliver Keane with his grandson Jack always enjoy a Teddy's ice cream at the end of the East Pier.'

'My grandfather, Canon George Chamberlain, was Rector of the Mariners' Church from 1925 until 1959. The photo was taken on the East Pier sometime in the 1930s.'

Canon George Chamberlain

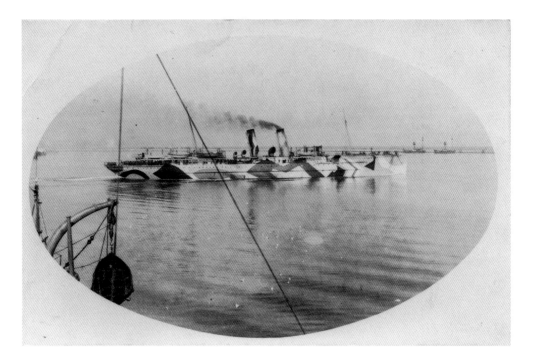

RMS *Leinster* in dazzle camouflage, leaving Kingstown Harbour (Dún Laoghaire) with West Pier and light ships in background. Courtesy Ian Lawler Collection.

RMS *Leinster* under escort from Submarine Scout Zero 50 (SSZ50). Courtesy Ian Lawler Collection.

KELLY-ANN CONROY WITH RUAIRÍ AT A WEEK OLD (PHOTO BY JON KELLY)

'My husband has been on the RNLI for eighteen years nearly and we like to visit coastal areas and have a walk. We enjoy seeing the boats and yachts at that time of year. Also the pier is such a buzzing place, people walking, dating, eating ice cream, and even dancing with music on the stand. I was able to sit and feed and change Ruairí and four people stopped to chat.'

RIGHT: PHOTO BY MICHAEL LEE.

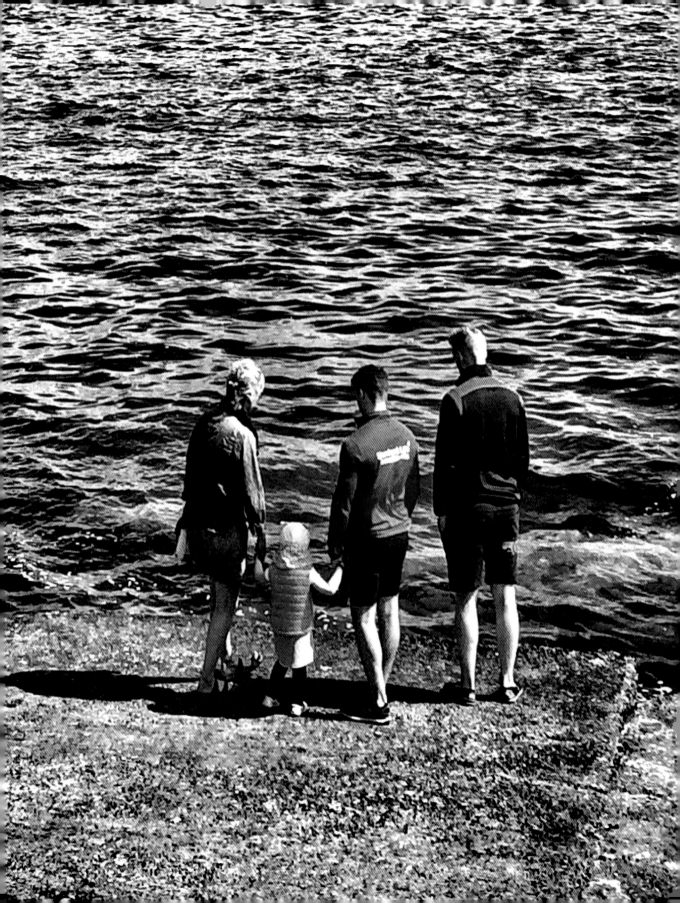

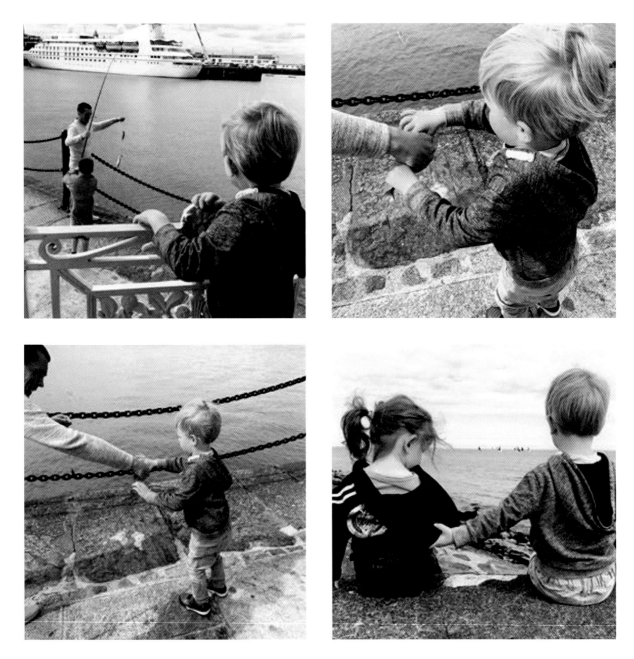

Twins Sebastian & Bella fascinated by fisherman on the pier.

SUSANN TSCHOERNER

154

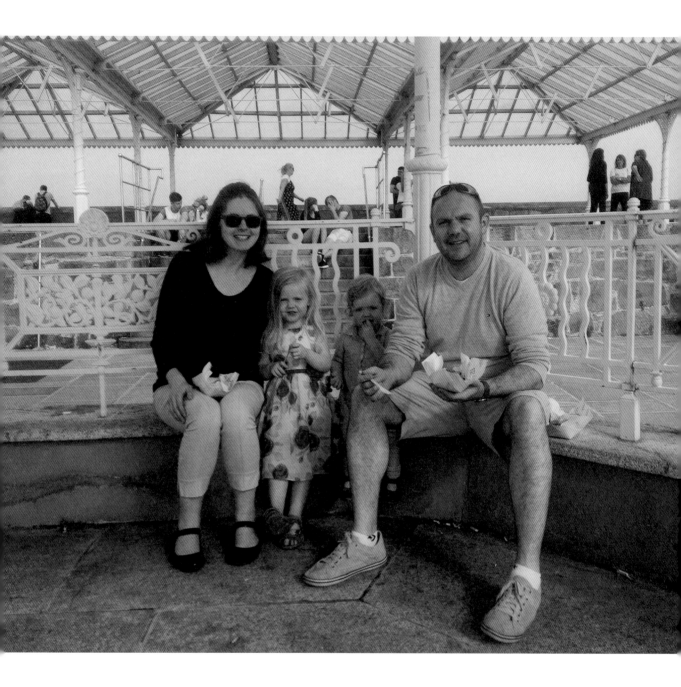

LOUISE GALLAGHER

'A photo of us enjoying that most perfect of evenings ... fish and chips on the pier! Not pictured but followed by a Teddy's ice cream for dessert.'

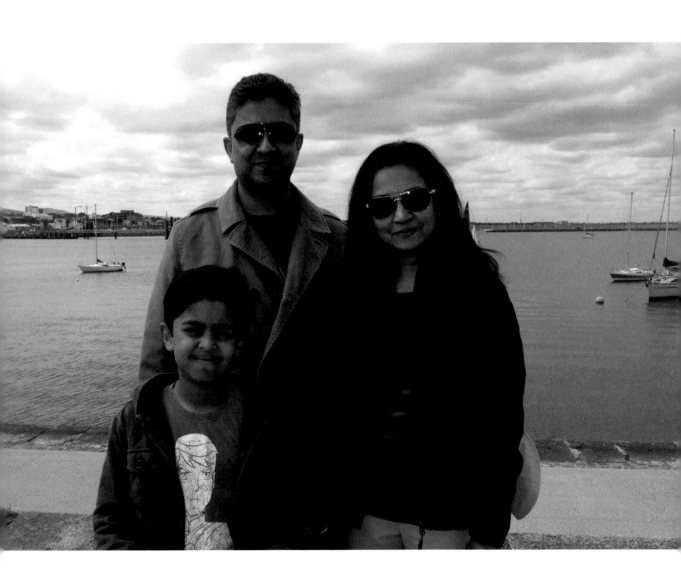

BHAWNA SINGH SUROTH AND FAMILY (PHOTO BY JON KELLY)

DEREK NIXON AND BIKE (PHOTO BY JON KELLY)

CHAPTER 4
PETS ON THE PIER

You could argue that a chapter entitled 'Pets on the Pier' is a bit of a misnomer since our furry friend the dog dominates the photos in this pet parade. In fact a pot-bellied pig jauntily taking the air or a cat on a lead being dragged unwillingly along have yet to be seen on the pier. So some snaps of seals have been included in the name of species-balance and the odd seabird too!

Countless canines parade the East and West piers on a daily basis and it is hoped that the following pages of photos give a good factual cross section of the colourful variety of pooches and their humans panting, running and sometimes even protesting at the length of the walk! One requisite bit of apparatus for any stroll down the pier is of course the pooper scooper, introduced several years ago by the Council to ensure comfort for all visitors to the pier.

Any dog owner will testify to the fact that letting your dog bring you for a walk is of superior health benefit than the best efforts of an army of personal trainers. Who can resist the sad-eyed pleading, the head steadfastly cocked in the direction of the front door, the long drawn out sighs and whimpers and even the effrontery of dragging the lead forward and boldly plonking it at your feet? These not-so-subtle signals guarantee that you'll be up off the couch in no time and trotting along at full throttle on the pier with your grinning pup pal in tow. On any random Saturday morning you will find the heartiest and healthiest pet owners in Ireland marching merrily along to the beat of their dog's drum.

Every dog has its day and as the following mug shots show – though they come in all shapes and sizes, makes and breeds – one thing is for sure, the amazing animals portrayed in the following pages are legends in their own lifetimes for their very proud owners.

LEFT: ADRIAN MCCLURG AND TREY (PHOTO BY JON KELLY)

NINETY-NINES

by Lucinda Jacob
(from *Hopscotch in the Sky*)

On the seafront in my home town
people come and go like tides,
walk slowly up the promenade,
and back again.

There's an old man who comes along,
he seems alone but still he queues
For an ice-cream, and then buys two.
He turns again

then holds one out for his old dog
and they sit together, side by side
licking the drips, watching the tide
turn back again.

JOHNNY BLAIR, PHOTO BY
OWNER LESLIE BLAIR

'A wonderful life: Meeting and spending precious moments on our beautiful pier in the fresh sea air with friends: Tillie (my mother) and I with neighbour and canine friend in 1974.'

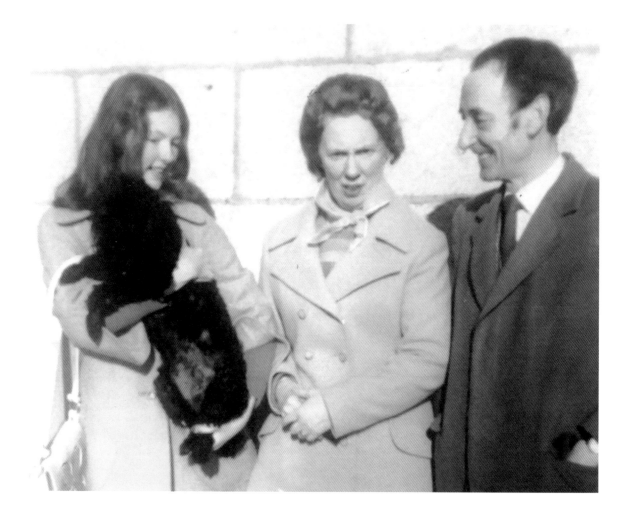

RIGHT: DEIRDRE DARGAN AND ANN CAVEY WITH POPPY (PHOTO BY JON KELLY)

'I grew up with Ann in Donnybrook and we've been friends since early childhood with happy memories of Saturday trips to the pictures in The Pavilion as children, and later, as adults, regular walks and chats on the pier, to keep in touch over the years. Though I now live in Ranelagh, the pier has been a place I have always gone to very frequently throughout my life. I have walked it with all the important people in my life and often alone, to get my head together. I am envious of a very good friend from Donegal who lives in an apartment overlooking the pier and walks it every morning!'

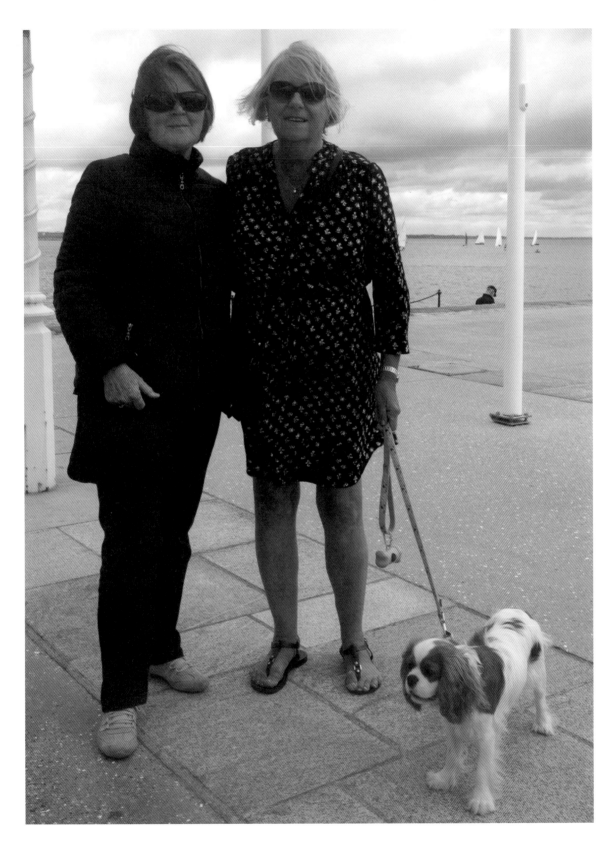

PHOTO BY ANTJE HUBOLD

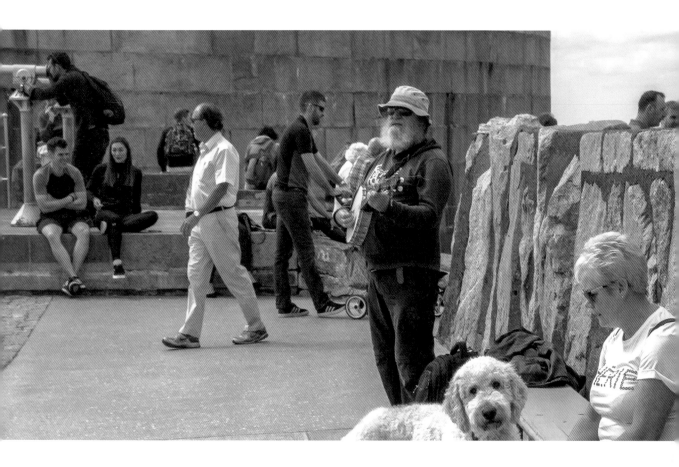

LISA KELLY-SHOEBRIDGE

Lisa Kelly-Shoebridge with her dog Kailen at end of pier with banjo player in background, taken by her husband Keith Shoebridge.

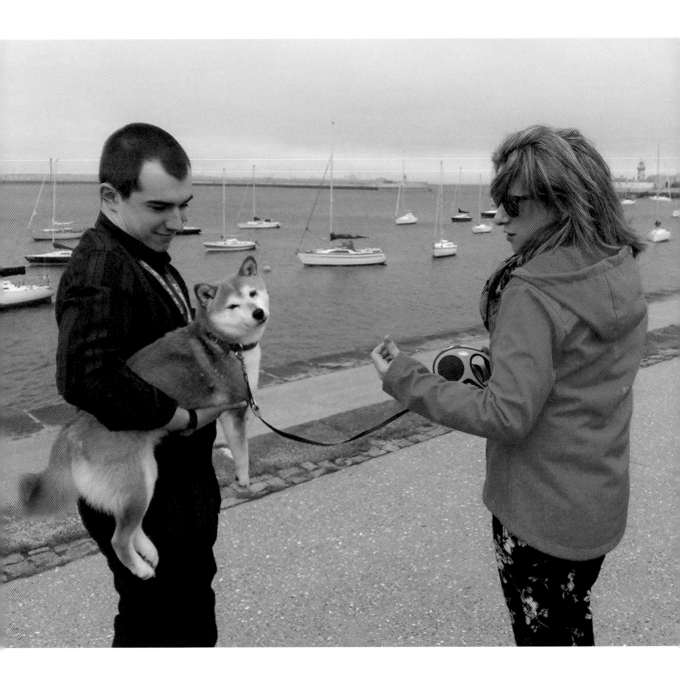

BRENDA CAREY AND ROBERT MURPHY WITH DOG

To mark the exact anniversary of the bicentenary of the pier on 31 May 2017, staff from dlr LexIcon went for a walk down the East Pier to capture some photos for dlr's Local History files. They met lots of interesting people and a few friendly pets also. Some of their other photos can be found in different sections of this book!

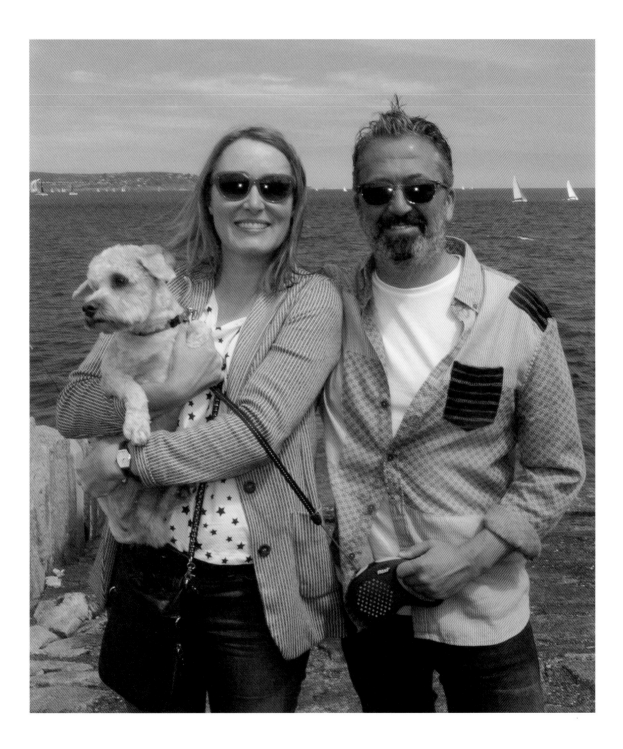

ABOVE: JOHN & CLAIRE WEBSTER WITH DOG CHARLIE (PHOTO BY JON KELLY)

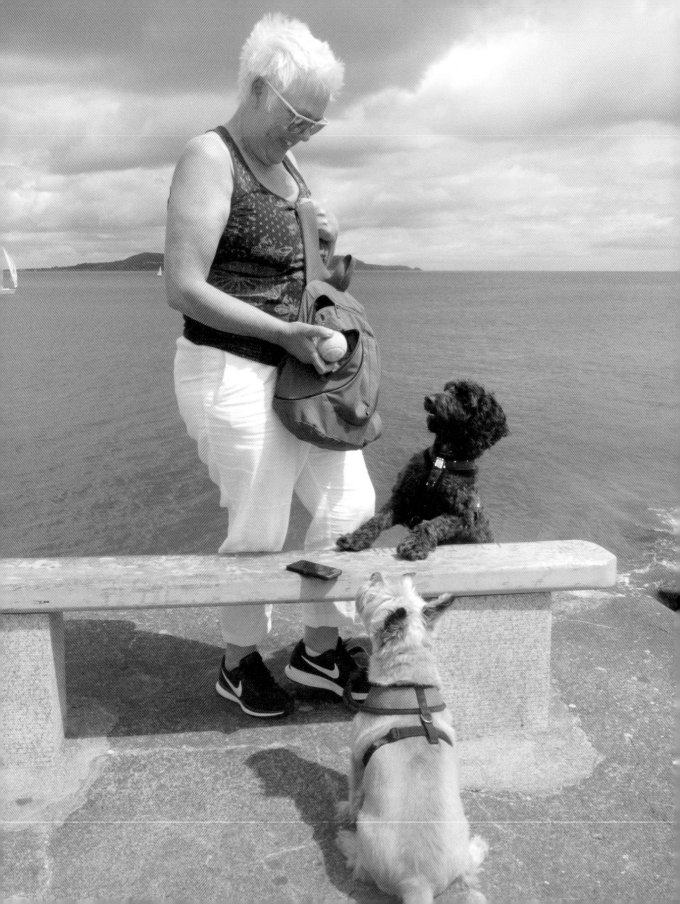

ABOVE: DEREK LYONS WITH PAXO (PHOTO BY JON KELLY)

SARAH TRENAMEN

'Red looking over the harbour wall on Mother's Day.
My favourite photo of him.'

DÚN LAOGHAIRE

by Eric Thompson

When I was a boy, I played on the pier,
Fished with my Dad, HSS passing near
I'd play on the bandstand & often would sing,
Imagining greatness … a popstar or king …

I'd order a shot from the cannon at shore,
to hit all the pirates until they're no more,
I'd ride on my bike to the end and then back,
My father ensuring his reach was intact

A boy to a teenager past through with haste
Those games on the pier turned to walks with my mates
A kiss on the pier did cement my first love,
I'll never forget her, a gift from above.

Then as I got older, I often was found,
Just walking the dog, or jogging around
The beauty and peace is on offer to all
That walk up the pier, or sit on the wall.

Now when I walk on the pier I feel more
Nostalgic than I ever did do before,
Walking beside me, my young Pirate screams,
'Load up the cannon' then spills his ice cream

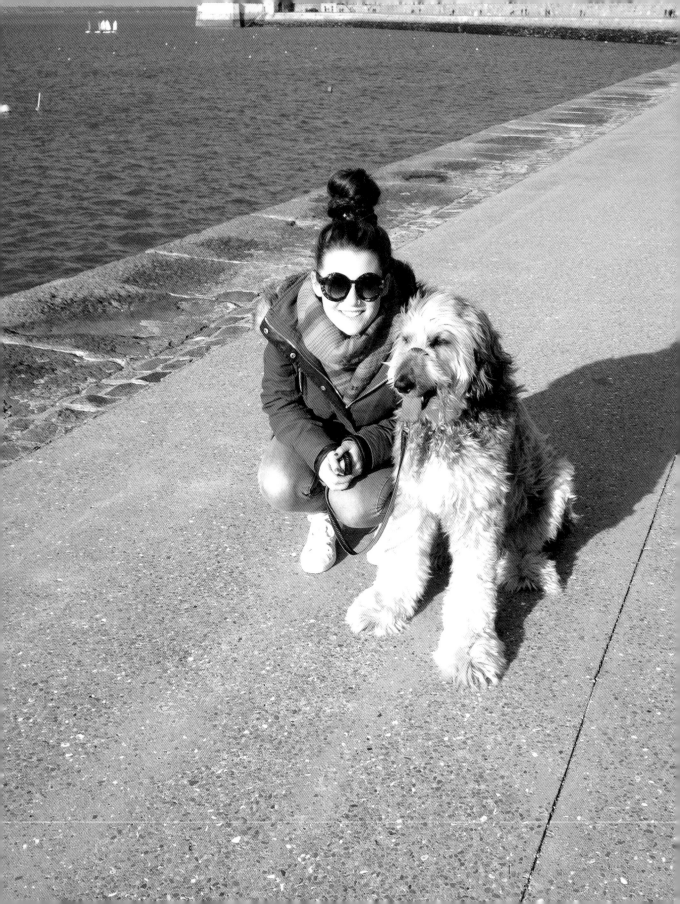

LEFT: HANNAH O'SHEEHAN

This wonderful photo of Hannah and her beautiful dog Levi captures a moment in time. Levi died in 2017 but he absolutely loved walking the pier and so many people always stopped to chat to Levi's owners that they jokingly said that they could have worn T-shirts saying, 'His name is Levi, he's an Afghan hound and yes he does eat us out of house and home!' On one occasion, when Levi was outside a jeans shop, the owners saw the perfect photo opportunity and begged his owners for a photo promoting a certain brand of jeans! He is greatly missed but his owners have many happy memories of their jaunts down the pier with their incredibly photogenic and loving dog.

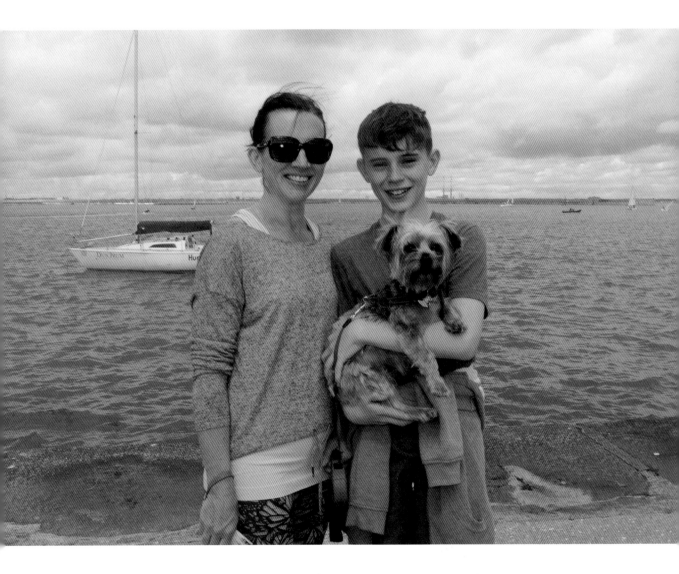

ABOVE: FIONNUALA BALLANTYNE (PHOTO BY JON KELLY)

'Our dog is called Milly. We love to walk the pier and enjoy Dún Laoghaire in all seasons and all weathers.'

A regular visitor to the West Pier, especially with fishermen nearby! Photo © Local Studies Collection.

RIGHT: DAMIAN COLEMAN AND MONTY (PHOTO BY JON KELLY)

'We are so fortunate to have this fantastic amenity on our doorstep. It changes from day to day and season to season but it always helps you clear your mind and get some exercise.'

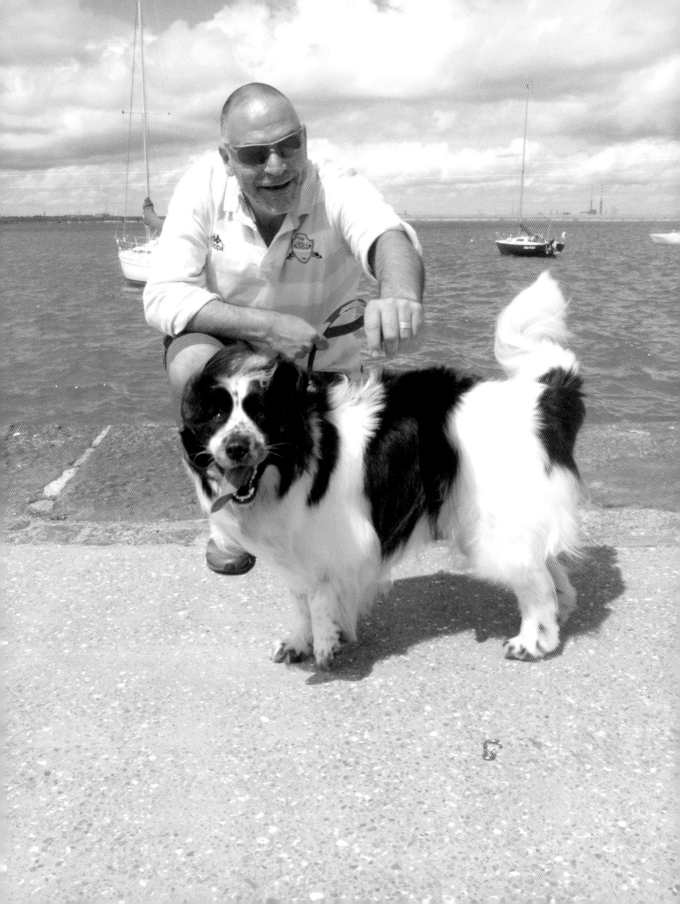

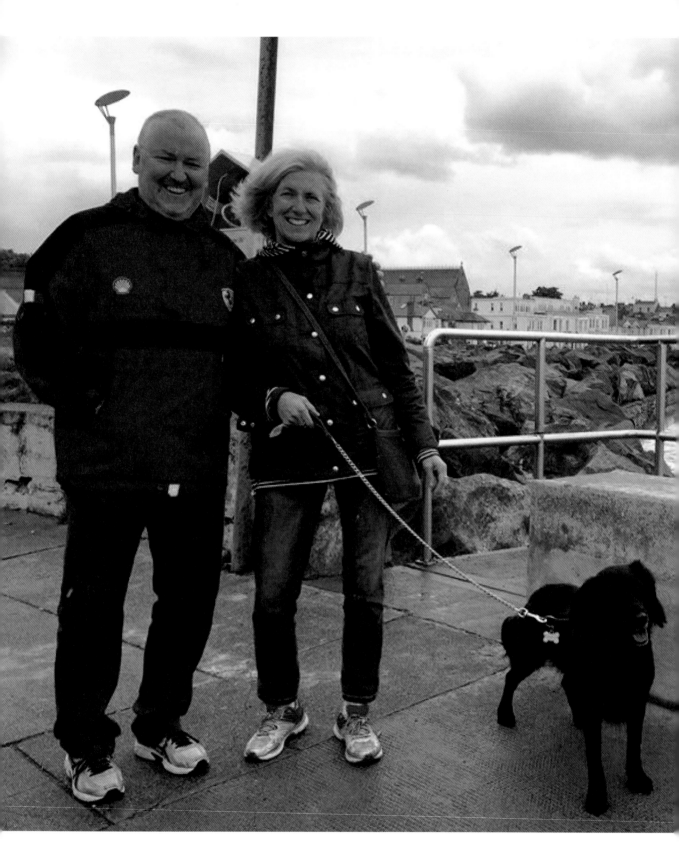

FIONA ALLEN WITH BROTHER BARRY
DIGNAM & DOG ZENA

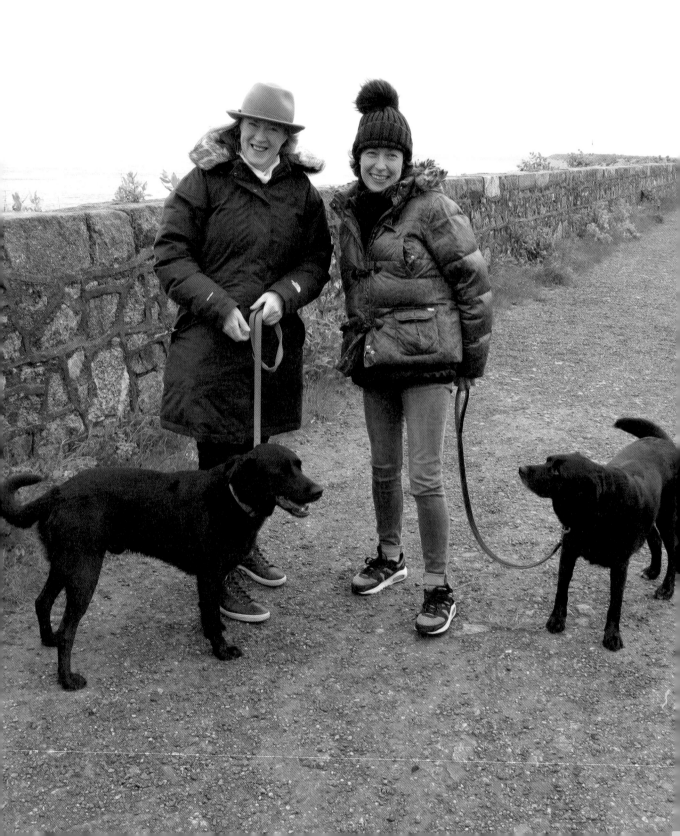

SARAH WEBB (FORMER DLR WRITER IN RESIDENCE 2016-17) & LUCKY WITH NEOLITA LANE & PEPPER – 2 SETS OF BEST FRIENDS!

'We try to walk the West Pier with the dogs as often as we can. We love the company and they do too! At least once a week, ideally more but sometimes life gets in the way. Lucky and Pepper have known each other since they both came to our families as rescue dogs. They bonded from the very start. I like the West Pier best as it's wilder and less busy. The dogs like sniffing in the grass too.

'I grew up in Dalkey and we took regular enforced marches down the East Pier. Maybe that's why I like the West Pier best now! I now live in Dún Laoghaire and I love walking out of my door. Once I'm on the street the sea is at the bottom of the road, sparkling at me. It's hard to be in a bad mood when you see that shimmering expanse of blue stretching all the way to Howth and beyond. I'm so lucky to live by the sea!'

Above: Two of Sarah Webb's children play with Lucky the dog at the Royal St George Yacht Club, Dún Laoghaire Harbour

SINÉAD BUCKLEY QUINN & FOZZIE

Sinéad is the Manager of the Irish Design Gallery and regularly walks the pier with her family and her dog Fozzie. The Irish Design Gallery is very dog-friendly with water provided for thirsty canines returning from lively walks on the pier!

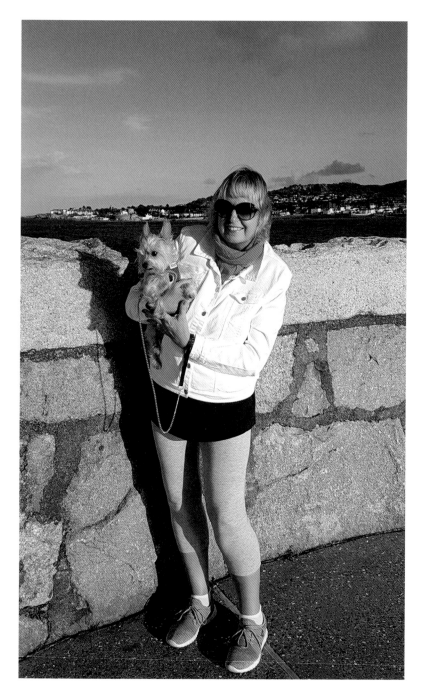

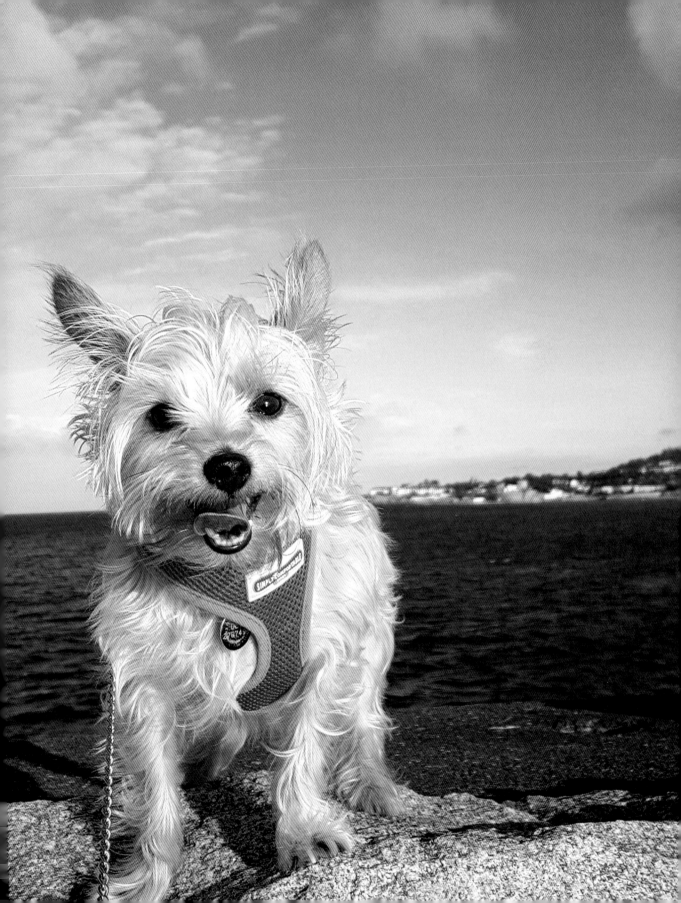

ICE HOUSE SEALS

by Mark Granier

(from *Taking the Plunge*)

A gang of them know where to hang:
below the storage house and fish shop at the end
of the Coal Harbour Pier (wedged between fishing boats

and a wind-chiming thicket of yachts). They bob up
for dangled fish-scraps, bringing us coal-dark
unsurprisable eyes, the roll

of scarred industrial bodies at home
in the open-plan house we climbed from and may
one day be repossessed by.

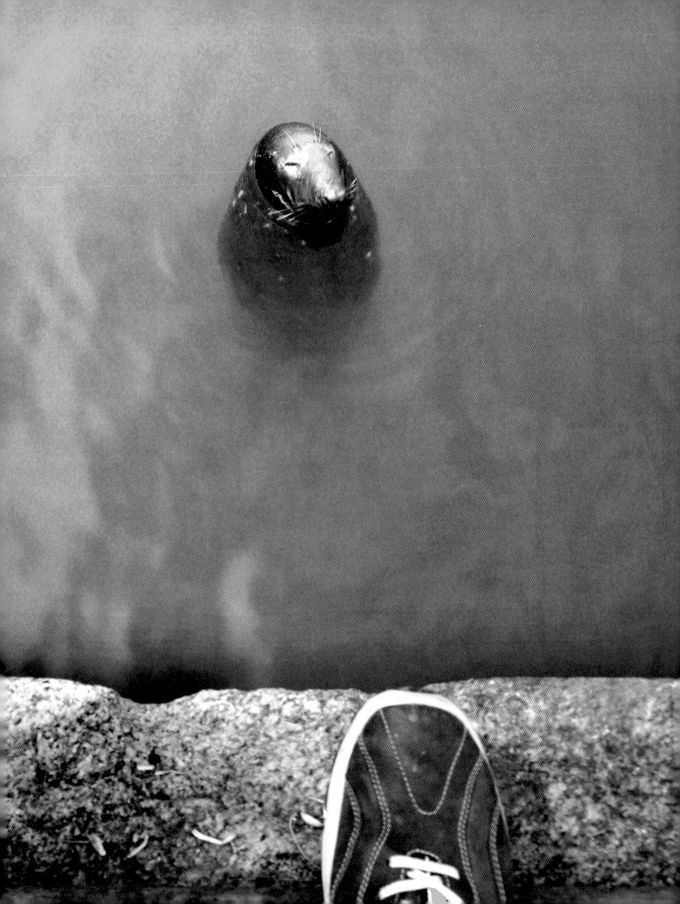

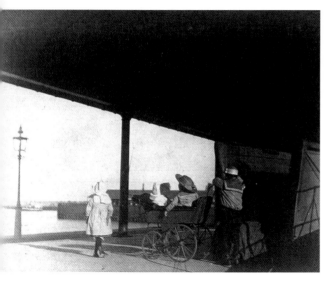

Victoria Wharf, Kingstown.
Image courtesy of Colin Scudds.

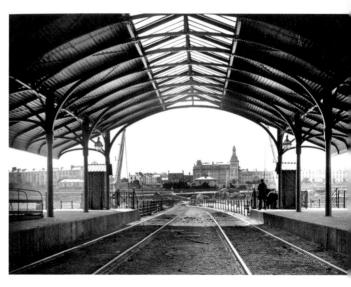

Carlisle Pier. View into Kingstown. Image courtesy
of the National Library of Ireland, S.P. 834

3rd class single ticket from Dún Laoghaire to Holyhead.
Stamped 30 August 1957. Image courtesy of Colin Scudds.

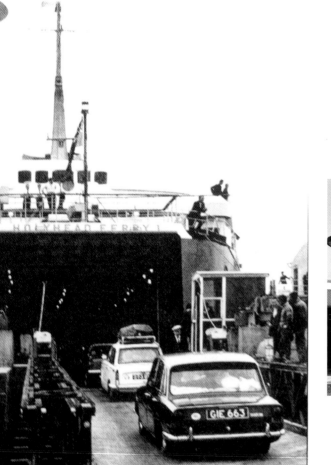

Above: Disused Carlisle Pier building in the 1980s.
Image courtesy of Colin Scudds.

Left: Cars driving on to car ferry berthed at East Pier. 1965
Image courtesy of Colin Scudds.

CHAPTER 5
THE CARLISLE PIER AND HARBOUR HOUSE

THE CARLISLE PIER

'Who can pause to gaze at the almost one square mile of water, swishing its chilly pathways about Dún Laoghaire harbour, without glimpsing the ghostly outlines of that army of Irish people who embarked from this spot? Sink or swim, they must have thought, and pinned their courage to the mast. They were en route to a new life – possibly a better life. But not necessarily. No guarantees were on offer with the bargain struck between an emigrant and fate. They trusted to the promise of a land of milk and honey, but who knew how fresh the milk would be, how sweet the honey?'

'Casting Off' by Martina Devlin (from *Taking the Plunge*)

In addition to the two main piers enclosing the harbour, there is a separate pier called the Carlisle Pier, to which the City of Dublin Steam Packet mail steamers plied twice daily to and from Holyhead. Four vessels had been specially built for the service, capable of attaining a speed of 24 knots and they were the *Ulster*, *Munster*, *Leinster* and *Connaught*.

Construction began on the pier in 1853 and it was completed in 1856 and named after the Earl of Carlisle, the Lord Lieutenant of Ireland at this time. The Dublin–Kingstown Railway line continued from Kingstown Railway Station by means of a spur line; this was completed in 1859. In 1969, a new entrance hall was constructed to the side of the rail line and in 1980, the spur to the pier was closed when the DART was introduced.

The *Ulster*, *Munster*, *Leinster* and *Connaught* sailed regularly during World War I. The *Connaught* was withdrawn in 1916 for use as a government troopship and was later sunk. The *Leinster* narrowly missed a U-boat attack in 1917 but on 10 October 1918, she was torpedoed and over 560 people perished in the horrific disaster, the greatest loss of life ever in Irish waters.

The Carlisle Pier gradually fell into disuse with the construction of a new ferry terminal at St Michael's/Victoria Wharf in 1969 but the mail boat continued to operate from Carlisle Pier until 1976. In 2009, the Victorian structure at Carlisle Pier was demolished by the Harbour Company. It is used today for occasional maritime and yachting events but for many Irish people, especially during the 1950s and '60s, this was their point of departure for life in England and many never returned.

The final ferry to leave Dún Laoghaire for Holyhead was the Stena Explorer on 9 September 2014 and on 5 February 2015, Stena announced that they were terminating their service in Dún Laoghaire. Future plans both for Carlisle Pier and St Michael's Pier remain under discussion.

'Dún Laoghaire harbour, the backdrop for departures, was the last sight of Ireland caught by many of these emigrants, and a plaque on the East Pier marks the lost generations of exiles who set out from there. Never to return. Some went as unwillingly as the convicts once shipped from this harbour on prison hulls bound for Australia. Others had the spirit of adventure to sustain them, to help them look forward instead of back.'

'Casting Off' by Martina Devlin (from *Taking the Plunge*)

EMIGRATION AND MODERN COMMUNICATIONS

Saying farewell to family or friends as they depart on a journey to foreign parts may be an emotional experience. But although the physical distance can be daunting when your loved ones are living far away, at least in this age of hyper communications, it's certain that it won't be long until you see their faces again, if only through the magic of Skype. Hearing their voices is only a touch on the phone screen away and the immediacy of email and text messaging is nothing short of astounding. Not to mention all of the sharing (and over-sharing!) on social media. New technology can bring your family closer to you and keep you connected to them in a regular and meaningful way, although it's no substitute for the moment when you can envelop them in a huge hug again.

Imagine then saying goodbye to them on Dún Laoghaire Pier, the greedy maw of the vast mail boat waiting to suck them in, with no guarantee that they would ever return. Imagine a time in the 1950s and '60s when most families didn't have telephones, when it took up to five days for a letter to come from England, up to a month from America, when the journey by ship from the harbour to Holyhead took twelve hours and then the endless waiting, changing, and finally journey's end in unfamiliar London, Birmingham, Coventry or Derby. Imagine the poignancy of departing from picturesque Dún Laoghaire to perhaps alight in the grim industrial Midlands, scarcely knowing a soul and most likely almost penniless.

But happily, for people walking on the pier today, there's a new buoyancy and sense of optimism in the air, with an economy which affords most young people the ability to remain in the country to be educated, find employment and have a good quality of life. A recent sighting of a large Stena Vessel docked in the harbour caused some to wonder if the 'mail boat' was going to resume operating from Dún Laoghaire. For some, this might have aroused interest from an economic perspective but for others, perhaps it cast a shadow from the all-too-recent past on that bright May day.

Na hEireannaigh Dhearmadta

In commemoration of that generation of post World War II
emigrants who left their homes, counties and country
from The Carlisle Pier, never to return
Often called "The Forgotten Irish", this plaque recalls
their contribution and their loss.

Supported by Friends of the "Forgotten Irish"
and the Dún Laoghaire Harbour Company
15th May 2012

Photo © Local Studies Collection

PRISON HULKS: THE *ESSEX* (1824-37) AND THE *SUCCESS* (1897)

In 1824, a convict ship, the *Essex*, was stationed in Kingstown Harbour. It was a thorn in the side of the Harbour Master as it was sited just off the East Pier. Unlike prison hulks in England, prisoners on board were never taken ashore for rock-breaking or road-laying. It never actually left the harbour but was used as a holding vessel until the prisoners on board were taken to Cork and then transported to Australia. Dark, damp and poorly maintained, many of the undernourished prisoners succumbed to ill health. It was capable of holding 275 convicts and between 1834 and 1837, when it was finally removed, 5,251 prisoners spent time awaiting deportation in the *Essex*, including two prisoners under ten years of age, twenty-five under fourteen, and fourteen under the age of sixteen.

In 1897, another former prison hulk, the *Success*, entered Kingstown Harbour. Conditions were appalling with cells below deck 7 foot by 7 foot for the better behaved prisoners and 4 foot by 7 for the rest. Most offences were entirely trivial and many of the so-called hardened criminals were boys and girls aged thirteen to fifteen years old. The *Success*, the last of the convict ships, was finally destroyed by fire in 1946.

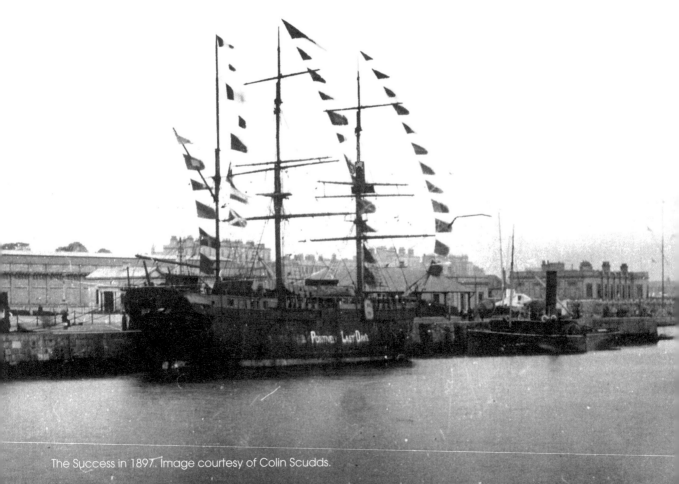

The *Success* in 1897. Image courtesy of Colin Scudds.

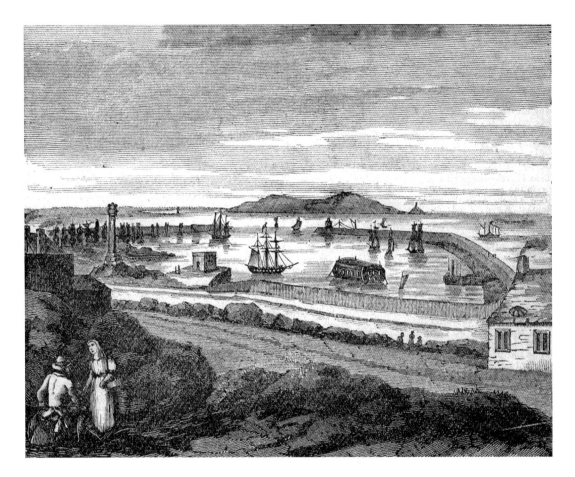

The *Essex*, pictured in a Penny Journal print of 1834. Image courtesy of Colin Scudds.

DAVID KEEGAN

David Keegan lives in Toronto and is a regular visitor to Dún Laoghaire where he grew up. These photos were taken in 2007. What a difference a decade makes!

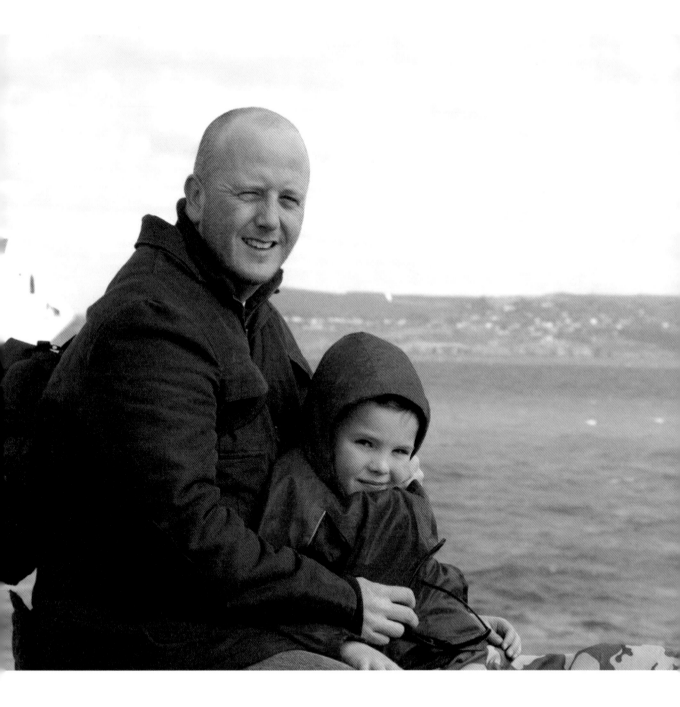

JANET CONNOLLY

Anyone remember a local band named Menace playing on the bandstand in the 1980s? Janet Connolly from Dún Laoghaire, now living in Canada, mentioned them when she sent us this lovely photo from one of her visits home. Janet has many happy memories of first date walks on the pier (sigh!) and never visits Dublin without doing her walk in her very special place where she has brought many Canadian friends over the years.

JERRY AND MAURA CORCORAN

 This photo was taken in November 2017 when Maura and Jerry came up from Offaly for the day to visit the Electric Generations exhibition at dlr LexIcon. Jerry worked with the ESB for many years after returning to Ireland from England with his young family in 1978, forty years ago in 2018! Maura and Jerry travelled regularly from Offaly via Dún Laoghaire Harbour to Holyhead in the 1960s and '70s and then onward to their home in North West London. They lived in Wembley, Stonebridge Park and their longest 'stay' was in Park Royal when Jerry was working with Guinness in London.

On this visit to Dún Laoghaire, Maura was keen to have a close look at the Serpentine Seat, created by her cousin, ceramic artist Orla Kaminska, who was commissioned to create this beautiful and much-loved seat in 1995.

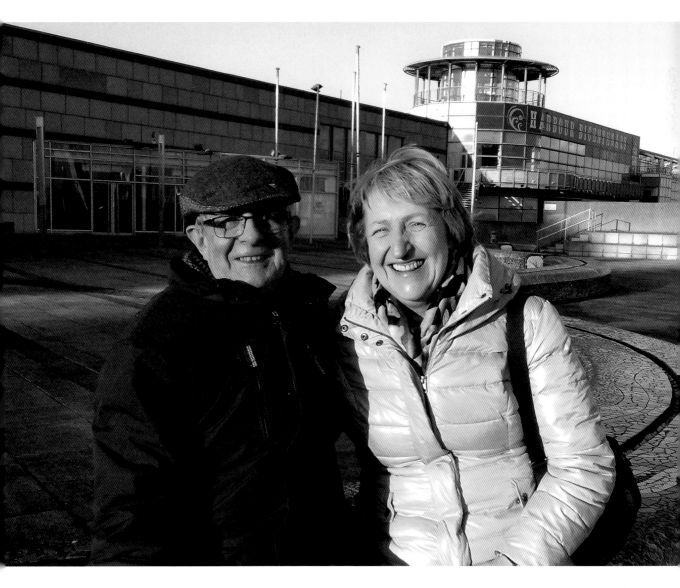

Left to right: Marie Doorley Nestor, Joanna Doorley, Nora Doorley and Bridget Keppler

MARIE NESTOR DOORLEY AND BRIDGET KEPPLER (SISTERS) WITH THEIR NIECES JOANNA AND NORA DOORLEY

This photo, taken in 2004, celebrates Nora's recent First Holy Communion with a walk on the pier. Bridget describes her connection with Dún Laoghaire: 'From 1967 to 1969, I worked in Dún Laoghaire when I left my home town, Ferbane, Co. Offaly. It was hard enough to earn a living in the 1960s and I was pleased to work as a shop assistant in G. O'Connor's jewellery shop on 51 Lower George's Street, still thriving today. Would you believe that I can recall the phone number to this day! I earned £5 per week, worked from 9 a.m. to 6 p.m. and had a half day on Wednesdays. I lived in Monkstown and the cost for the two-bedroom house in Belgrave Square that I shared with my sister Loretta was £2 per week. It was rented by a lovely woman, Mrs Harding, who was very good to us – she worked in the Sweepstakes' offices at Ballsbridge. When Annette, another sister, joined us a few years later, we rented a bigger place on the top floor of a four-storey house at Montpelier Parade. Annette worked for a time in Power's supermarket in George's Street but eventually we both got jobs at Rayon Mills in Sallynoggin, weaving various cloths and earning £6 a week plus a bonus for quantity and quality! Shift work hours were 7 a.m. to 3 p.m. and 3 p.m. to 11 p.m. My sisters and I loved to go dancing at the Top Hat Ballroom in Monkstown and we also got the bus to the Arcadia in Bray.

I usually walked or cycled to work as it wasn't very far but once my bike was stolen and I was really upset as a bike cost around £2.50 back then. I loved the pier and used to walk the West Pier most evenings. Loretta went to London in 1968 and Annette and I followed her in April 1969 – many Irish people found good jobs there back then. I travelled by boat to Holyhead from Dún Laoghaire and then by train to London. I have lived in England ever since then and love the countryside where I live now in Hertfordshire!'

Marie was the youngest daughter in the family but remembers regular trips to Dún Laoghaire to visit her sisters during her school years and recalls waiting outside O'Connor's jewellery shop for Bridget. She enjoyed walks down the piers with her sisters and also to Bray Head on many occasions. Marie didn't work in Dún Laoghaire herself but followed her sisters to London where she has lived on and off for many years.

Steam Boat Train (1959) . Image courtesy of the National Library of Ireland.

Overlooking the Carlisle Pier, the Harbour Master's House is perfectly positioned to oversee the comings and goings at the busy pier. It was built in 1840 and from 1845, the first occupant was Lieutenant William Hutchison. The house was built close to the reservoir in the area of the Churl Rocks (now the water feature at the front entrance of dlr LexIcon on Haigh Terrace) and the house is now occupied by the Design Gallery. The Harbour Master's Office is located at the end of Haigh Terrace and was recently refurbished by the Council. On rough days, Peter Pearson noted that a blue flag was flown from Captain Hutchison's office indicating that the normal boatmen's fares for transferring passengers to and from ships could be doubled.

The second Harbour Master was Captain the Honourable Francis George Crofton, R.N. who served from 1878 to1900. Throughout his tenure as Harbour Master of Kingstown, Captain Crofton and his family lived at Harbour House and, like Captain Hutchison, he also was Secretary of the Kingstown RNLI Lifeboat Station. In 2015, Francis Crofton's great-grandson Patrick Crofton visited Dún Laoghaire after making contact with the Dún Laoghaire Borough Historical Society.

He presented the Society with a copy of Captain Crofton's book entitled *Yarns* and also an oil painting of his great-grandfather, reproduced here. When Captain Crofton died on 30 September 1900, all the flags were flown at half-mast on ships in Kingstown Harbour.

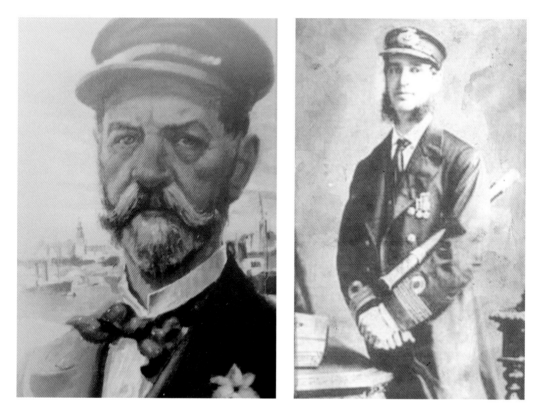

Left: Portrait of the Hon. F.G. Crofton by his great-grandson Patrick Crofton. Portrait presented to the Dún Laoghaire Borough Historical Society and reproduced courtesy of Anna and Colin Scudds.
Right: Photograph of Capt. Francis G. Crofton, Lauder Brothers.

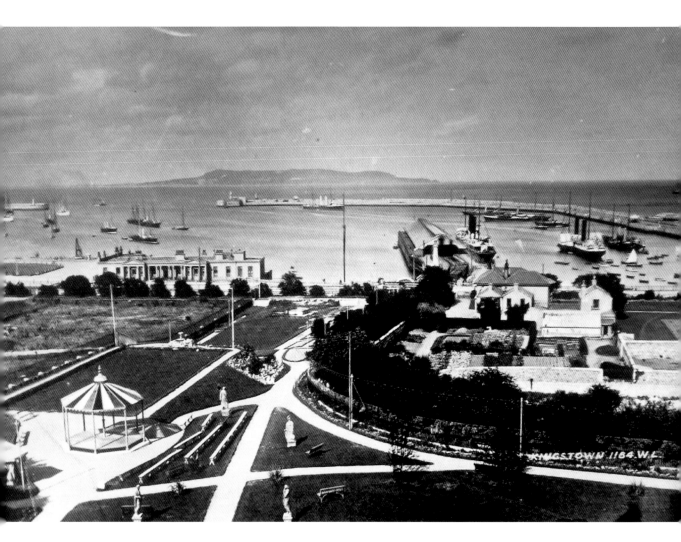

Photo of Harbour House from the Lawrence Collection. Image courtesy of the National Library of Ireland.

MARCONI

In July 1897, Guglielmo Marconi formed the Wireless Telegraph and Signal Company Ltd. One of its first commissions was to report on one of the highlights of the yachting calendar, the Kingstown Regatta, providing live coverage reports on the races, starting on 20 July 1898. Marconi hired a tug, the *Flying Huntress*, and he communicated with George Kemp at the Harbour Master's House. During the two-day event, 700 news flashes were sent and then forwarded to the newspaper offices. It was the first time in the world that radio was used in journalism and a plaque marking this important event can be seen on the east side of Moran Park House.

Russell Kane moved with his parents Hugh and Agnes and brother Hugh to live in Harbour House in 1937 when he was just three years old. They remained there until 1947 and Russell remembers this period of his life vividly: idyllic days out with his friends, swimming in the baths and at Seapoint and Killiney, interspersed with terrifying moments during the Emergency when he and his family had to huddle in an air raid shelter at the back of the Harbour Master's Office during an attack in nearby Glasthule.

Russell's father Hugh was appointed Store Keeper with Dún Laoghaire Borough and boarded initially at the Mad Hatter's accommodation (near Toscana's today). Housing was very difficult to come by during this period but Hugh was adamant he wanted to bring his young family from Carlow to live with him. He was offered a caretaker's lease at Harbour House which was a godsend – rent was free, light, gas and coal were free and he was able to make some further income from cultivating a small market garden at the back of the house. The extent of the house can be seen in this photo of Harbour House from the Lawrence Collection, reproduced on page 203. It was easily twice the size of today's Design Gallery with some seventeen rooms, a coach house and coach yard and extensive trees around the perimeter protecting the pond/reservoir area at end of the garden. Close to the pond, Russell remembered a grave stone for pets – mostly dogs owned by the Crofton family during the late nineteenth century.

Russell went to school to the Presentation Convent Glasthule for the first few years before switching to the Christian Brothers School at Eblana Terrace. His bedroom was at the front of the house – not only was the room directly in line with the comforting glow of the lighthouse at the end of the East Pier but the unmistakable mournful sound of the foghorn lulled him to sleep on many occasions.

In early 1940, Russell remembered being kitted out with a gas mask and evacuee identification papers in County Hall. The gas mask was held in a cardboard box with a shoulder strap. Not long afterwards, he was out in the garden with his father when they witnessed a low-flying dog fight with two British fighter planes pursuing a German fighter plane. He even recalled seeing a barrage balloon flying over the Holyhead mail boat in the harbour – this was a large, kite-like, aerodynamic balloon, anchored to the ground by cables with netting. It was intended as an obstacle to an attacking low-flying enemy aircraft. During the war, the entire lower ground floor of Harbour House was used for regular first aid training and preparation for emergencies. What with the water supply from the pond for fire engines and the proximity to the pier, it was a perfectly positioned base for a rapid response to local events.

The bombing in the Sandycove/Glasthule area took place on 20 December 1940 when two bombs were dropped literally up the road from Harbour House. With the family of Captain Bob McGuirk, the Assistant Harbour Master of the time, and their immediate neighbour, they all sheltered in the little beehive air raid shelter behind the McGuirk's house until the danger had passed. Russell recalled how cold and dark it was and the terror of not knowing how long they might have to remain in the shelter.

Russell Kane overlooking Harbour House, Summer 2018. Photo © Local Studies Collection.

In 1947, the Kane family moved from Dún Laoghaire to their own terraced house in Walkin-stown. Russell, always fascinated by flight, joined the Irish Army Air Corps where he served as a pilot for five years before leaving to join Aer Lingus with which he flew for a further thirty years. During his time with Aer Lingus, he studied law at the King's Inns and was called to the Bar in 1975. He later studied Aviation Law at University College London and, on retiring from Aer Lingus, spent twenty years as an aviation consultant, specialising in aviation law as it applies to the operation of aircraft. Today he lives in Dundrum but is a frequent visitor to his old haunts in Dún Laoghaire, regularly walking the pier in company with an old friend and former Air Corps and Aer Lingus colleague.

Harbour House has had many different roles and numerous residents over the decades since the mid twentieth century. In 1954, according to Peter Pearson, Moran Park was laid out on land encompassing the old reservoir of 'Tank Field' which was bought from the Office of Public Works for £8,000. The grounds had served as the garden to the Harbour Master's house. Some discussion took place about the possibility of turning the house into a small museum. It overlooked the popular Bowling Green behind the house and Ursula's Café is often recalled fondly by locals. Before it became the Design Gallery, it was used extensively by the dlr Festival of World Cultures team and dlr Arts Office staff.

Once the LexIcon was built, Harbour House was refurbished by Dún Laoghaire-Rathdown County Council as part of the Metals Rejuvenation Project and opened officially in March 2016 as the Irish Design Gallery. It prides itself on its range of treasures designed and handmade in Ireland, most within a 50km radius of Dún Laoghaire. The Irish Design Gallery curates new work regularly, providing opportunities to showcase original work by designers, artists and photographers, many of whom are members of the Design Crafts Council of Ireland.

Harbour House, now the Irish Design Gallery

Right: Sinéad Buckley Quinn, Director of the Irish Design Gallery

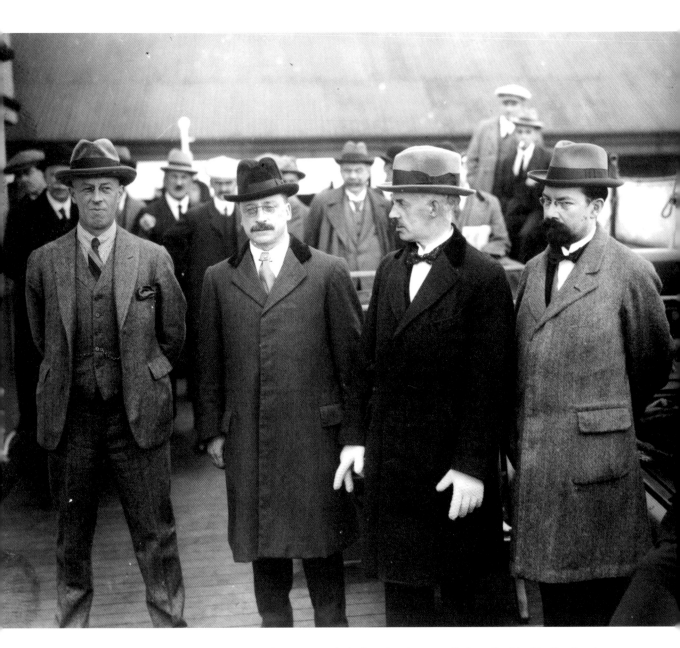

Members of the Irish delegation at Kingstown en route to London for negotiations that led to the Treaty.
Robert Barton, Arthur Griffith, Eamon Duggan and Gavan Duffy. December 1st 1921.

CHAPTER 6
CELEBRATIONS AND FESTIVALS ON THE PIER

'Walking, jogging, strolling, slouching, dandering, holding hands or linking arms, in pairs, groups, with dogs, or alone as Krapp on a stormy March night with his wind-gauged 'vision at last', the endless, changing people tread this 'most walked walk in Ireland.' Easy to imagine the different costumes, trailing Victorian or Edwardian skirts, boaters, sober suits, cloth caps and trilbies of the mid-twentieth century, shading into our present day tracksuits, jeans, baseball hats ... Easy to imagine our shoes, like theirs, imperceptibly wearing the stone, ruffling histories, rehearsing a well-measured haunt.'

'The East Pier, Dún Laoghaire' by Mark Granier
(from Blooming Lit exhibition, curated by Tim Carey)

Over the last 200 years, the East and West Piers have been popular destinations for people from all over the world. Famous politicians, royals and celebrities have embarked and disembarked at the ferry terminals and this chapter highlights a few such visitors in addition to celebrating the many festivals and happenings that find their way to the piers in any given year. Some are more formal ceremonial occasions, such as the royal visits in the nineteenth century, and others are meaningful personal occasions: the weddings, engagements and first dates that are immortalised forever in family photos.

POLITICAL AND ROYAL VISITORS

A number of photos exist of the members of the Irish delegation at Kingstown en route to and from London for negotiations that led to the Treaty. But prior to that, it was a frequent stopover for royal visitors.

One of the most visible references to royal visits to Dún Laoghaire is the King George IV memorial, commemorating not only the laying of the first foundation stone on 31 May 1817 but also the visit of King George IV in 1821. King George IV's visit took place not long after his accession to the throne and he travelled to and from Ireland on the paddle-steamer *Lightning*, later renamed *Royal Sovereign*. One month after he left Ireland via Dunleary, the name of the town was changed to Kingstown and the main street was named George's Street.

Queen Victoria Fountain, erected in 1901 by
Kingstown Town Commissioners. Manufactured
by Glasgow firm Walter McFarlanes and Co.

George IV Monument. Photo 2010.
Image courtesy of Colin Scudds.

The Lord Lieutenant receiving the Royal Visitors, the Prince and Princess of Wales. Detail from
Illustrated London News, 1885. Image courtesy of Colin Scudds

Queen Victoria visited Kingstown on no less than four occasions in 1849, 1853, 1861 (with Prince Albert and three of their nine children) and in April 1900.

'We steamed slowly and majestically into the harbour of Kingstown, which was covered with thousands and thousands of spectators, cheering most enthusiastically. It is a splendid harbour, and was full of ships of every kind.'

An excerpt from the diary of Queen Victoria, Viceregal Lodge,
Phoenix Park, Monday, 6 August 1849

The Queen Victoria Fountain was erected in 1901 by Kingstown Town Commissioners. It was manufactured by Glasgow firm Walter McFarlanes and Co. On 21 July 1903, King Edward VII and Queen Alexandra arrived at Kingstown and they returned to Ireland again on 26 April 1904 and again on 10 July 1907 when they visited the Irish International exhibition in Dublin. The last visit of a reigning British monarch to Kingstown was that of George V, who arrived with Queen Mary and their son, the Prince of Wales (the future King Edward VIII) and daughter Princess Mary. They arrived in Kingstown on 8 July 1911.

In 1874, William Thackeray, who was well known for his satirical writings during his visits to Ireland, described the George IV monument as 'a hideous Obelisk, stuck on four fat balls and surmounted with a crown on a cushion'. It was built for £550 and designed by one of the engineers working on the pier, John Aird (c.1760–1832).

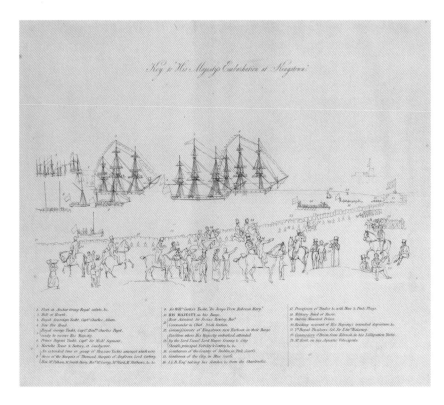

Key toThe Embarkation of George IV at Kingstown, 3 Sept 1821. Engraved by Robert Havell the Elder, English, 1769-1832 and Robert Havell the Younger, English, 1793-1878. After Joseph Patrick Haverty, Irish 1794-1864. NGI 20821/ P7227. Photo © National Gallery of Ireland.

It is possible to glimpse from the images on this page a sense of how the harbour was progressing by 1821. In addition to the rigging, flags and bunting, the East Pier is fully in place but without the promenades, walls and masonry quays.

The visit of King George IV focused public interest on the new port and from this period onwards, it was to become a fashionable destination. With the development of the railway line in 1834, Kingstown was much sought after as it was well served as a hub of transport and communication both on land and sea and of course it sported one of the world's largest and finest harbours.

Enjoy the rest of this chapter which captures an eclectic mix of events. From the literary (dlr Library Voices and Mountains to Sea dlr Book Festival) to the musical (Beatyard and Bandstand recitals), fitness (Red Bull Flugtag and IRONMAN), boating (Tall Ships to Volvo regatta), business (Peer to Pier) to artists on the pier – there is something here for everyone.

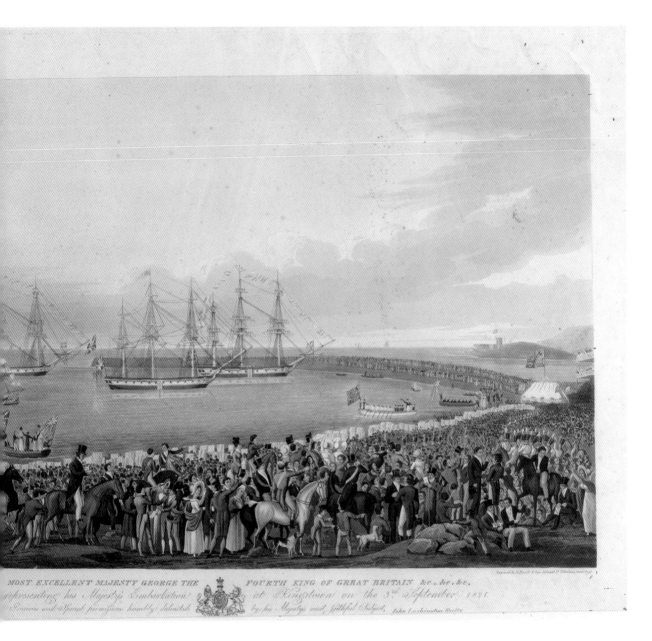

MOST EXCELLENT MAJESTY GEORGE THE FOURTH KING OF GREAT BRITAIN &c..&c.&c.

The Embarkation of George IV, King of England (1762-1830) at Kingstown (now Dún Laoghaire), 3 Sept 1821. (From a J.R. Reilly sketch taken on the spot.) Joseph Patrick Haverty 1794-1864. Aquatint and etching. NGI 11651. Photo © National Gallery of Ireland.

ANN PATCHETT (PHOTO BY GER HOLLAND)

Ann Patchett visited dlr LexIcon on 22 May 2017 to discuss her latest novel, *Commonwealth*, with journalist and arts broadcaster Edel Coffey as part of the dlr Library Voices series. Patchett, an American author, received the PEN/Faulkner Award and the Orange Prize for Fiction in 2002 for her novel *Bel Canto*. This is a favourite spot for photographers, on 4th floor at dlr LexIcon, looking out towards the bay with the East Pier providing a suitable backdrop!

MIA GALLAGHER (PHOTO BY GER HOLLAND)

Award-winning author Mia Gallagher writes novels, short stories and plays. In 2009–2010, she was Writer in Residence with dlr/IADT. She works professionally as an editor and mentor and has been facilitating workshops in creativity, storytelling, drama and performance. Her most recent publications are *Shift* and *Beautiful Pictures of the Lost Homeland*. In this photo, taken during the Mountains to Sea dlr Book Festival in 2014 before the LexIcon was open officially to the public, Mia was giving a workshop.

'I've been sea-swimming in Seapoint year-round over the last three years. I tend to walk the West Pier now, but the East pier always has a special place in my heart. Memories of growing up and being a moany gothic teenager.'

MOUNTAINS TO SEA

The Mountains to Sea dlr Book Festival began in September 2009 and is one of Ireland's pre-eminent literary festivals, attracting the finest national and international writers to the heart of Dún Laoghaire. It takes place in a festival hub chiefly between the Pavilion Theatre and dlr LexIcon, overlooking the East Pier and many of the authors get a chance to explore the harbour area during their stay, weather permitting! For the first five years of the festival, the brochure and poster design showcased books by the participating authors bookended neatly between the two pier ends. Then, in 2015, the design switched the perspective, looking back in from the East Pier to the shore and mountains beyond. The foreground reveals a Mediterranean-like harbour filled with picturesque boats against a backdrop of spires, the chateau-styled Royal Marine Hotel and the dramatic dlr LexIcon.

The festival continues to go from strength to strength and remains a key highlight in Dún Laoghaire-Rathdown's calendar.

Taking a shot at choosing their Mountains to Sea events! (Photo by Ger Holland)

SUSAN LYNCH, LISA MURPHY, CAROLYN BROWN & CORMAC KINSELLA
(PHOTO BY GER HOLLAND)

The Mountains to Sea Team 2017
Left to right, back row -Bert Wright, Bríd Boland and Marian Thérèse Keyes.
Left to right, front row - Sarah Webb, Carolyn Brown and Betty Stenson.

Renowned American poet-laureate Robert Pinsky was a guest at the Mountains to Sea dlr Book Festival in March 2017. The acclaimed poet received a warm welcome as he read from his new and published poems, spent time in conversation with broadcaster Olivia O'Leary where he shared his sense of optimism and hope for humanity, and taught a poetry master class to some enthusiastic participants. He is pictured with Liz Kelly, Director of Mountains to Sea Book Festival, as she brought him on a tour of dlr LexIcon Library, where they spent time admiring the spectacular views from the upper levels.

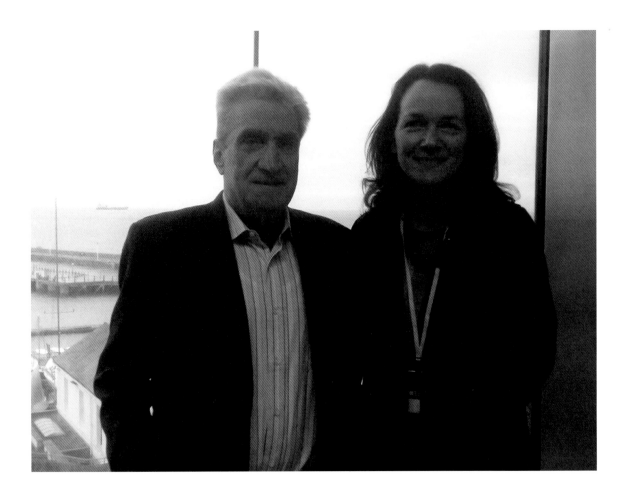

Robert Pinsky, one of America's foremost poets with Liz Kelly, Director Mountains to Sea Book Festival at dlr LexIcon. Photo © Local Studies Collection

DR. ANGELA DAVIS (PHOTO BY CORMAC KINSELLA)

Dr. Angela Davis, the American political activist, academic, and author is world renowned for her ongoing work to combat all forms of oppression in the USA and beyond. Once on the FBI's most wanted list, she has borne personal witness to all of the struggles of our era. She received a rapturous welcome when she took part in the Mountains to Sea dlr Book Festival in March 2018 and this beautiful photo of her was captured by PR guru Cormac Kinsella as they strolled on the pier prior to her appearance at dlr Pavilion Theatre.

GEORGE SAUNDERS AND SINÉAD GLEESON DURING THE MOUNTAINS TO SEA FESTIVAL IN 2017. (PHOTO BY GER HOLLAND)

WILLA FITZGERALD (PHOTO BY JON KELLY)

'Getting to spend a summer in Ireland shooting *Little Women* was an absolute dream. Most mornings were started with a walk down the pier or a run to Dalkey, and Ireland's stunning natural beauty was a daily inspiration.'

Also pictured are Annes Elwy (who plays Beth March in the BBC series) and Jonah Hauer-King (who plays Laurie Laurence).

Marino Branch
Brainse Marino
Tel: 8336297

BEATYARD FESTIVAL

Beatyard, organised by Bodytonic, have been hosting their fantastic annual festival in Dún Laoghaire since they moved here in 2015 after a decade in their city centre location. It takes place during the August Bank Holiday, a last hurrah before summer officially finishes up and the autumn of schools, colleges and classes begins again! With an outstanding and eclectic mix of retro and contemporary acts, it is a great success, aided in no small measure by the bespoke food and drink in their Eatyard and fun and creativity in their Gamesyard. Beatyard takes place on St Michael's Wharf, originally called Victoria Wharf. The final Stena Explorer ferry to leave Dún Laoghaire from St Michael's Wharf, bound for Holyhead, set off on 9 September 2014.

Packed audiences attending Beatyard 2017, cradled between the West and East Piers.
Photos courtesy of Beatyard Festival organisers.

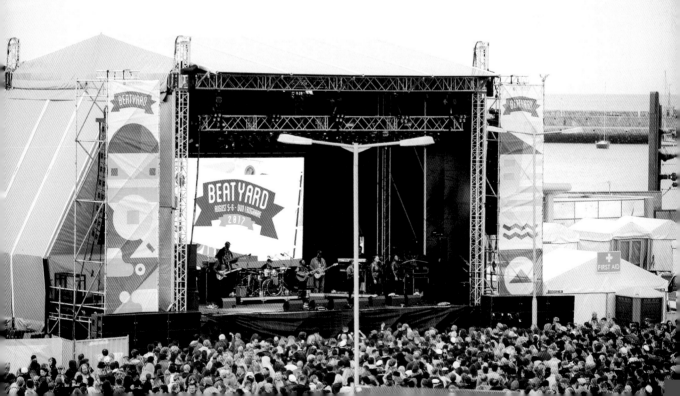

MARINE ARTISTS

GERARD P. DOLAN (PHOTO BY JON KELLY)

PATRICIA HUGHES (PHOTO BY JON KELLY)

BRENDA O'CONNOR (PHOTO BY JON KELLY)

DARLENE GARR (PHOTO BY JON KELLY)

Born in the USA, internationally known artist Darlene Garr has been painting professionally for over thirty-five years and with more than 200 solo and group shows has received wide recognition for her talent, boasting numerous paintings in collections throughout the world. Since arriving in Ireland from Brussels over twenty-one years ago she has found her voice. 'The amazing light, movement and colours in the Irish skies keep me amazed at the never-ending magic of nature. Something within me is always waiting to emerge. During my unconscious time I listen for what is seeking expression, then joyfully engage with whatever surfaces ... In my work, spontaneous movement is as much a medium as the paint itself ... sweeping, relaxed motion allows me to instinctively lay down form and colour in a fluid, high energy manner which keeps the work very physical in nature.' www.darlenegarrart.com

PAUL CHRISTOPHER FLYNN (PHOTO BY JON KELLY)

'Fifty years ago, I watched my Granddad fishing off this pier. I've stood on it watching the boat carrying family members emigrating and I've stood on it waiting for the same boat to bring them home. Now I come here to sell my paintings. And to eat 99's. With red syrup. Just like fifty years ago.'

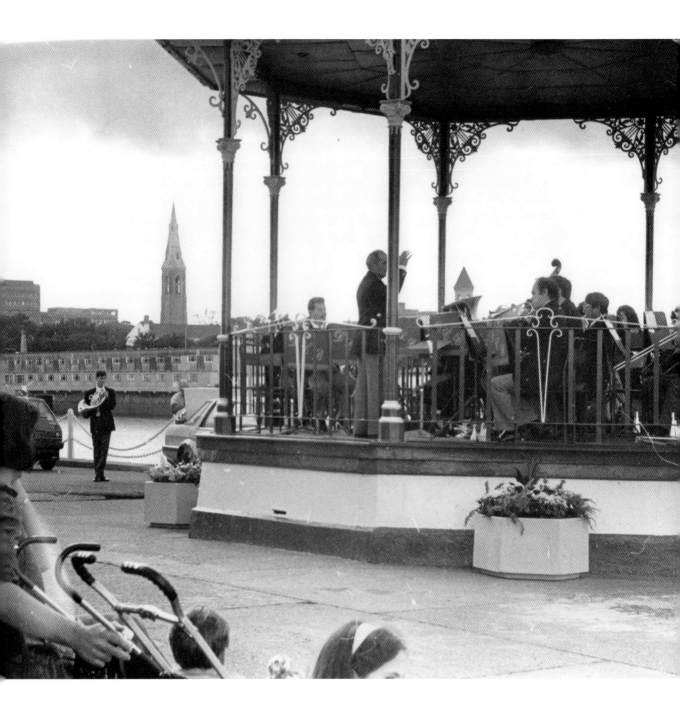

BANDSTAND CONCERT (PHOTO BY COLIN SCUDDS)

Photograph of the East Pier bandstand taken in September 1987, on a Sunday afternoon. Concerts on the bandstand have been a popular entertainment since Victorian Times. The horn player on the left arrived late and is warming up before joining his companions. The woman on the left is Ann Brady, for many years a town councillor, with her grandchildren.

SEASIDE ENTERTAINMENT

by Éamon Sweeney

Over the years, Dún Laoghaire has hosted everything from a Victorian circus to punk rock royalty. In 1850, Pablo Fanque pitched a huge tent in Glasthule for three performances of his famous circus, which John Lennon immortalised in the song 'Being for the Benefit of Mr Kite' on Sgt Pepper's Lonely Hearts Club Band.

An advert for Fanque's circus placed in *The Freeman's Journal* on 17 June 1850 read: 'Mons. P.F. feels a pleasure in announcing to the inhabitants of KINGSTOWN, that he has made arrangements to give THREE GRAND DAY AND EVENING FETES on THURSDAY, June 20th; FRIDAY, 21st: and SATURDAY, 22nd, in a splendid Mammoth Marquee erected in GLASTHULE TERRACE, capable of holding Two Thousand persons at one time.'

The Kingstown Concert Rooms, Assembly Rooms, the front lawn of the Royal Marine Hotel, the East Pier bandstand and the Town Hall itself all featured events before the construction of the Pavilion in 1903, which was modelled on a Mississippi river boat.

In the second half of the twentieth century, rock n' roll and punk rock found a seaside haven at the Top Hat Ballroom on Longford Place, which is now a block of apartments. The Clash played the Top Hat on 12 October 1978, which RTÉ presenter Dave Fanning considers one of the greatest shows he's ever seen. The support act were the Virgin Prunes, an Irish avant garde post-punk band featuring Gavin Friday.

The Pavilion Theatre. Photo by Ger Holland.

Other acts who played the Top Hat include U2, Danzig, The Stranglers, Faith No More, Metallica, The Mission, Slayer, The Jam, Nuclear Assault, Zed Yago, WASP, Exodus, Slammer, Crumbsuckers, The Waterboys, The Jesus and Mary Chain, Onslaught, Suicidal Tendencies, Kreator, Death, The Pogues with The Dubliners (then featuring Dún Laoghaire born and bred legend Ronnie Drew), Sepultura, Anthrax, Prong, and of course, Sonic Youth and Nirvana, just a few short weeks before the Seattle trio released a song entitled 'Smells Like Teen Spirit'.

In an interview to mark the twenty-fifth anniversary of Nevermind, Kris Novoselic reflected on playing the Top Hat. "There weren't a lot of people there to see Nirvana," Novoselic recalled, 'It was the calm before the storm. We were just this band from the north-west corner of the United States. I always loved going to Ireland because there was good beer and no language barrier.'

Today, international musical and theatrical talent comes to the present-day Pavilion Theatre, and Mountains to Sea has become one of the country's leading literary festivals. Who knows what the future will bring? To paraphrase the late David Bowie, you can be guaranteed that it won't be boring.

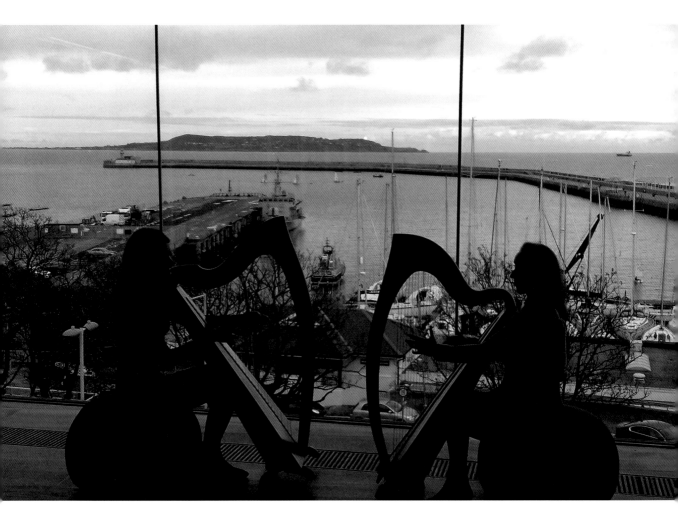

The Harpathon at dlr LexIcon in 2017

IRONMAN

This famous race certainly isn't for the fainthearted! It starts with a 1.9km swim from Sandycove before a 90.1km bike course around the county, followed by a 21.1km run, finishing up in Dún Laoghaire Harbour. IRONMAN started in 1978 on the island of Hawaii, based on a debate between navy personnel to see which athlete was the fittest: the swimmer, the cyclist or the runner. Back in 1978, fifteen people set out to complete the race and Naval Commander John Collins famously said, 'Whoever finishes, they will be called an IRONMAN.' This year, in 2018, the event celebrates its fortieth anniversary and it has become a global movement of thousands of people, bound together by a single goal. Dún Laoghaire will be hosting the only IRONMAN 70.3 race in the country this year and has secured the rights for three years to this very high-profile worldwide event.

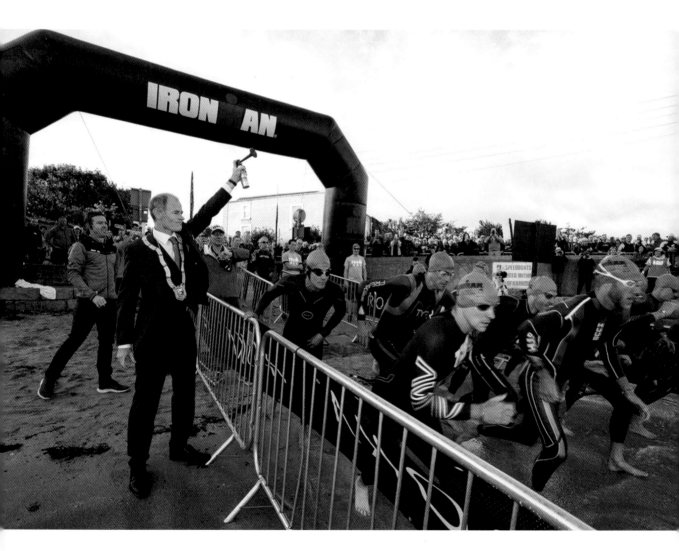

IRONMAN race started by An Cathaoirleach Cllr. Ossian Smyth at Seapoint.
Photos by Peter Cavanagh.

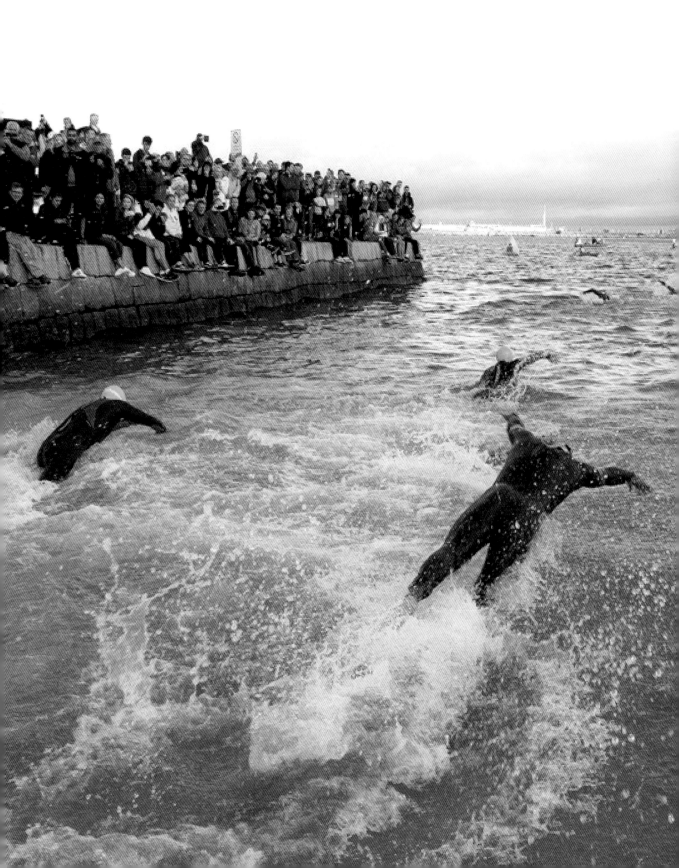

RED BULL FLUGTAG

After a break of seven years when the Red Bull Flugtag was first held here in 2011, this zany festival returned to Dún Laoghaire on Sunday, 20 May 2018. The whole idea behind the Flugtag is that competitors try to fly homemade, human-powered flying machines. The size and weight of the aircraft is limited and it is launched off a pier of around 9 metres or 30 feet high into the sea. The event is all about entertainment – the flying machines rarely fly more than a few feet, plunging immediately into the water! The winners are judged by distance, creativity and showmanship and the aircraft is fuelled by muscle, gravity and imagination! On 20 May, forty-three teams competed in front of a massive audience of over 65,000 people. The Pink Panther team won first prize. Dressed as police, robber and an inspector, they flew a magnificent 12 metres! Second prize went to the Luasers from Spin 1038, championing a Luas-themed aircraft and third prize went to Pegasus.

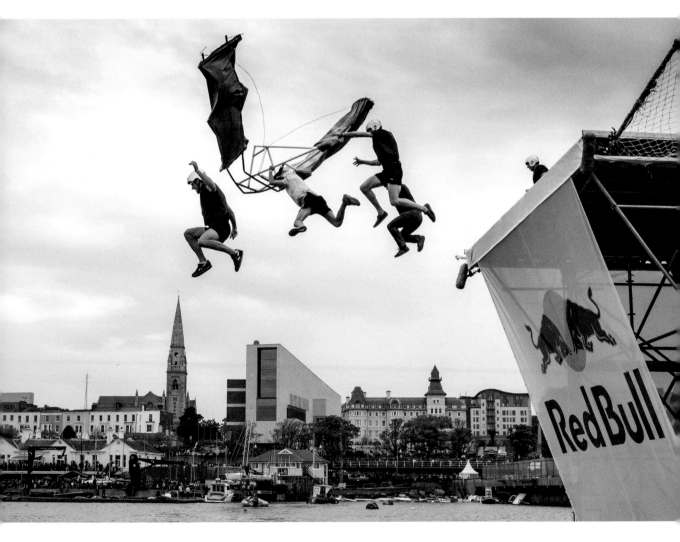

Photos courtesy of Morgan Treacy/Red Bull Content Pool

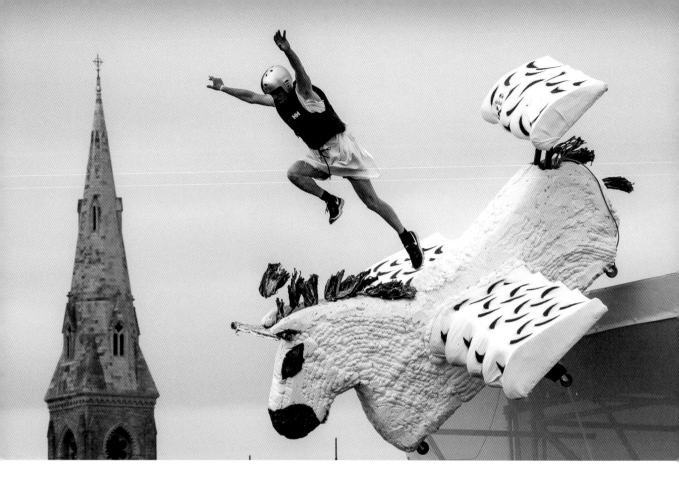

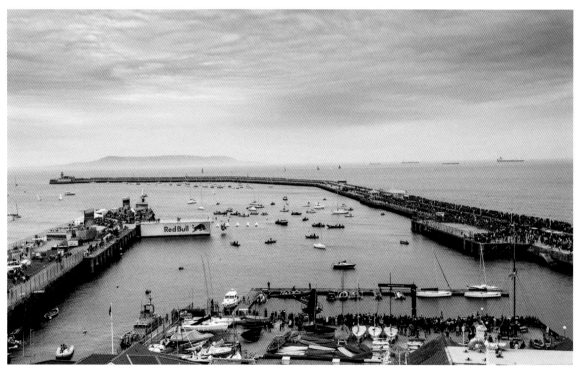

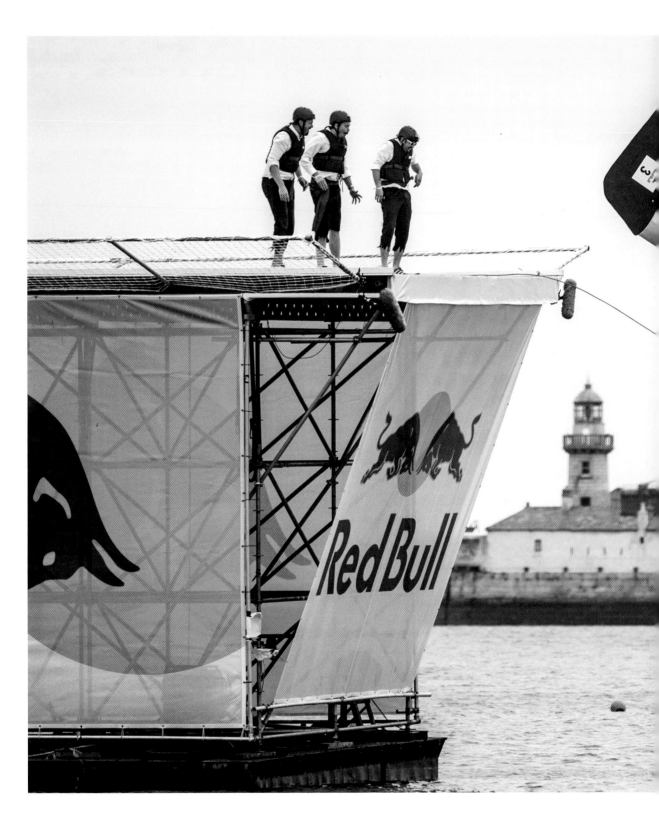

Photos courtesy of Samo Vidic/Red Bull Content Pool

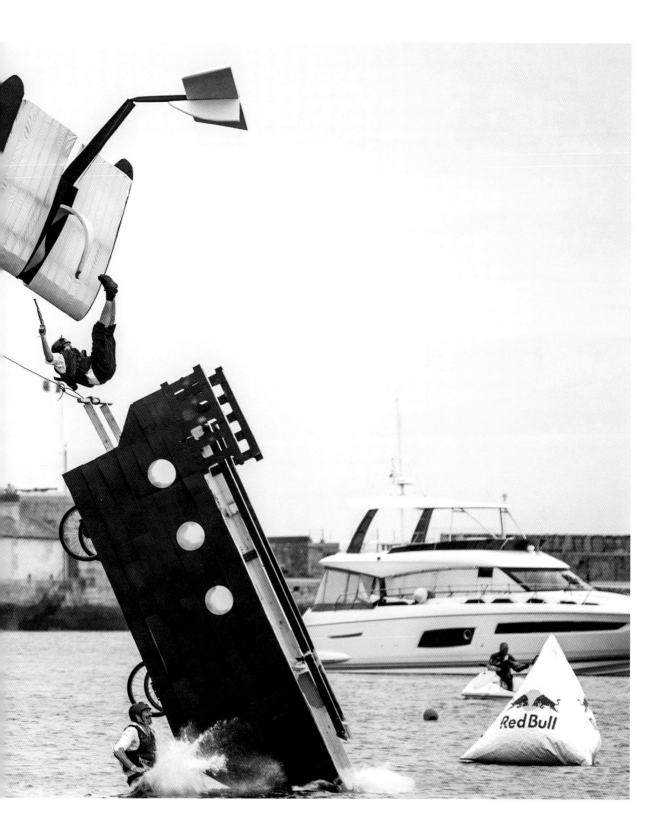

SHIPS IN THE BAY

Every year, a wide variety of boating races and events take place in Dublin Bay. Regattas were a huge visitor attraction from the late nineteenth century (as we can see in the photo below) and what with four major yacht clubs dotted along the Dún Laoghaire coastline, there is no shortage of keen sailors! Every summer, the Tall Ships glide into view, stately as galleons and eerily out of time (see Cyril Byrne's stunning photo at the front of this book). Not to mention the numerous international Volvo races and many other key fixtures throughout the year.

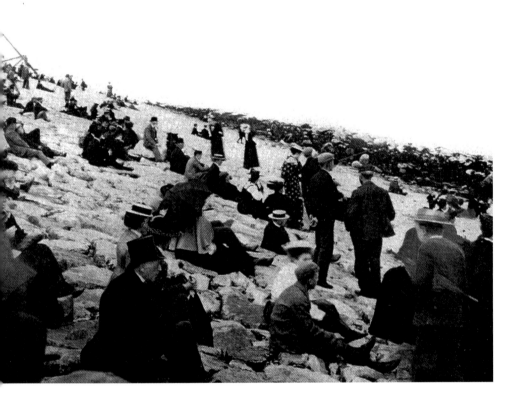

Above: The Regatta, Kingstown, Co. Dublin, 1896. Image courtesy of Irish Historical Picture Company.

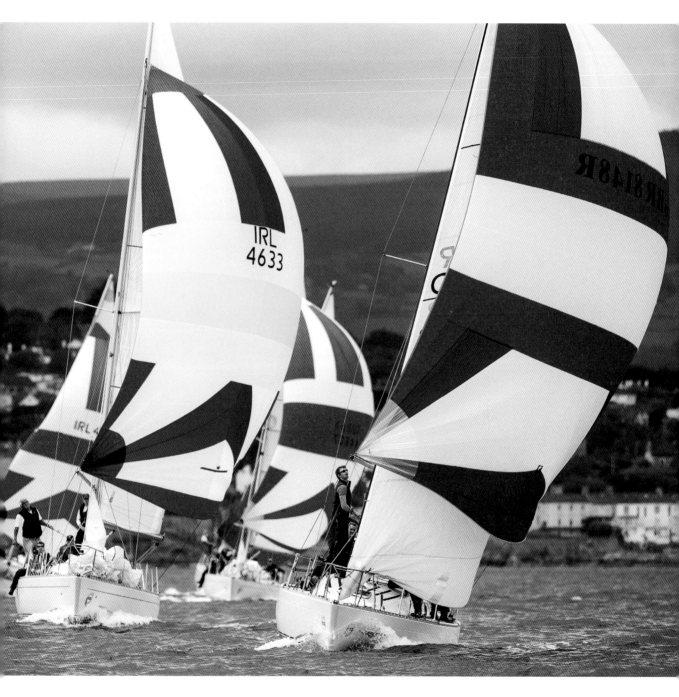

The Volvo Regatta. Photo courtesy of Gareth Craig Photography / Fotosail.com Marine Photography.

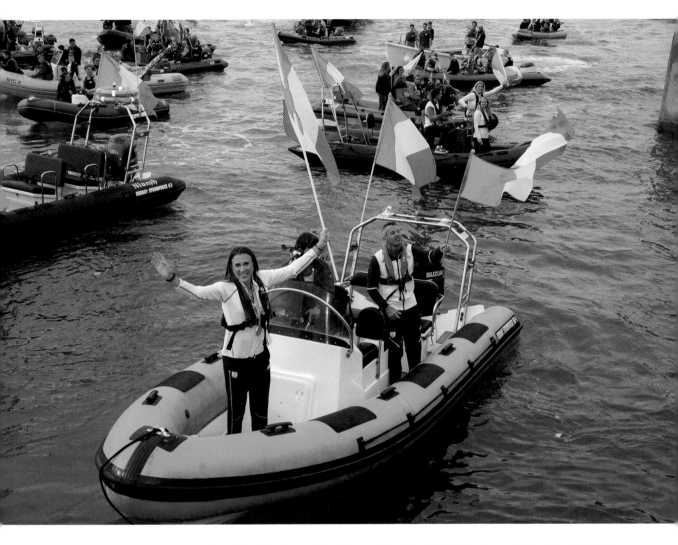

Olympic sailing silver medallist Annalise Murphy arriving in a celebratory flotilla that was led by the RNLI Dún Laoghaire Lifeboat and 25 yachts and ribs in August 2016, following her win in the Rio Olympics. Annalise was led up the pier by Sonna Samba drummers and An Cathaoirleach Cllr. Cormac Devlin to a public celebration in the People's Park. Photos by Peter Cavanagh.

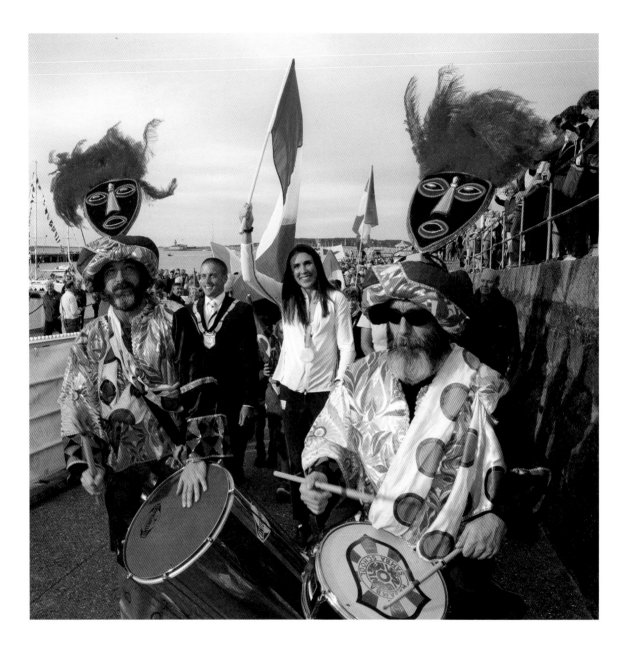

Above: courtesy of Peter Houlihan of PH Photography

PEER TO PIER

dlr's Local Enterprise Office organised their first 'Peer to Pier' networking walk during Local Enterprise Week on 9 March 2018. It was such a success that they followed up with another networking walk a month later. Hundreds of people turned up including mentors, exec coaches, start-up representatives, funders and agencies and they enjoyed 2.5km of networking! Owen Laverty, Head of Enterprise at dlr, described it as a 'unique format which proved extremely popular in March, so we decided to run it again in April. Comments from participants suggested that there was something about the act of walking that created a stronger and more lasting connection which was very conducive to doing business.' The networking comprised of a series of points along the pier where people were encouraged to 'swap' their walking partners before reaching the end of the Pier. They were then treated to ice cream and coffee before returning to one of the nearby yacht clubs to continue networking. www.peertopier.ie

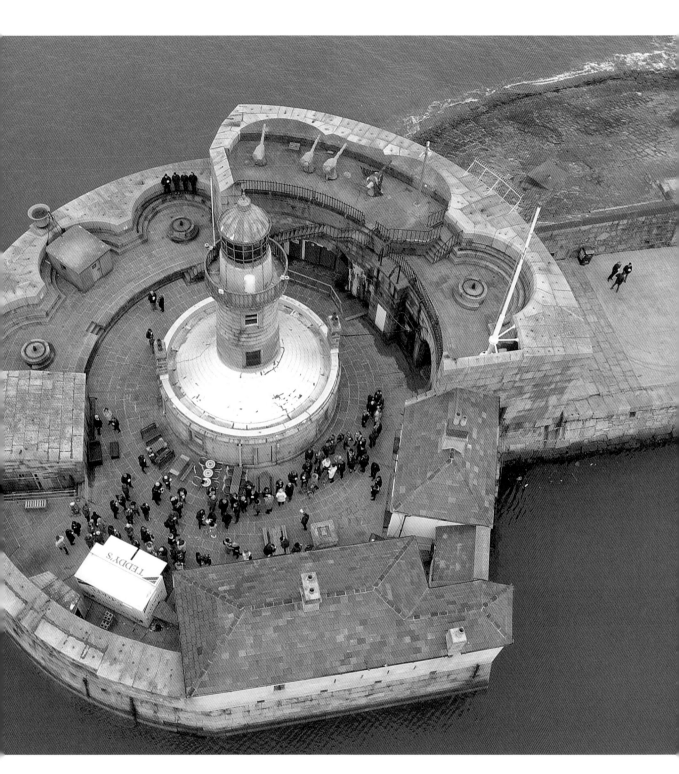

Photo by Ian Kiely who is COO of Drone Consultants Ireland, based in the Media Cube in IADT. Ian has had an interest in drones since 2014 and has become recognised as one of several global Irish thought-leaders on drone applications . He can be contacted at ik@droneconsultantsireland.ie

WEDDINGS AND ENGAGEMENTS

DEBBI PEDRESCHI

Photo by Phil Voon of Give Us A Goo Photography www.giveusagoo.com/

'Myself and Patrick got engaged in December of 2015, in Cologne, Germany where we were over visiting the Christmas markets. Patrick proposed to me (after seven years of being together) on a dinner cruise under the stars. We chose Dún Laoghaire Pier as our location for the "engagement" shoot as it means so much to us. We both knew the bandstand separately before we knew each other, and it's one of our favourite places. We have lived in Dún Laoghaire together for nine years, and will leave it in a couple of weeks to start our new married life together in Galway, so it was important to us to have some beautiful memories to take with us. I think Phil (the photographer) has given us that.'

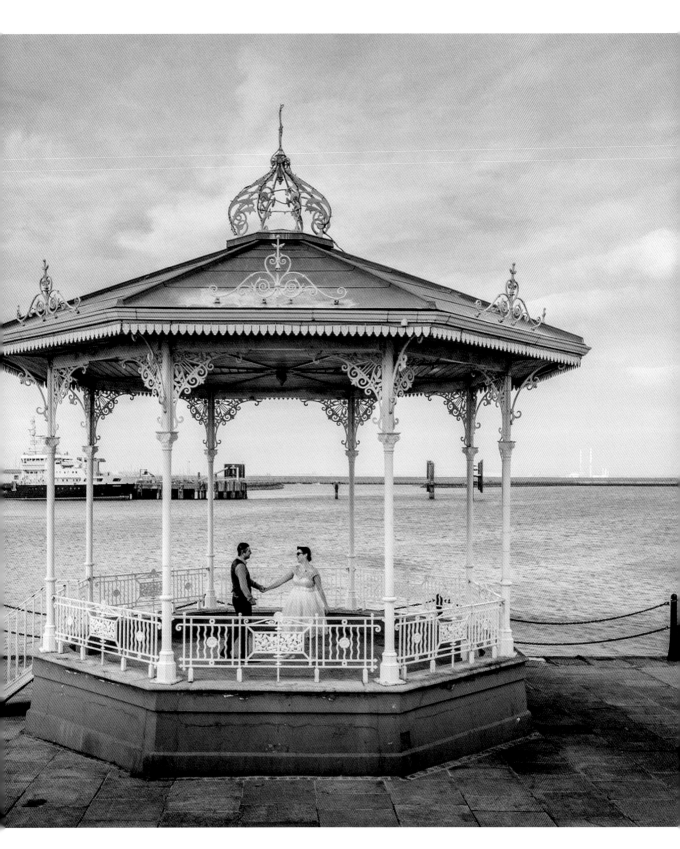

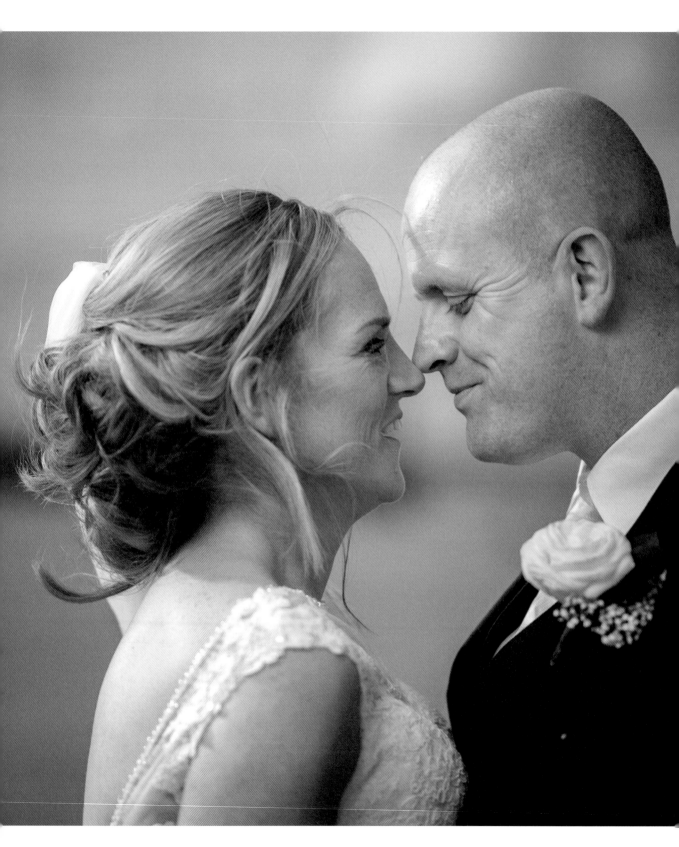

NICOLA FLANAGAN

'We met through work and started dating in 2003. First date and kiss was in IMC in Dún Laoghaire – we went to watch Maid in Manhattan! Dún Laoghaire became our meeting spot and we had many walks along the Pier. Fifteen years later we are married with three boys and still spend many sunny days on the pier with a Teddy's ice cream followed by a trip to the People's Park.'

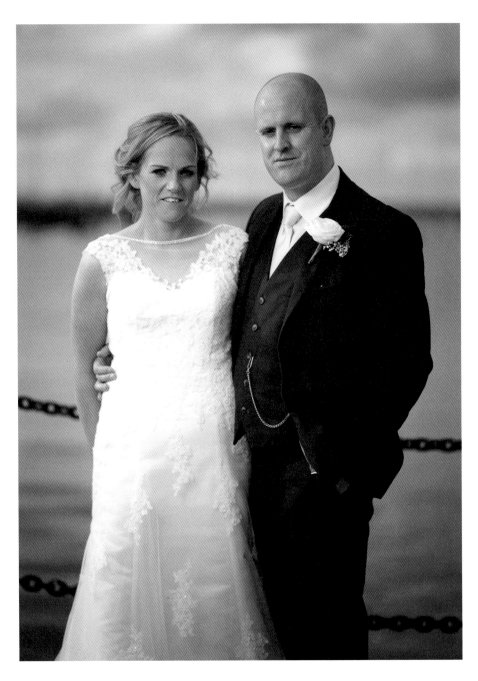

ORLA MULLANE

'The photo was taken on 15 July 2011, our wedding day. We had a ball and enjoyed a Teddy's ice cream while getting our photos done. Apparently it rained but we barely noticed!'

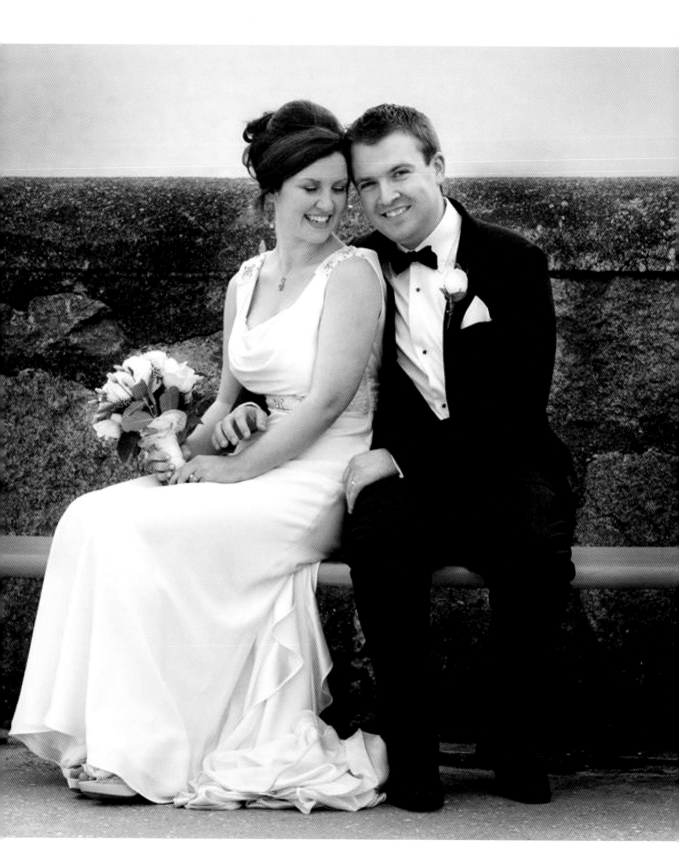

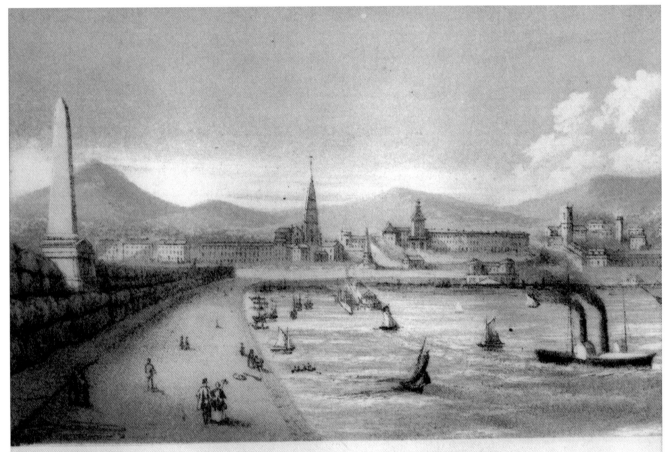

VIEW OF KINGSTOWN, FROM THE BOYD MEMORIAL, EAST PIER.

Drawn for Gaskin's "Irish Varieties."

(1869)

View of Kingstown from the Boyd Memorial East Pier. Drawn for Gaskin's *Irish Varieties* 1869.
© Local Studies Collection

CHAPTER 7
STORMS, SCENERY AND SUNSCAPES

From wild and treacherous storms, dangerous fog conditions and heavy snowstorms to idyllic, tranquil sunsets, Dún Laoghaire Piers have witnessed the ever-changing contrasts in weather fronts across Dublin Bay. This chapter highlights some of the extreme conditions seen over the last 200 years, many leading to tragic loss of life and maritime disasters but we also celebrate the natural beauty of Dún Laoghaire and its piers, not least with the magnificent sunrises and sunsets captured by so many people as they gaze across Dublin Bay during their during their early morning and evening strolls.

THE GREAT STORM OF 1861

In February 1861, one of the worst storms ever recorded took place, giving rise to winds of over 140km per hour, causing havoc on land and sea. Six ships were reported sinking off the Wicklow coast and two brigs went down, one in Dalkey Sound and another off Killiney – there were no survivors from either shipwreck.

For the first time in thirty years, the postal communications between Ireland and England were interrupted as the mail packet encountered massive waves outside Kingstown Harbour, carrying away part of her decking and completely submerging the post office below deck. A large quantity of correspondence, damaged by sea water, was sent back to the GPO in Dublin to be dried and identified. One schooner, the *Clyde*, laden with salt, was driven onto the rocks at the back of the East Pier under the battery and was eventually driven into the harbour and dashed to pieces between the Royal Irish Yacht Club and the Coal Quay. In all, more than twenty-three ships were wrecked in the harbour area during this storm.

By midday on 9 February, the storm worsened. John McNeil Boyd, captain of the HMS *Ajax* which was stationed in Kingstown Harbour, went to the rescue of the *Industry* and the *Neptune*, both floundering at the back of the East Pier. Boyd fired a rocket with a line attached towards the *Neptune* but it was carried away by the gale. He and five volunteers waded into the water making a human chain to reach the crew but a mountainous wave swept them all out to sea and they were drowned. Only one of the *Neptune*'s crew survived but all of the crew of the *Industry*, apart from the captain, were saved. The RNLI awarded the silver medal posthumously to Captain Boyd's wife and the other crew members of the *Ajax*. Partly as a result of this tragedy, the RNLI set up a lifeboat station in the immediate area.

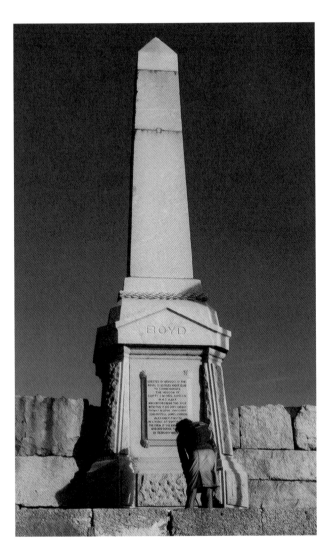

Above: Boyd Memorial. October 2010. Image courtesy of Colin Scudds.

Right: Artist's impression of the Boyd Rescue, *Illustrated London News*, 1861. Image courtesy of Séamus Cannon.

In addition to the memorial on the East Pier, there are also memorials to Captain Boyd and his men in Carrickbrennan Graveyard, Monkstown and St Patrick's Cathedral Dublin.

CHRISTMAS EVE 1895

This date heralds another tragic moment in Irish lifeboat history. The SS *Palme*, en route from Liverpool, attempted to shelter in Kingstown but couldn't make it into the harbour and it ran aground opposite Blackrock with the crew still on board, too far to get to shore. Two lifeboats went

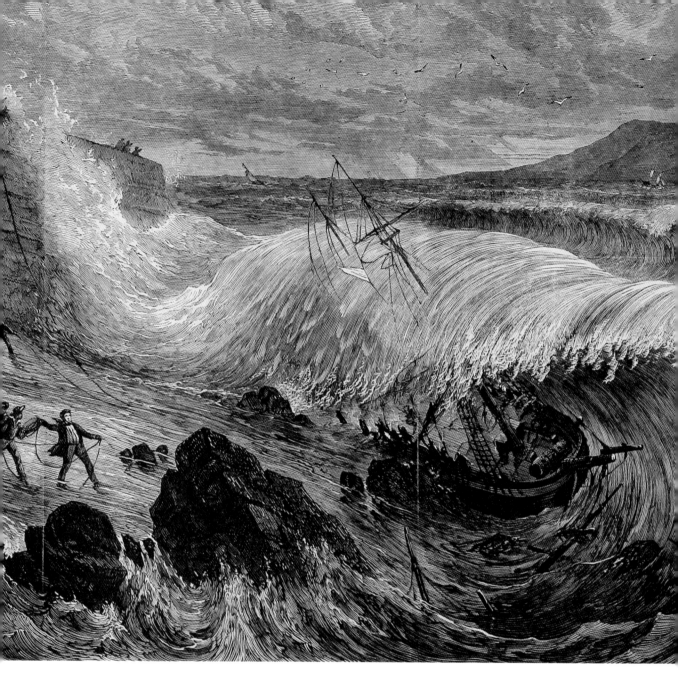

to the rescue but the first, the *Civil Service No 7*, capsized and the entire crew perished. The second life boat, the *Hannah Pickard*, also capsized but recovered and made it back to shore. Ultimately, the crew of the SS *Palme* was saved several days later by the SS *Tearaght*, an Irish Lights vessel. The Christmas Eve disaster is commemorated annually and the granite plaque near the lifeboat house by the East Pier recalls, 'From this stone boathouse in 1895 in a terrible storm 15 brave men from this lifeboat station rowed out to rescue the crew of a wrecked ship … Their sacrifice will not be forgotten.'

Ava and Darren Blackmore enjoying the People on the Pier celebration at dlr LexIcon in December 2017.
Photo by Peter Cavanagh.

DARREN BLACKMORE

Family ties with the area go back a long way for Darren Blackmore. His great-aunt's husband Francis Saunders tragically drowned in the Dún Laoghaire lifeboat disaster of 1895 while his great-great aunt drowned when the RMS *Leinster* was sunk in 1918. But his uncles who went on to serve in the RNLI doubtless helped save many lives from being lost at sea.

In these less turbulent times, Darren carries on the family tradition of taking a walk on the pier most evenings, with his wife Lisa and young daughter Ava. A Dún Laoghaire man to the core we'd say!

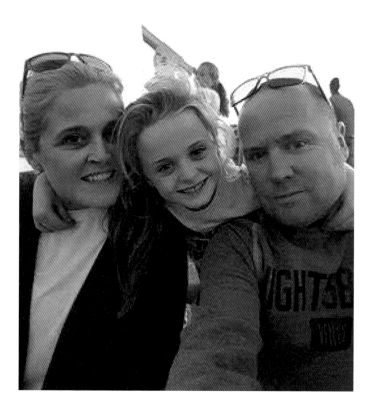

DOWN BY DÚN LAOGHAIRE

by Celia de Fréine

My grandmother, Esther Ryan, was a Dún Laoghaire woman born and bred. Her husband, Thomas Freeney, was born in Liverpool to an Irish family who moved to Dún Laoghaire. Both families lived by the sea. The sea gave them a living, it also exacted a cost. Sometimes that cost was the ultimate one, as when Esther's brother, James, lost his life on Christmas Eve, 1895. James was a crew member of the *Civil Service No 7* lifeboat who, along with fourteen others, set out during a storm to rescue those aboard the SS *Palme*, a barque which had got into difficulties in Dublin Bay.

Although Dún Laoghaire was home to the Freeneys, Thomas spent little time there. When he was fourteen he ran away and joined the British Navy. Having served his time he married Esther and became a coastguard. Their children were born in different coastguard stations around the country. By 1920, when the family returned to Dublin, the War of Independence had begun and coastguard stations were a prime target for the IRA. Twice the Freeneys came under attack. On one occasion, before their accommodation was burnt to the ground, Thomas was told he could remove the family's belongings. They had recently invested in a piano but there wasn't enough time to shift the unwieldy instrument. As Esther comforted her terrified children, the Commandant caught sight of a picture of the Sacred Heart of Jesus hung on the mantle. Thomas asked: 'Are you going to set fire to that?'

As well as being a devout Catholic, Thomas was a loyal servant of the crown. When the Free State was founded he continued to serve and the family moved to the North. His two sisters married British Soldiers, one of whom lost his life in the RMS *Leinster*. The second sister married in 1918 but died within months from Spanish influenza. My father was a devout Catholic, though his attitude to the crown was somewhat ambivalent. By the time I reached the age of reason I decided my loyalties lay elsewhere.

Each time I visit Dún Laoghaire pier I think of my family and the part the sea played in their lives, in particular the events of Christmas Eve, 1895, when those fifteen crewmen were lost in one of the worst tragedies to befall the RNLI in Ireland.

In 2011 I was invited to take part in a series of workshops in the Pavilion Theatre facilitated by Conal Morrison. When the series came to an end those of us involved formed the Pavilion Playwrights and produced a series of rehearsed readings of our work. My first play *Present* involved two characters, James Ryan and his imagined pregnant girlfriend. Its theme concerned that universal conflict: whether to discharge one's duty to one's dearly beloved or to answer that higher call. *Present* developed into the monologue *Beth* which was staged alongside *Katie* by Lia Mills in 2016. *Katie* & *Beth* formed part of the programme in the Two Cities One Book Festival the same year. *Beth* is set on Easter Monday, 1916. The seamstress and single mother wonders why her son, James, hasn't come home. Where is he? What could he have got up to?

Katie & *Beth* played to a full house and was the first dramatic production staged in the LexIcon Studio Theatre. What better place than overlooking Dún Laoghaire Harbour, a stone's throw from the monument dedicated to James Ryan and the fourteen others who lost their lives on Christmas Eve, 1895?

Right: Celia de Fréine and her granddaughter Celia Harte (Photo by Vanya Harte).

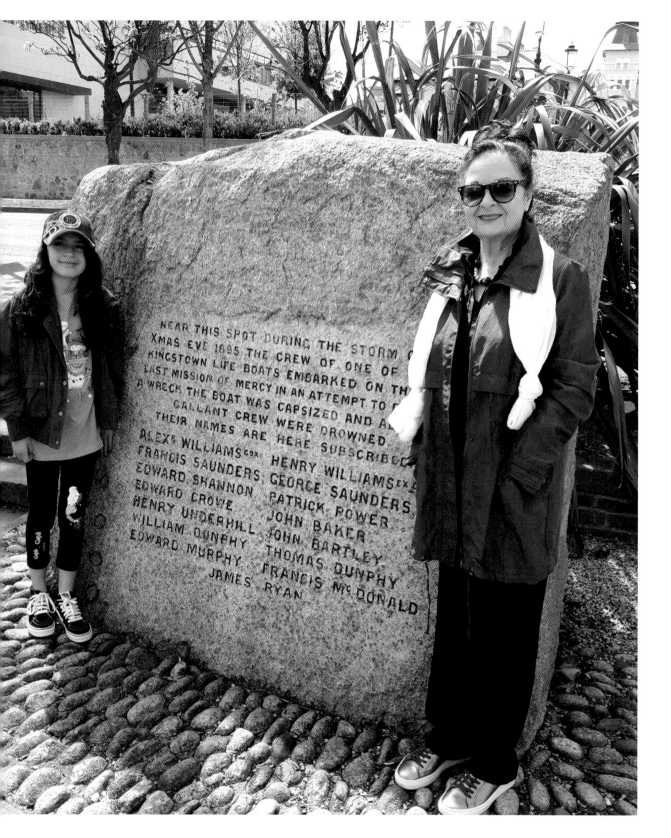

NEAR THIS SPOT DURING THE STORM O
XMAS EVE 1895 THE CREW OF ONE OF
KINGSTOWN LIFE BOATS EMBARKED ON TH
LAST MISSION OF MERCY IN AN ATTEMPT TO
A WRECK THE BOAT WAS CAPSIZED AND A
GALLANT CREW WERE DROWNED
THEIR NAMES ARE HERE SUBSCRIBED

ALEX WILLIAMS COX HENRY WILLIAMS EX
FRANCIS SAUNDERS GEORGE SAUNDERS
EDWARD SHANNON PATRICK POWER
EDWARD CROWE JOHN BAKER
HENRY UNDERHILL JOHN BARTLEY
WILLIAM DUNPHY THOMAS DUNPHY
EDWARD MURPHY FRANCIS McDONALD
 JAMES RYAN

THE RNLI

by John Coveney

I 'emigrated' from Bishopstown in Cork to Dún Laoghaire in the early 1990s to work as a conservation officer for Birdwatch Ireland – or the Irish Wildbird Conservancy as it then was. In those days, before they moved to Kilcoole, it was based in Longford Place and backed onto the Old Dunleary Road – conveniently close to the West Pier . . . and the Purty Kitchen! After leaving Birdwatch Ireland in 1997, I worked as an ecological consultant and settled in Shankill. Through my interest in wildlife, I got to know the coasts of Cork and Kerry very well in my student days, so I've always been drawn to the shoreline of Dún Laoghaire-Rathdown – including both piers enclosing Dún Laoghaire Harbour. They are a regular destination for my long-term project on moon shots around Dublin Bay. During my time as an ecological consultant, I often did bird surveys in the Irish Sea and I was always conscious that the emergency services were available if we ever had a problem – fortunately we never did!

So, on Christmas Eve 2017, I photographed the RNLI's annual tribute on the East Pier to the loss of the Dún Laoghaire lifeboat's crew on Christmas Eve 1895 when they were attempting to rescue the crew of the ship that was in danger in the Bay.

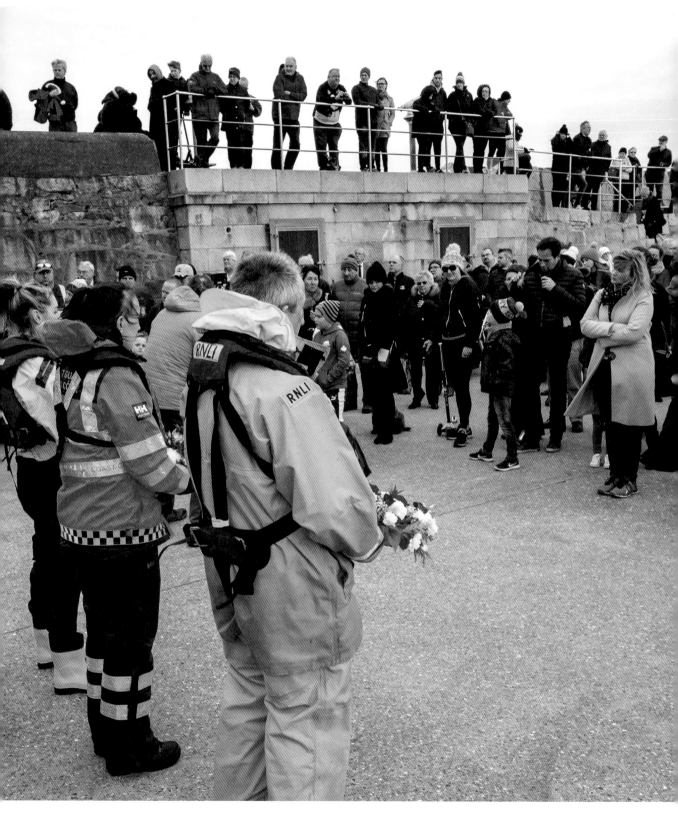

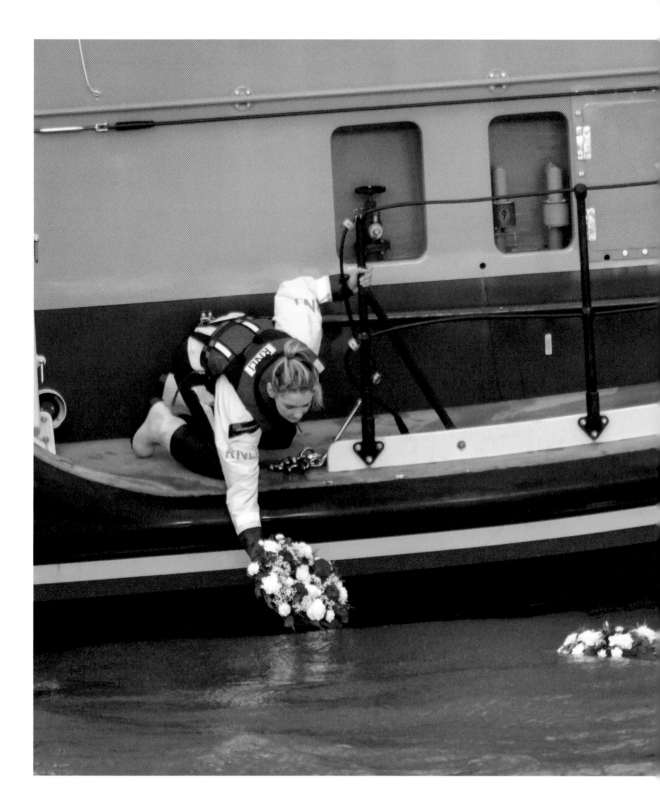

PHOTOS BY JOHN COVENEY

STORM OPHELIA AND STORM EMMA

The Spring of 2018 saw a series of remarkable storms and heavy snowfalls throughout Ireland. It had been eight years since Dún Laoghaire experienced such snowdrifts so it was the perfect opportunity to record the piers from a dramatic new perspective, albeit from a distance due to the severe damage incurred on the 200-year-old infrastructure.

PHOTOS BY BHAWNA SINGH SUROTH

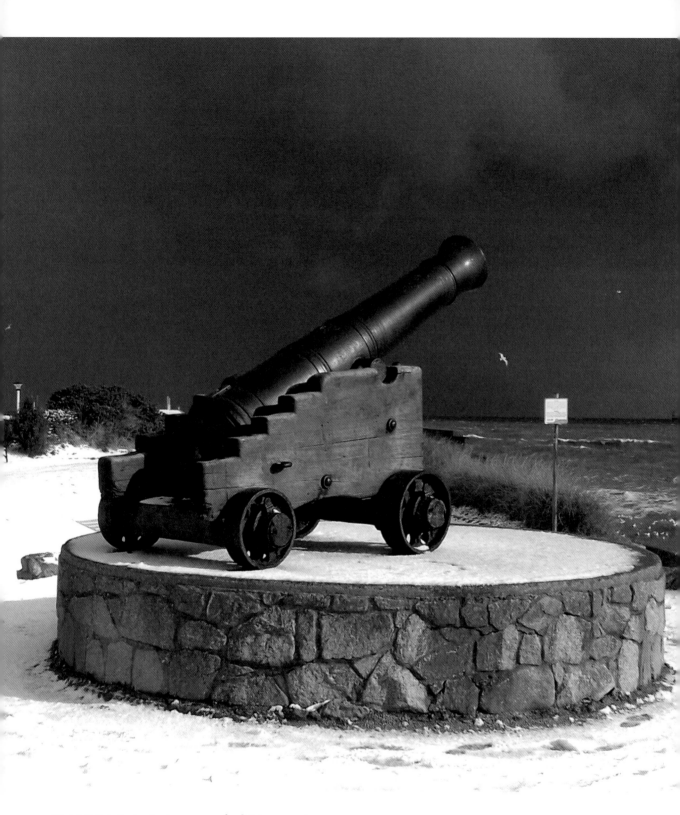

PHOTOS BY MARIAN THÉRÈSE KEYES

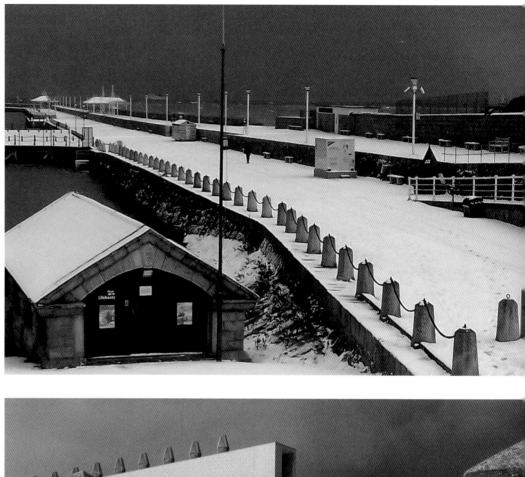

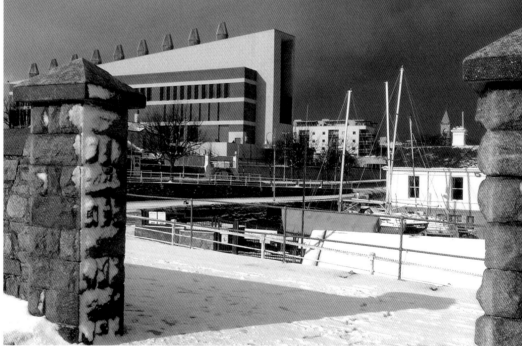

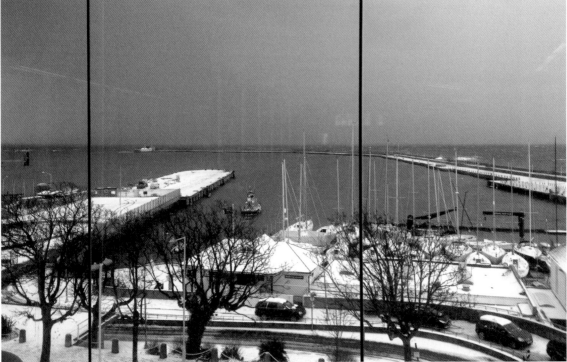

PHOTOS BY PETER PEARSON

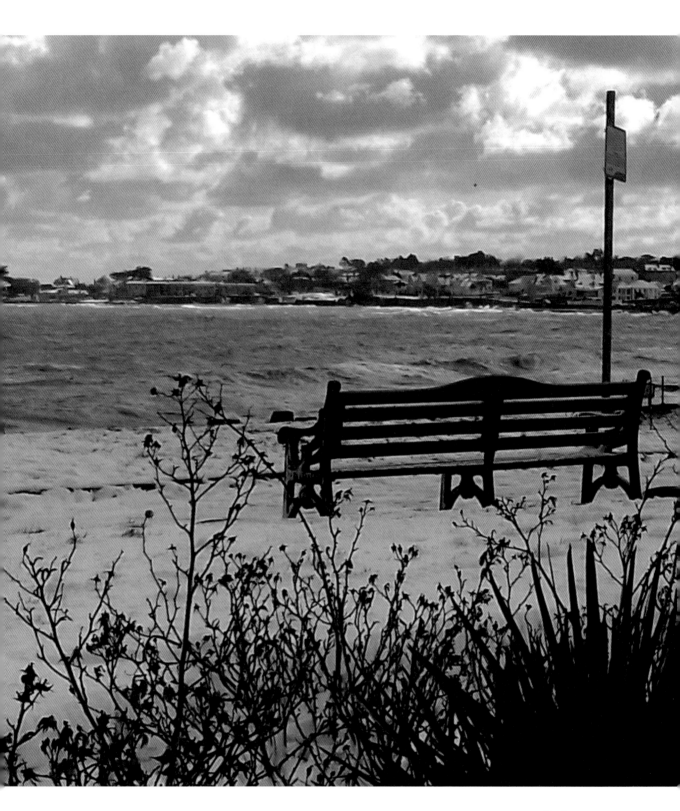

FOGGY CONDITIONS IN DÚN LAOGHAIRE

The last remaining foghorns around Ireland's coastline were switched off by the Commission of Irish Lights and Harbour Boards in early 2011. Foghorns are now considered obsolete and with the new advances in marine technology, they are no longer deemed an aid to navigation. The foghorn situated in the battery at the end of the East Pier closed down on 11 January 2011.

It is not just sailors who miss the sound of the foghorn. Many local residents, tucked up in their beds on a still, foggy night miss the familiar, comforting sound from afar.

Fergus Kelly recorded the harbour foghorn on a bitterly cold day in January 1987 and you can listen to this at www.dunlaoghairesoundmap.com. This is an ongoing project by Anthony Kelly and David Stalling to capture the sounds and stories of Dún Laoghaire, past and present.

'Dún Laoghaire harbour foghorn, recorded on a bitterly cold day in January 1987. A unique soundmark of the locality I grew up in, now sadly gone. The foghorn would carry right across the landscape in a low mournful drone whose note would end as though it were reaching the end of its breath, like a large animal exhaling. A very evocative sound, which also gave a sense of the space that it reverberated within, a sense of the landscape as a sounding board. It got the hook in me from an early age – it sunk in like a depth charge, which now feels like a part of my DNA, rooted in the very marrow of my early memories. So glad I had the presence of mind to record it before it disappeared.'

Fergus Kelly, May 2015

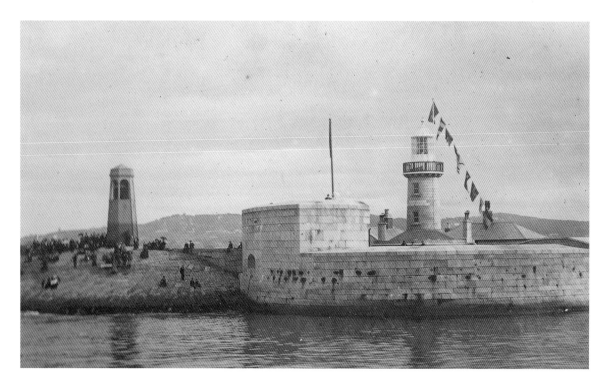

East Pier from the *Ulster* showing foghorn. Anon. 1897. Seymour Cresswell Collection. Courtesy of Vincent Delany and dlr Local Studies Collection.

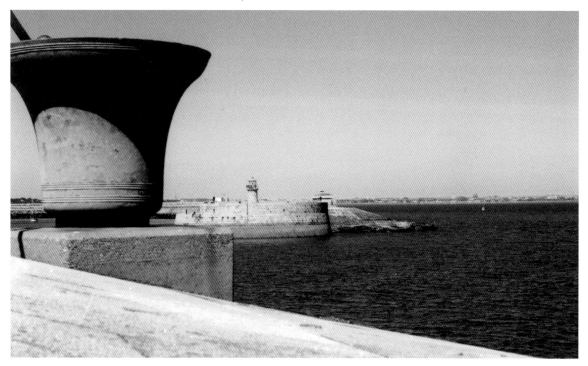

The foghorn bell at end of the East Pier. 2012. Image courtesy of Colin Scudds.

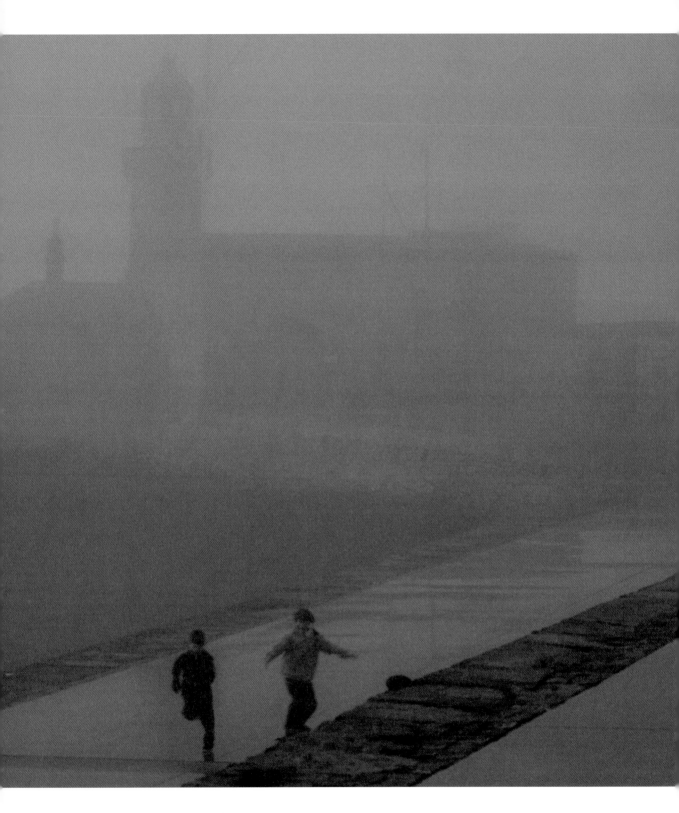

PHOTO BY CIARA BREHONY

'*We decided to take a stroll down the east pier, as so many others did, and it was a magical wonderland of another kind. Heavy swathes of sea mist crept silently around, making sound a strange muffled loudness. And as we walked through the dense moisture the foghorn resounded forlornly in our ears, and I was instantly transported back to my childhood bed, burrowing under the blankets as I listened, waiting to hear it again. It's a sound that will forever be both haunting, and powerfully poignant for me.*

'*And on we walked, people's footsteps echoing quietly-loud across the concrete, their voices murmuring in our ears. And then I heard, as though on some fairy wind, the lonesome sound of music, gradually growing louder until a tall, bearded man loomed out of the freezing haze, his fingers walking over the strings of his banjo, an accompaniment to our walk.*'

Ciara Brehony
from 'Where We Found Ourselves Today'
Milkmoon, 29 December 2009

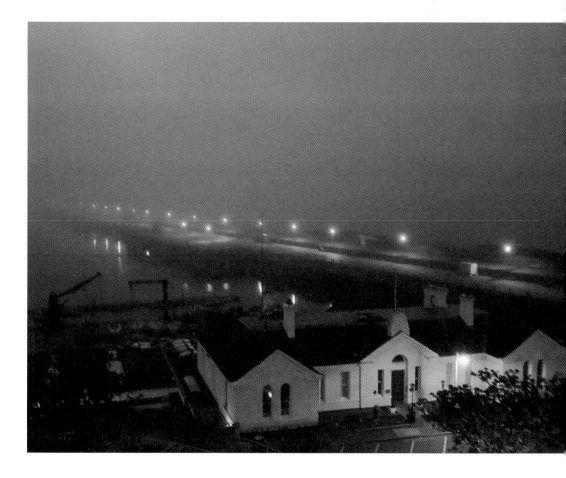

PHOTO BY BART GRZEBALSKI

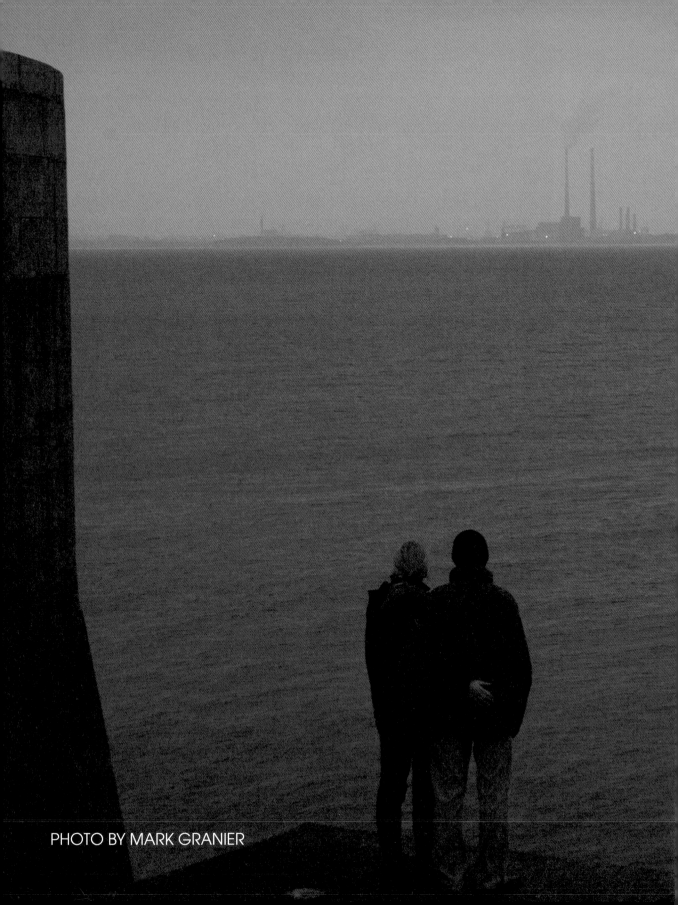

PHOTO BY MARK GRANIER

FOGGY DEW, EAST PIER
by Mark Granier
(from *Taking the Plunge*)

A banjo player, long-red-bearded, in place
as the honey-grey masonry. A late
wintering gaze. I offered

'cold work' and he nodded, gave me
the edge of a smile. Hooded, grey-blue eyes
had travelled a few leagues more

than an evening stroll on a pier.
What was that tune that tracked me to the end, to touch
the wall of the lighthouse?

LIGHTSHIPS

At the beginning of the twentieth century, there were eleven lightship stations around the coast of Ireland. They served instead of lighthouses on land and were placed further out to sea to warn ships of danger. Lightships also kept records of passing ships and weather observations. For purposes of visibility, the ships were normally painted with a red hull and the name of the station painted on the side in white uppercase letters.

Over the years, they were de-manned and automated and in turn replaced by Large Automatic Navigation Buoys (Lanbys). The *South Rock* and *Coninbeg* were Lanbys and they remained a familiar site in Dún Laoghaire Harbour until they were withdrawn, *South Rock* in 2009 and *Coninbeg* in 2010. Lanbys have now been replaced by Superbuoys, a new generation of maritime navigational aids.

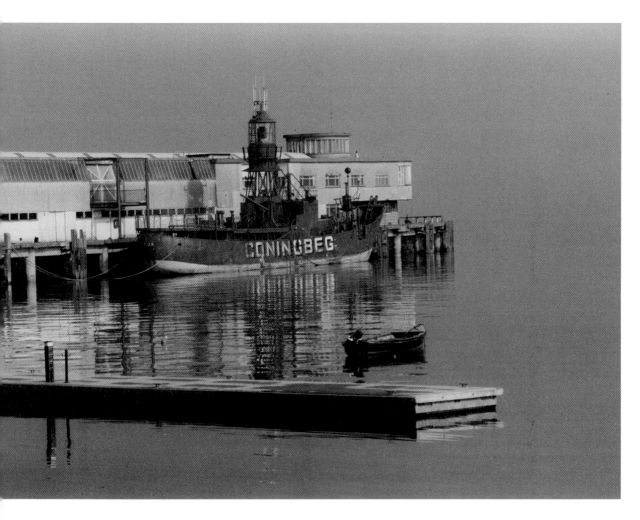

The *Coninbeg* Lightship at Carlisle Pier. 2002. Image courtesy of Colin Scudds.

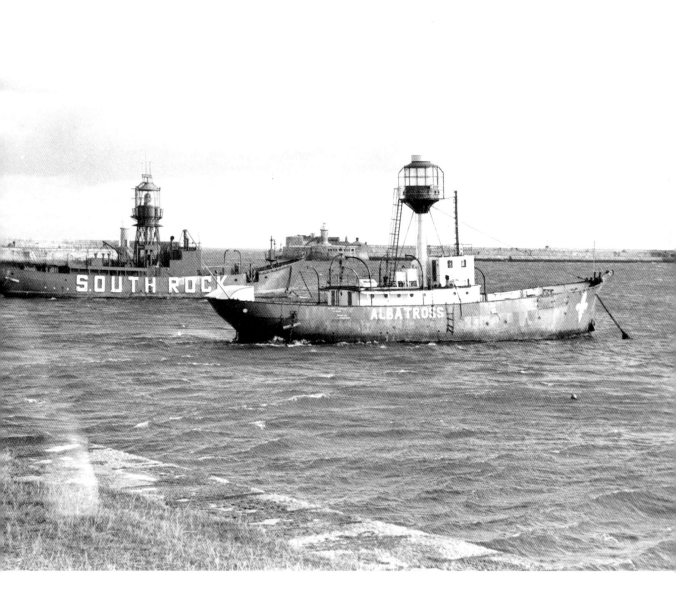

The *South Rock* and *Albatross* Lightships. 1986. Image courtesy of Colin Scudds.

SUNSCAPES & NIGHT LIGHTS ON THE PIER

'When I admire the wonders of a sunset or the beauty of the moon, my soul expands in the worship of the creator.'

Mahatma Gandhi

For many people, their evening stroll is almost a religious rite; the last act after a busy day. On a fine evening the walk along the pier with the sun slowly sinking into the Irish Sea can be a spiritual experience, uplifting and enchanting in equal measure. The sky, the sea, the broad esplanade, the ships, the reflection of red, orange and yellow light on the water, the view across the bay to Howth and the Pigeon House, equally magically illuminated. Shadows become longer than their owners and a silence descends as the busy day falls away. It's little wonder that Dún Laoghaire Harbour is consistently ranked as one of the most beautiful places to watch the sunset in Ireland.

The scientific explanation for nature's amazing artistry is a phenomenon called scattering. Molecules and small particles in the atmosphere change the direction of light rays, causing them to scatter, affecting the colour of light coming from the sky, but the details are determined by the wavelength of the light and the size of the particle. Although each of the following photographs was taken at the same general location over a twelve-month period, the photographs are as unique as the eye of the individual beholder. This is not just due to the different seasons and times during which the shots were taken but also due to the subjective nature of vision and perspective and the personal reasons for being on the pier. One of our regular contributors, Rachel Duffy Howe, mother of two young children, brings the kids out 'for a final scoot on the pier', tiring them out before bedtime and using the time to make some magical photographic memories too.

Contributors such as Dave Keegan, Ross Nolan, David Lynch and David Kavanagh have furnished us with some dazzling images of sunsets and given us some stunning 'night light' shots showing the pier, at night, as simply a quiet and tranquil place where people can relax at the end of a long day.

It can indeed be a pacific pier at night, with the clink of the berthed boats, the lapping of the water and the bright city lights like a distant pendant protecting the bay. It is of course a traditionally romantic night-time rendezvous point as well, with many tales of first dates on the pier, stolen kisses on the bandstand, engagements made and broken and assignations both passionate and prosaic!

The following images may well convince you of the restorative and relaxing nature of a late evening walk on Dún Laoghaire Pier.

'The lights of Kish swept around, bouncing off a thin band of water far in the distance, then vanished. The tide was out. Over the ooze and bustle of the city, the sky was rusty with pollution; above the sea, it was a soulless grey-black. The harbour towns of Blackrock and Dún Laoghaire glittered in the distance. The air was chilly again, poking nagging fingers under my clothes.'

From *Beautiful Pictures of the Lost Homeland* by Mia Gallagher

BART GRZEBALSKI

SUNSCAPES

BART GRZEBALSKI

Bart has a unique perspective on early morning Dún Laoghaire and this particular angle of the East Pier. He has been Night Security Officer at dlr LexIcon since it opened in late 2014 and loves to catch these quiet sunrise moments captured on these pages, not to mention the dramatic weather extremes over the seasons.

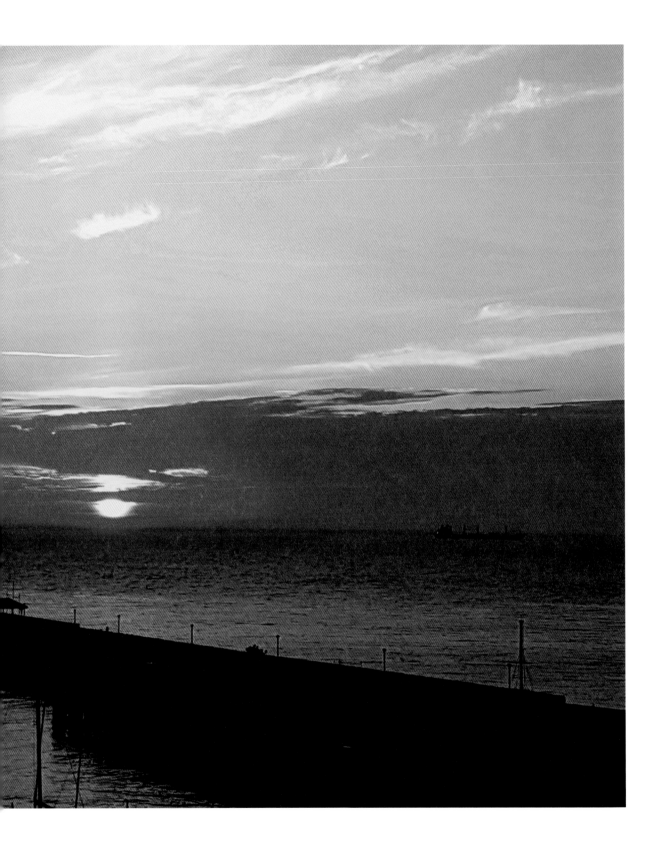

DAVE KEEGAN

'For me, the art of photography is capturing the right moments at the right time. I started photographing when I was a young teenager, I picked up my first SLR and I was hooked ever since. Street, landscape and music photography are my favourite styles to shoot, but I particularly love the work of the photojournalists in the 1950s, '60s and '70s, there's something classic and timeless about the images they produced. I shoot for all kinds of events today and I'll always try and add some sort of creativeness to the project no matter what the shoot or situation may be. A lot of photographers say that their photos are like their diaries and in my case that's very true as looking at my past images, they bring me right back to that time and place, so no words are needed!' facebook.com/DaveKeeganPhotography

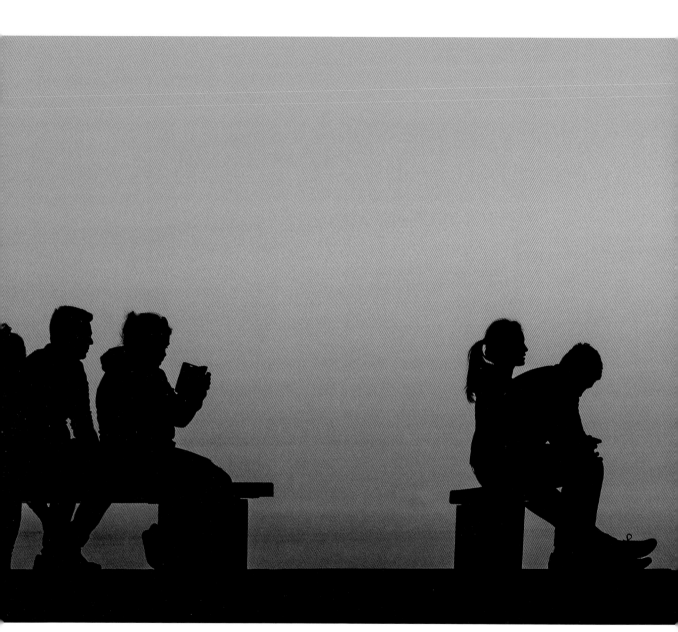

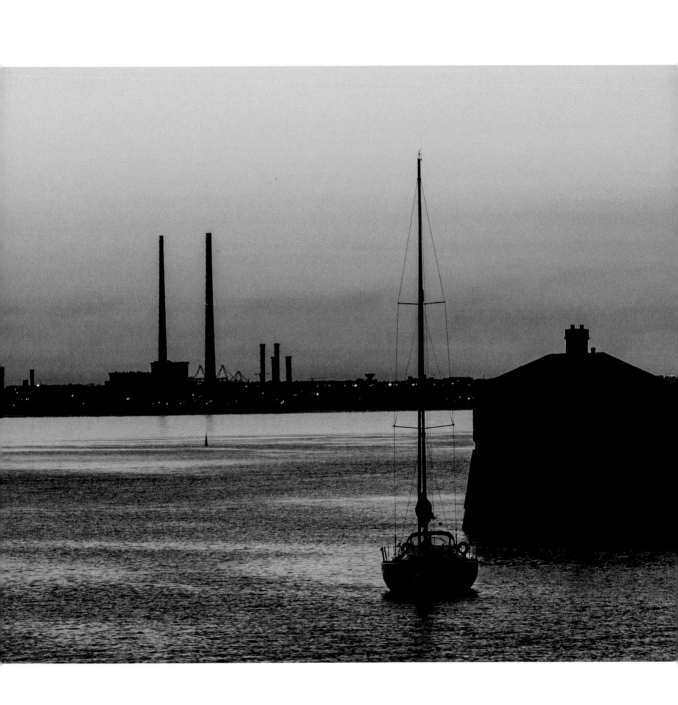

PHOTO BY DAVE KEEGAN

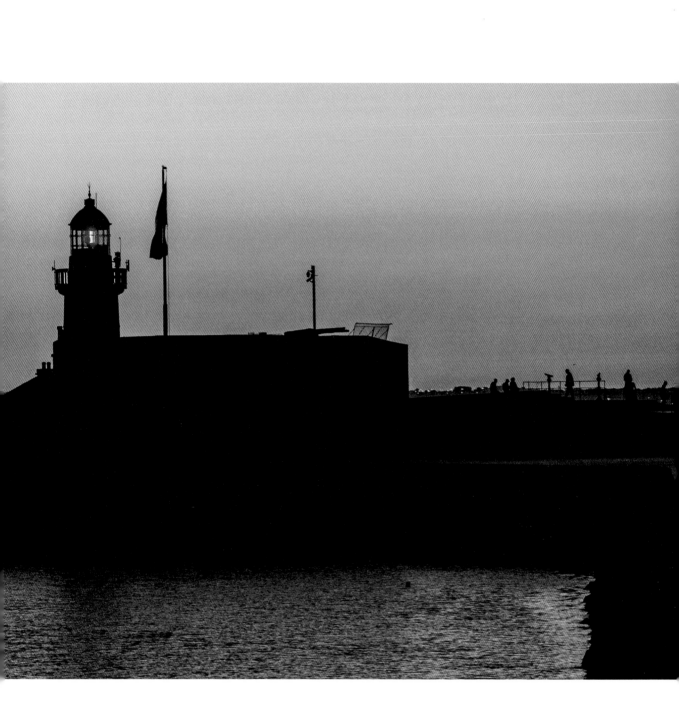

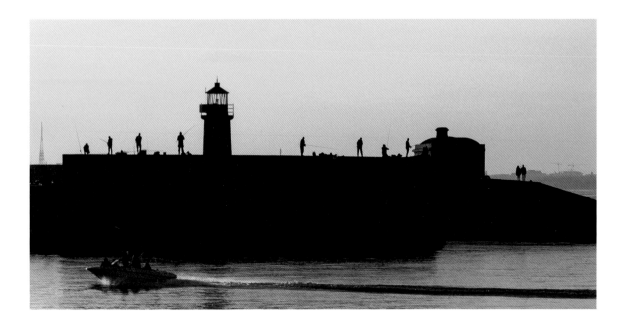

PHOTOS BY DAVE KEEGAN

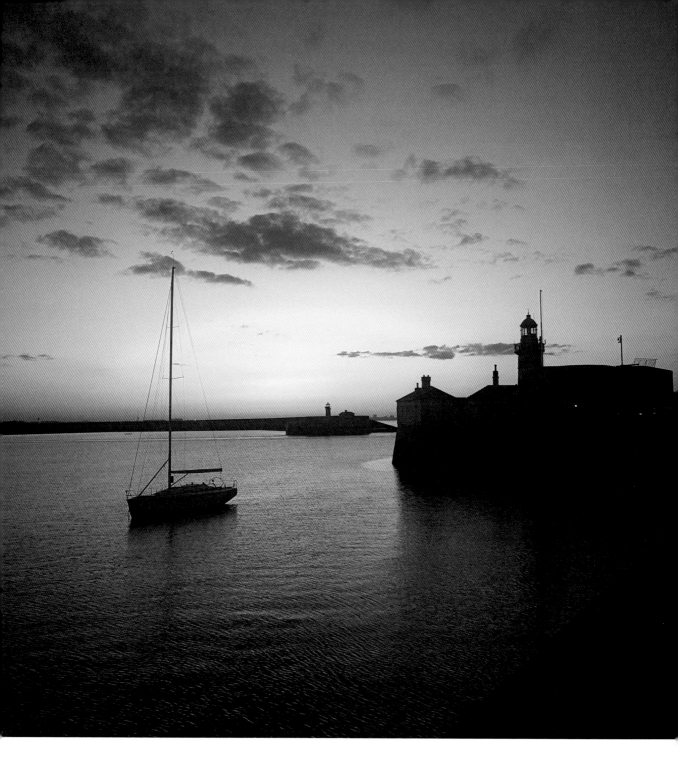

MARIA SHINE

'The pier was a place that helped me beat illness by kick-starting my love of photography and the outdoors again.'

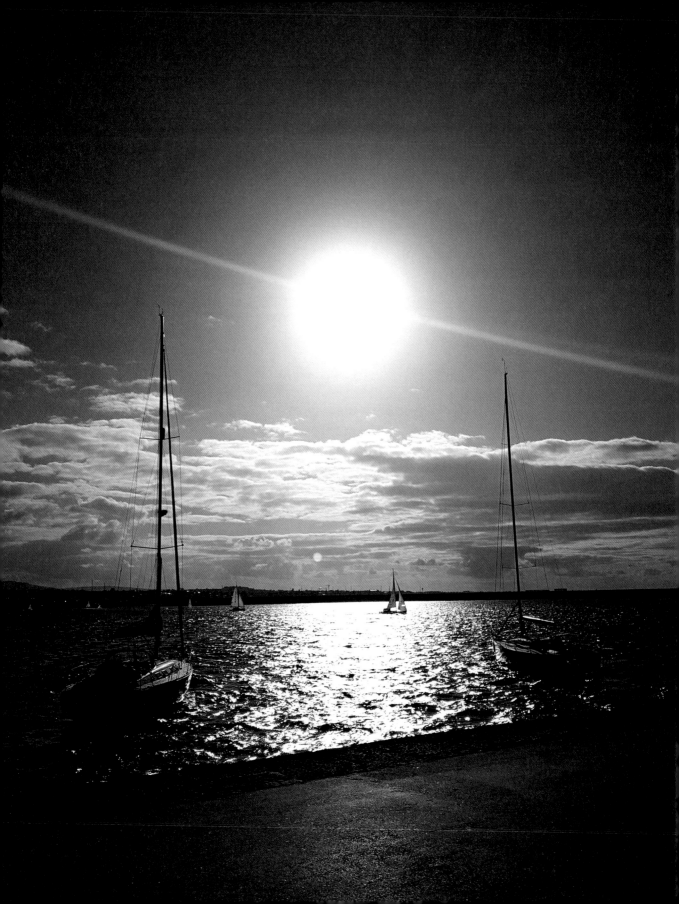

DAVID KAVANAGH

'Dún Laoghaire pier is one of the most peaceful places in Dublin.'

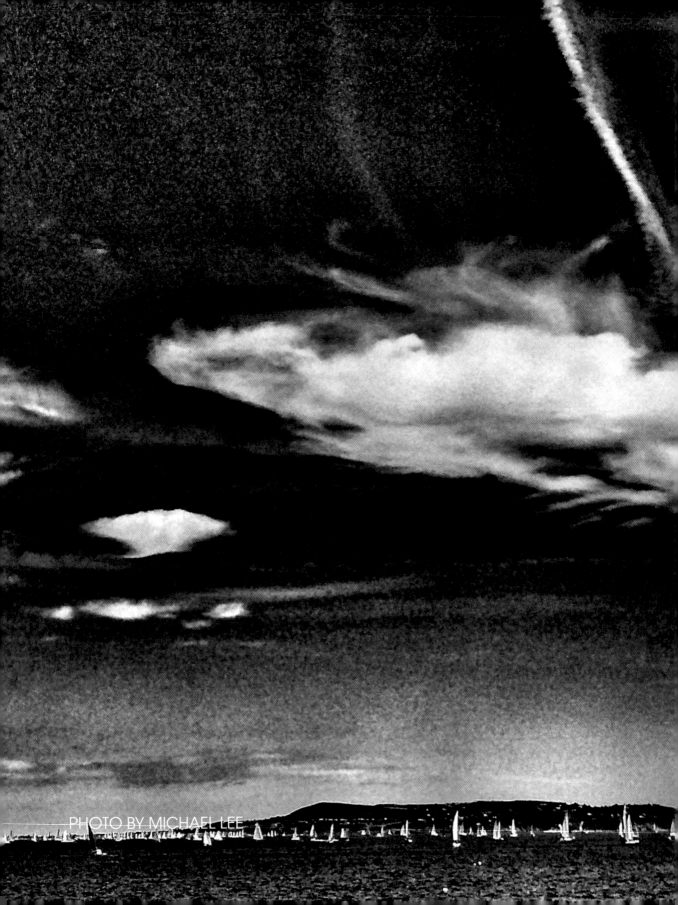

PHOTO BY MICHAEL LEE

ON DÚN LAOGHAIRE PIER

by Sally Dunne

Bells sound over water
Silver grey to deep sea green
Navy depths by ochre rock
Over fathoms of black, wind moves.

11 o'clock strikes on harbour wall
A boat sculls around pier head
Inside two stone arms
The solid trust of home.

'Growing up near Dún Laoghaire in the 1960s and '70s inevitably meant living a sea-affected life. Early learning took place at the baths, progressing through the pools – baby, kids, and then big. Sandycove Harbour was next before graduation at the Forty Foot. I can still feel the texture of the rope-covered diving board under my feet. The board went, as eventually did the Men Only status – Dún Laoghaire wasn't always in the van. Nowadays most of my swimming happens cross border in Wicklow, but this early-morning autumn swim brought me back to my home place. As I made my way between the two piers I looked over my shoulder and smiled as the old St Michael's Nursing Home came into view – is there a name for those of us born within a stone's throw of Dún Laoghaire harbour?'

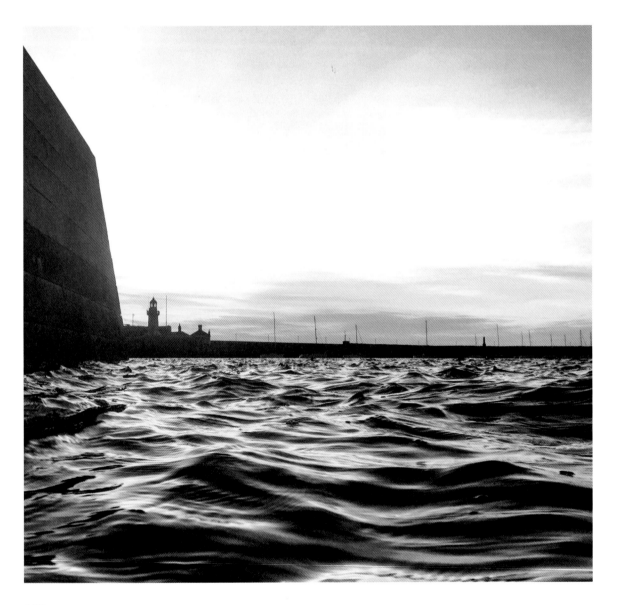

290

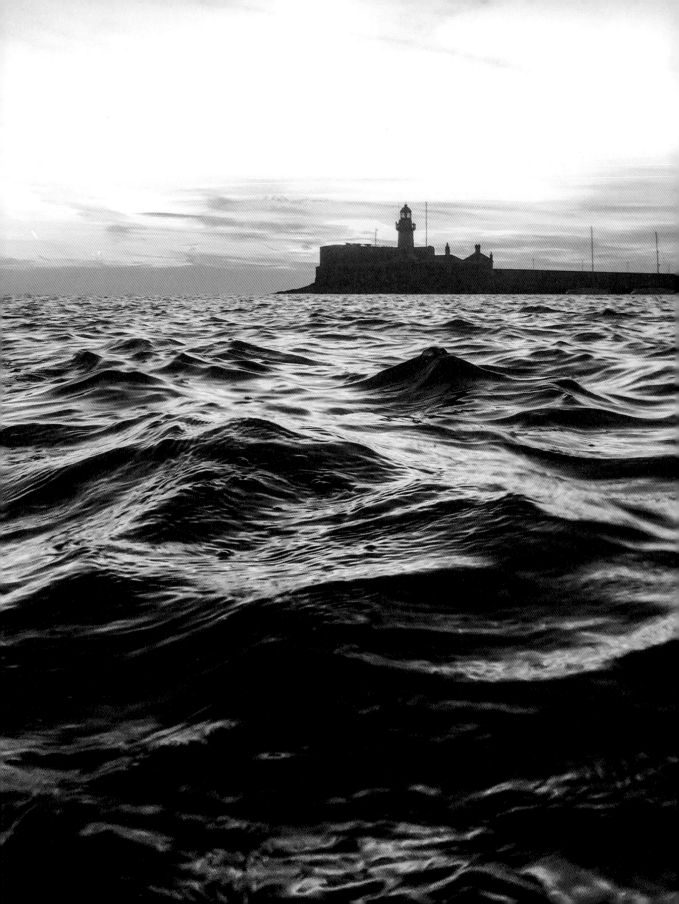

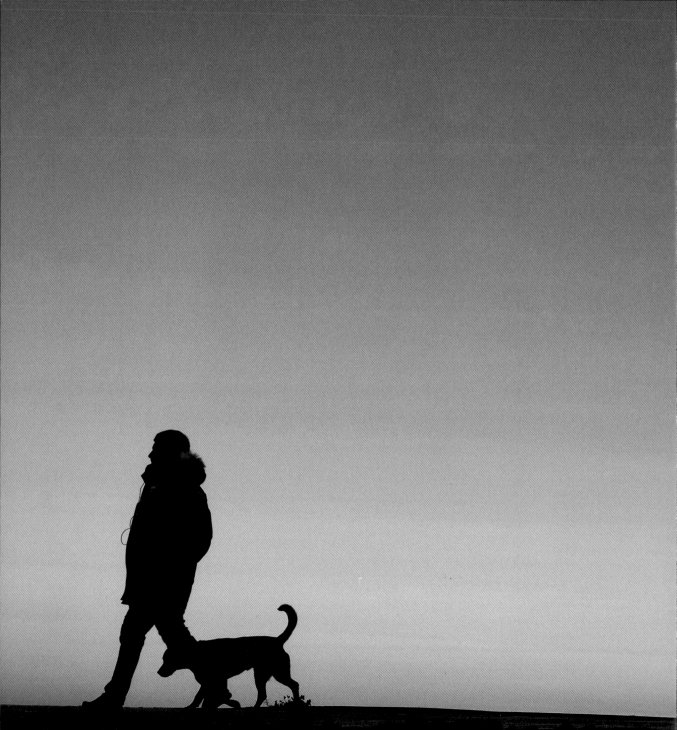

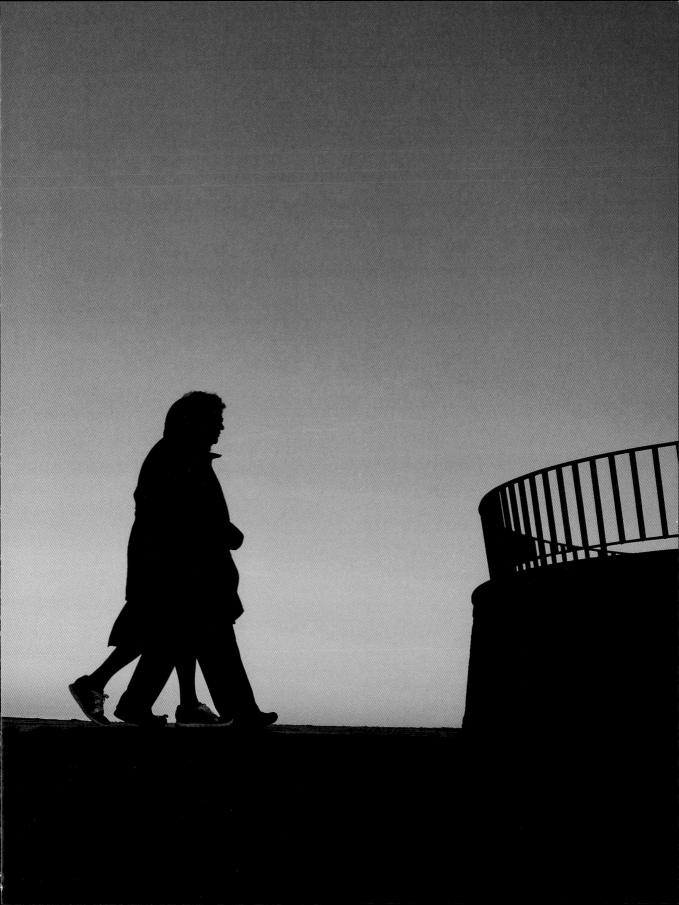

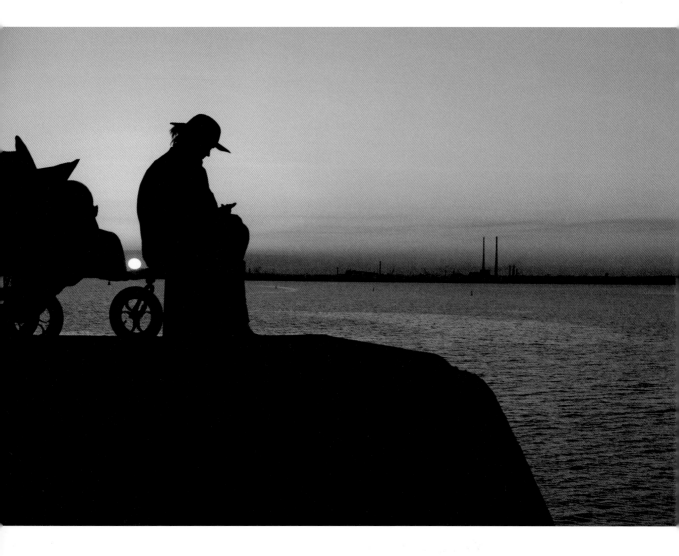

PHOTOS BY DAVID LYNCH

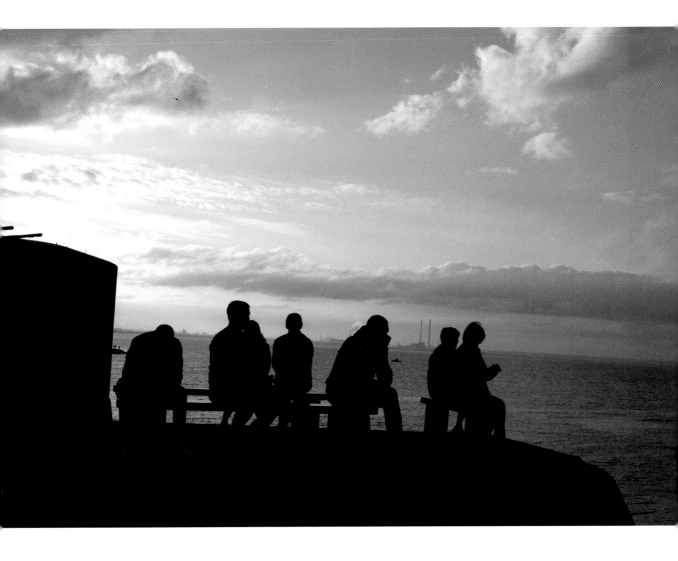

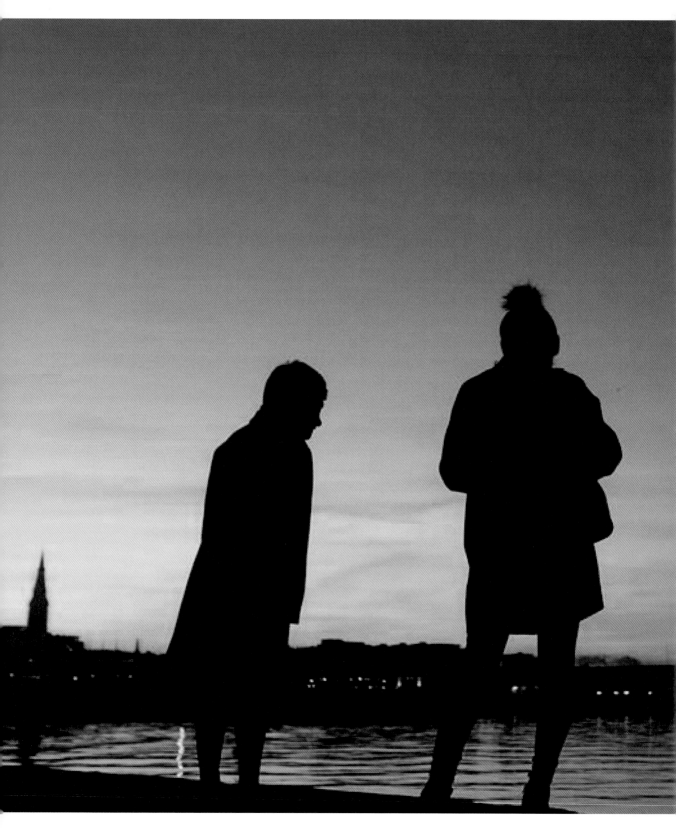

PHOTO BY MARK GRANIER

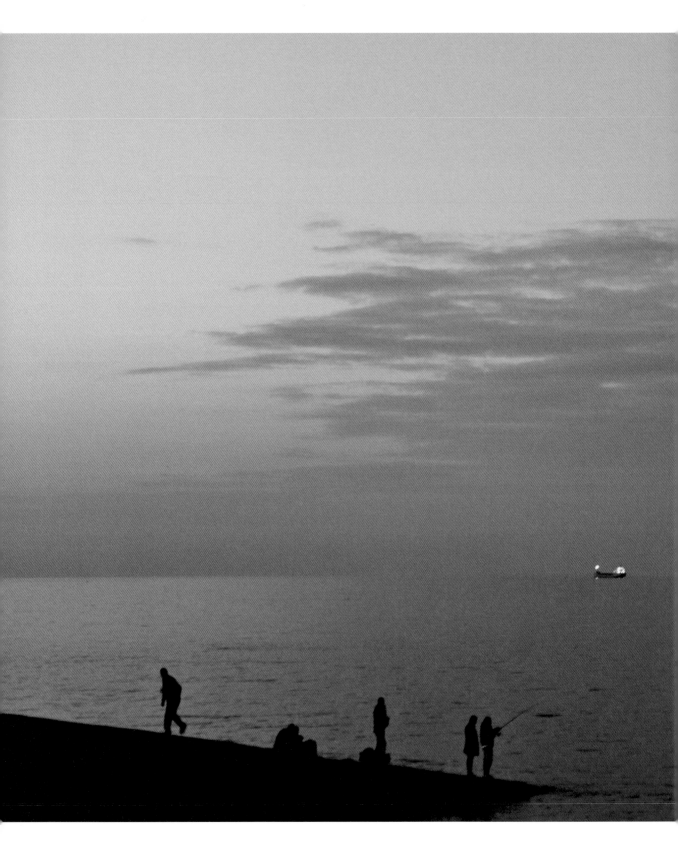

PHOTO BY MARK GRANIER

MARY CARROLL

'I am on long-term leave from work due to illness. I live in Dublin 2 but go to Dún Laoghaire most days to take in the sea air and sun and atmosphere. It does my health good. I love the pier and all the different things that go on every day. I'm not a photographer but love taking beautiful photos with my iPhone. Dún Laoghaire is my favourite place to be.'

PHOTO BY RACHEL DUFFY HOWE

PHOTO BY TARA COUGHLAN

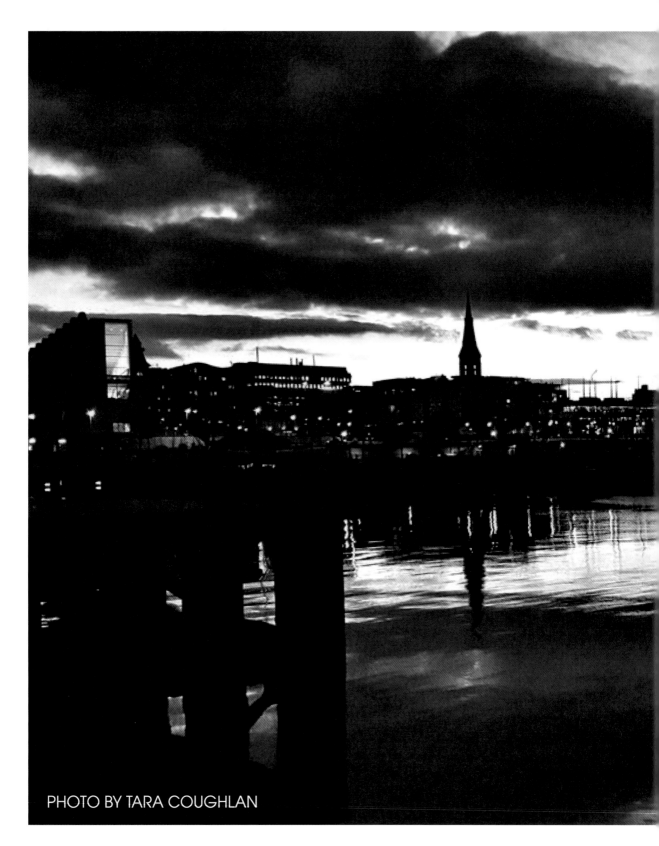

PHOTO BY TARA COUGHLAN

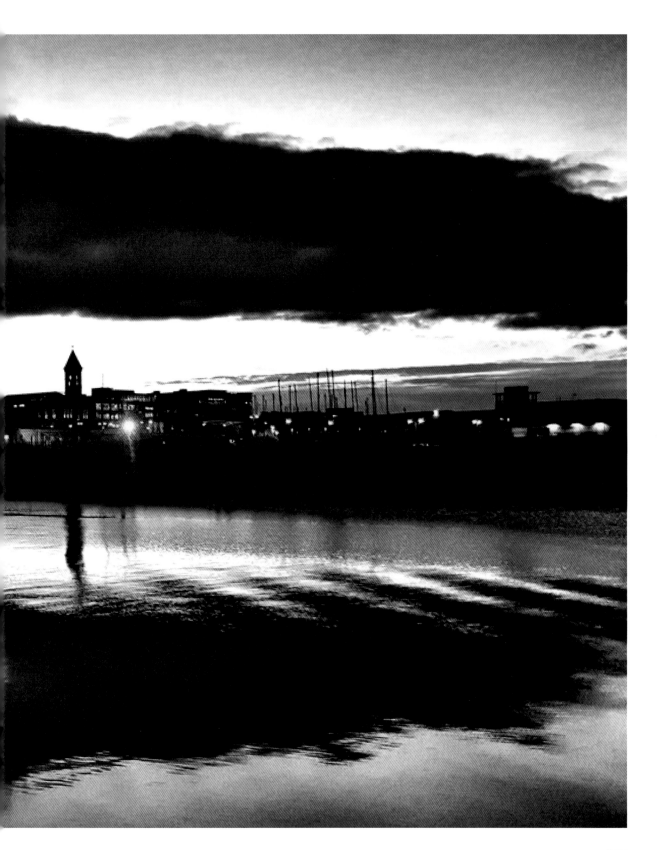

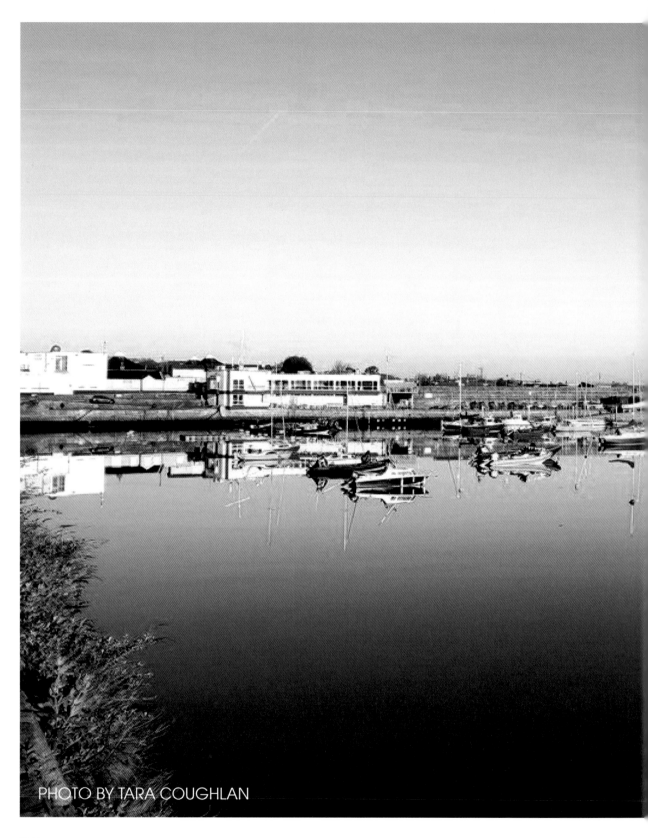
PHOTO BY TARA COUGHLAN

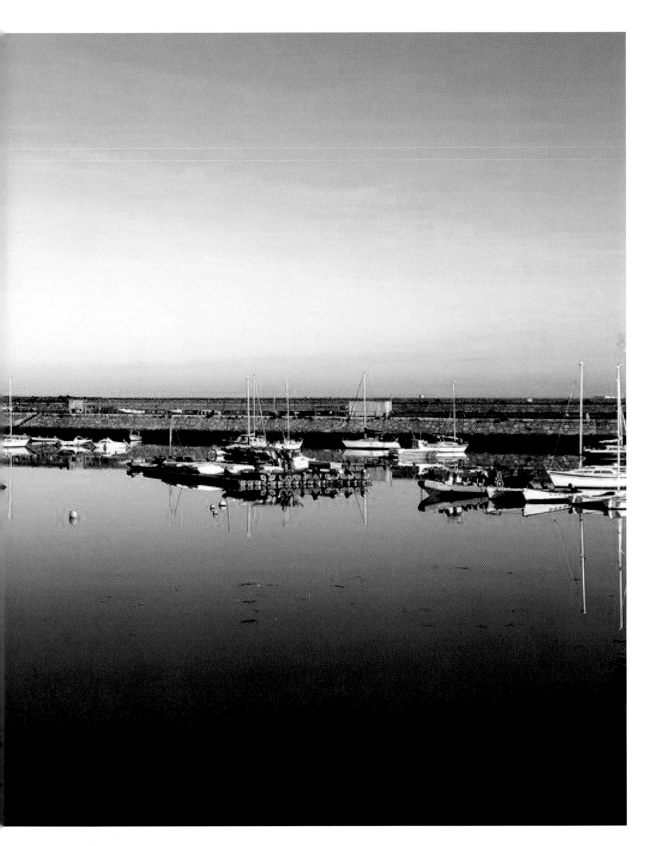

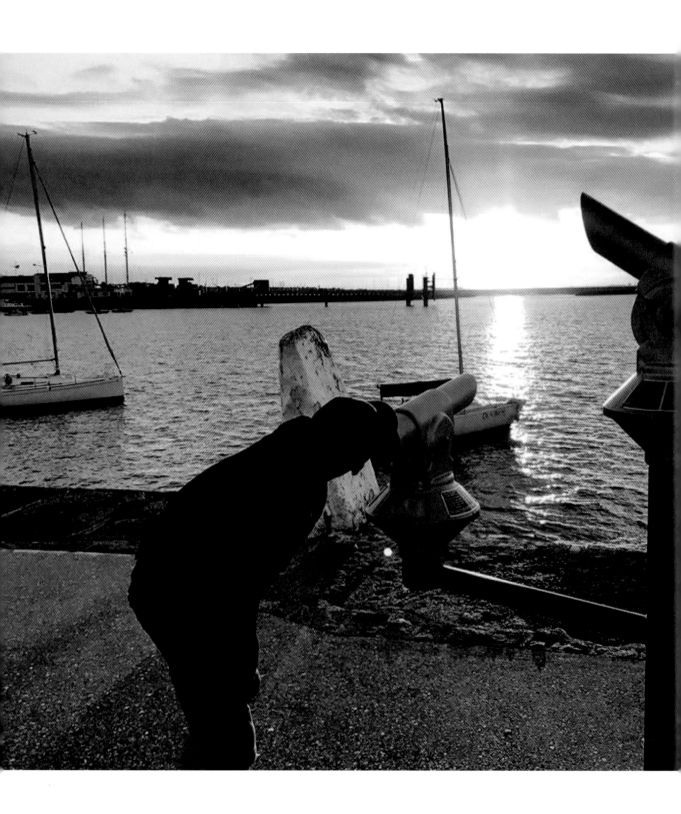

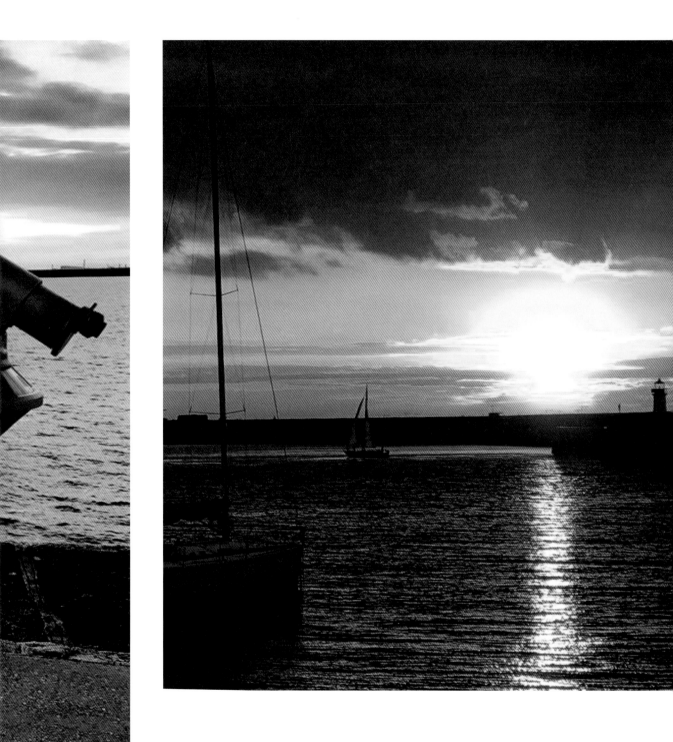

PHOTOS BY SARAH TRENAMEN

PHOTO BY NIAMH MCCARTHY-GRIFFIN

PHOTOS BY ROSEMARY WIDDY FAHY

'My parents used to bring me to the pier when I was a little girl. I would watch the boats bobbing up and down and listen to the sound of the masts, and the other everyday sounds would vanish.'

PHOTO BY ROSS NOLAN

PHOTO BY ROSS NOLAN

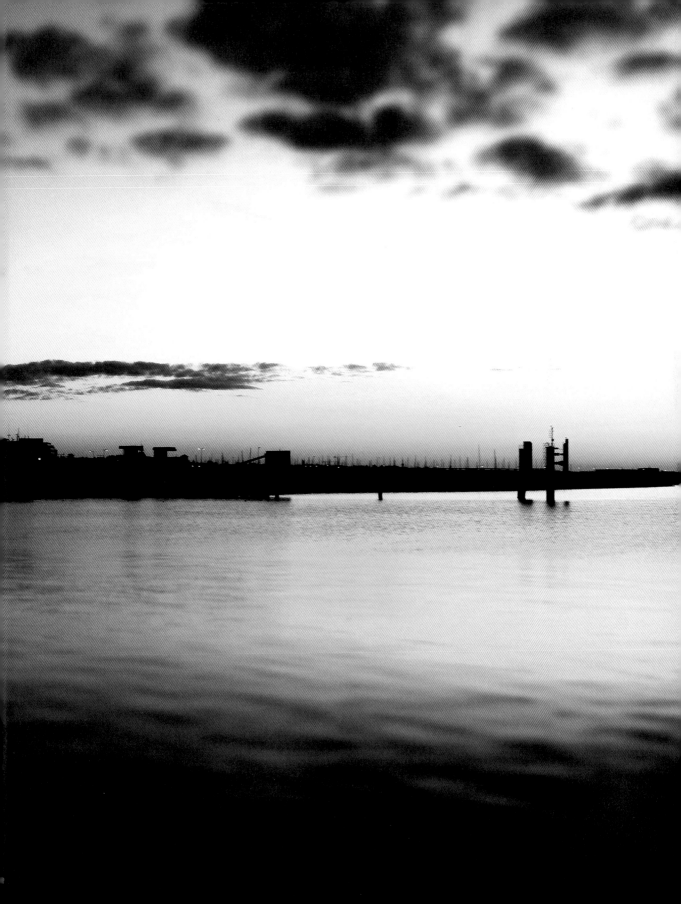

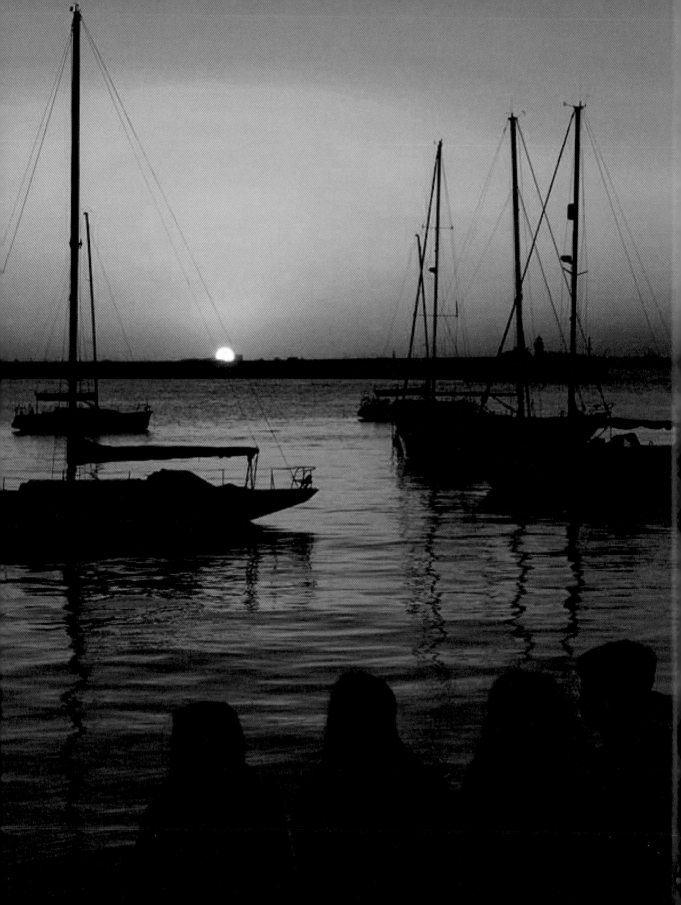

'Taking a walk on the West Pier, near the entrance of the pier I can be quite alert to the many busy sounds associated with our town: for example the trains, cars and people at work. But the further I travel down the pier, the more I tune to the harbour and its specific and bracing soundscape. Venturing onwards I find that I am leaving the sounds of the town behind: a unique and pronounced sensation of moving 'outwards' from the land, accompanied by differing sounds from the sea, now on both sides of the walkway. And when I get to the first turn, I can really become aware of that.'

<div align="right">Anthony Kelly, 21 April 2015</div>

From 'Sound Surprises' by La Cosa Preziosa (Susanna Caprara), Sound Journal section (www. lacosapreziosa.net). Included in A Sound Map of Dún Laoghaire, an ongoing project by Anthony Kelly and David Stalling (www.dunlaoghairesoundmap.com)

'I close my eyes and listen for a while. If you live by the sea you have this sound. This in-and-out of the tide. A wave breaks over the rocks. A small crescendo followed by a gentle sucking as the water pulls itself back and starts again: a fundamental sound, like breathing. My fingers are cold and I'm tired, but's good to be here letting these thoughts roll over me, like the tide over the rocks.'

<div align="right">from *Immersion* by Michelle Read in *Taking the Plunge*</div>

ACKNOWLEDGEMENTS

With many, many thanks to all of the people who have contributed their cherished photographs to this unique volume. Inspirational images and stories have intertwined here with the history of Dún Laoghaire Pier to produce this lovely publication. Our hope is that it may live on in the Dún Laoghaire Libraries Local Studies Collection for another 200 years, illuminating what life was like back in 2017 for those who may walk the pier in 2217!

Sincere thanks also to the many people strolling on the pier who stopped and had a chat with Jon Kelly, the amateur photographer extraordinaire who helped us to kick-start the collection of photos in the early days of the People on the Pier project. Many prose and poetry excerpts have been included in this book: thanks to Ciara Brehony, Celia de Fréine, Martina Devlin, Sally Dunne, Mia Gallagher, Mark Granier, Lucinda Jacob, Russell Kane, Anthony Kelly & David Stalling of A Sound Map of Dún Laoghaire, George Kelly, Flor MacCarthy, Luke Naessens, Julie Parsons, Lia Mills, Michelle Read, Eric Thompson, Daniel Wade and Sarah Webb and all the writers in the LexIcon Young Writers' Club.

We have done our utmost to ensure that photos, prose and poems have been captioned correctly throughout the book but any errors or oversights are our responsibility and we are keen to hear from you with any additional comments or corrections for future editions.

COUNTY COUNCIL

An Cathaoirleach Cllr. Ossian Smyth, Cllr Tom Murphy and Cllr Cormac Devlin (both also served terms as Cathaoirleach during the People on the Pier project), all the Councillors and the Management Team for their ongoing support, Mairead Owens, County Librarian, Nigel Curtin, Local Studies Librarian, David Gunning, Curator Archivist in Residence, all the dlr Library and Apleona team who have promoted the People on the Pier project on social media and with their many photos. Conor Peoples and staff in the Communications Office, Owen Laverty of the Local Enterprise Office.

LOCAL HISTORY COMMUNITY

Special thanks to the following who have all contributed suggestions and assistance: Anna and Colin Scudds of the Dún Laoghaire Borough Historical Society for permission to use images and text from the exhibition Bicentenary of Dún Laoghaire Harbour which was hosted in partnership with dlr LexIcon in May 2017, Dr Séamus Cannon, author of the recent 'You'd be Filled with Wonder': the story of Dún Laoghaire Harbour and for use of the image from the Illustrated London News of the Boyd disaster in 1861 and to authors included in the short Bibliography below.

With gratitude to staff in the National Gallery of Ireland, National Library of Ireland, The Irish Times office and to the Irish Historical Picture Company for permission to reproduce images contained within this publication, also the Ian Lawler Collection, Vincent Delany, the Seymour Cresswell Collection and Carolyn Hanaphy of the Dún Laoghaire Harbour Company. Thanks to Richard Howlett and Olivia Hearne of Concept2Print for providing many of the images from the Bicentenary of the Pier exhibition.

NEW ISLAND

Last but certainly not least, we wish to acknowledge the brilliant team at New Island, the ever-encouraging editor Dan Bolger, the brilliant designer Karen Vaughan, the supportive and always helpful Edwin Hegel, Mariel Deegan and Hannah Shorten and all from New Island who turned People on the Pier into such a wonderful book.

BIBLIOGRAPHY

Dr Séamus Cannon, with Gráinne O'Malley and Colin Scudds, '*You'd be Filled with Wonder*': *the story of Dún Laoghaire Harbour*, Blackrock Education Centre in association with Dún Laoghaire Harbour Company.

Tim Carey, *In Honour & Memory*: *Memorials of Dún Laoghaire-Rathdown*, Dún Laoghaire-Rathdown County Council, 2007.

Carr Cotter & Naessens Architects, *dlr LexIcon, Dún Laoghaire*, Gandon Editions, 2015.

Dún Laoghaire Borough Historical Society, *A Safe Anchorage*: *Dún Laoghaire/Kingstown Harbour 1817-2017*, 2017.

Rob Goodbody, *The Metals*: *From Dalkey to Dún Laoghaire*, Dún Laoghaire-Rathdown County Council, 2010.

Dr John de Courcy Ireland, *The History of Dún Laoghaire Harbour*, Caisleán an Bhurcaigh, 2001.

Vanessa Fox O'Loughlin (Editor) *Taking the Plunge*: *New Writing from Dún Laoghaire-Rathdown*, Dún Laoghaire-Rathdown County Council, 2014.

Peter Pearson, *Dún Laoghaire/Kingstown*, O'Brien Press, 1991.

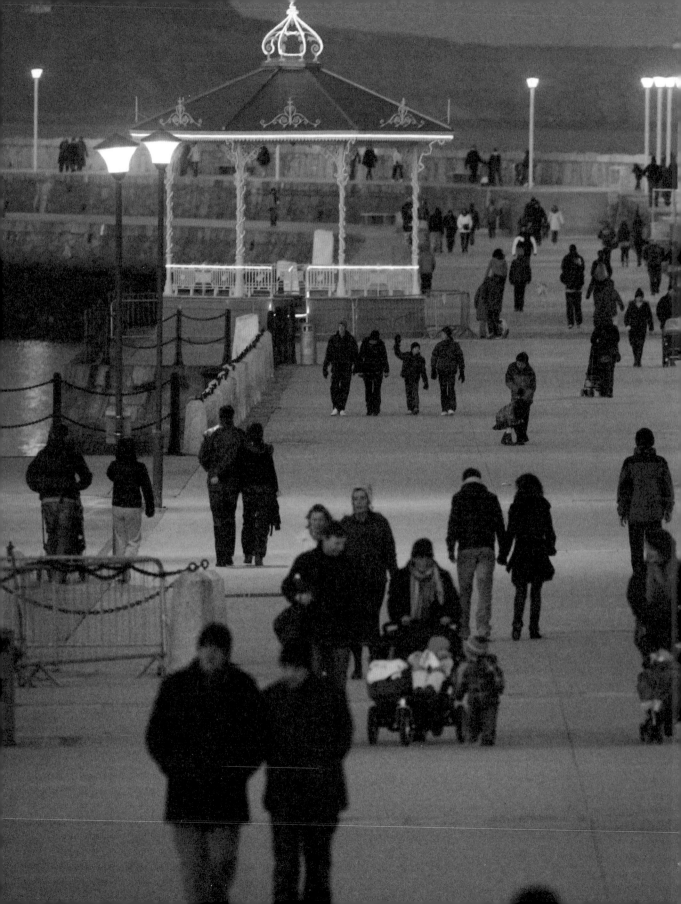